FabJob® Guide to

BECOME A FASHION DESIGNER

PETER J. GALLANIS AND JENNIFER JAMES

FABJOB® GUIDE TO
BECOME A FASHION DESIGNER
Lead Author: **Peter J. Gallanis**
Editor: **Jennifer James**

ISBN 1-894638-75-1

Library and Archives Canada Cataloguing in Publication

Gallanis, Peter J.
FabJob Guide to become a fashion designer / Peter J. Gallanis, Jennifer James.

Accompanied by CD-ROM.
Includes bibliographical references.
ISBN 1-894638-75-1

1. Fashion designer—Vocational guidance. I. James, Jennifer
II. Title. III. Title: Become a fashion designer.
TT507.G34 2005 746.9'2 C2005-902554-9

Important Disclaimer: Although every effort has been made to ensure this guide is free from errors, this publication is sold with the understanding that the authors, editors, and publisher are not responsible for the results of any action taken on the basis of information in this work, nor for any errors or omissions. The publishers, and the authors and editors, expressly disclaim all and any liability to any person, whether a purchaser of this publication or not, in respect of anything and of the consequences of anything done or omitted to be done by any such person in reliance, whether whole or partial, upon the whole or any part of the contents of this publication. If expert advice is required, services of a competent professional person should be sought.

About the Websites Mentioned in this Guide: Although we aim to provide the information you need within the guide, we have also included a number of websites because readers have told us they appreciate knowing about sources of additional information. (**TIP:** Don't include a period at the end of a web address when you type it into your browser.) Due to the constant development of the Internet, websites can change. Any websites mentioned in this guide are included for the convenience of readers only. We are not responsible for the content of any sites except FabJob.com.

FabJob Inc.
19 Horizon View Court
Calgary, Alberta, Canada T3Z 3M5

FabJob Inc.
4603 NE University Village #224
Seattle, Washington, USA 98105

To order books in bulk phone 403-949-2039
For media inquiries phone 403-949-4980

www.FabJob.com

About the Author

Lead author **Peter J. Gallanis** is a ten-year veteran of journalism and is currently managing editor of a trade magazine in Chicago, IL. He has worked formerly as a freelancer (Gallanis Freelance Writing Solutions) where his clients included the *Chicago Tribune*, and as an associate editor with *DSN Retailing Today*, a retail industry and fashion trade magazine.

He began his career as a reporter, editor and columnist with two award-winning newspapers in Chicago's west suburbs. A 1993 graduate of Northern Illinois University where he earned a BA in English, he lives in Des Plaines, IL, with his lovely wife Chriselda, son Alexander and daughter Antonia. You may visit Peter's website at **www.geocities.com/peter_gallanis**.

No work may be done without the support of family and friends, and I wish to thank: sisters Stephanie and Connie, Jim and Tony Burgholzer, Mark Bergsten, Paul Donovan, Bill Ogle, Tom Millard, Don Dicke, Stew Lambert, my mother Athena Gallanis, Gust Makedon, William Wild Bill Burgholzer, in-laws Rolly and Elda, children Alexander and Antonia, and Chriselda.

Dedicated to my loving mother-in-law
Elda Padolina (1943-2004).
The body of a lamb, the heart of a lion,
the spirit of a giant.

About the Editor

 Jennifer James leads the Editorial Department at FabJob Inc., the world's leading publisher of information about dream careers. She has edited, researched for, and contributed to more than 30 FabJob career guides, including the *FabJob Guide to Become a Makeup Artist*, and the *FabJob Guide to Become a Celebrity Personal Assistant*, as well as the forthcoming book *Dream Careers* by Tag and Catherine Goulet. A business communications consultant specializing in music and fashion, she has advised and prepared marketing materials to launch businesses and individual careers in these industries.

About the Contributing Authors

Caryne Brown is an editorial consultant and business planner based in Los Angeles. As Senior Editor of *Entrepreneur Magazine*, she wrote or supervised editing of more than 60 how-to books, and developed distance-learning courses in business planning and entrepreneurial management. Topics of business manuals she has written include image consulting, start-up basics, and increasing sales. As the "Ask the Experts" columnist for *Income Opportunities Magazine*, she answered reader inquiries on small business management. She was a founding editor of *Woman's Enterprise*, and her numerous other writing credits include *American History*, *Architectural Digest*, *Bon Appétit*, *Ironman*, and *Shape*.

Alisa Gordaneer is the author of two FabJob guides, including *FabJob Guide to Become a Florist,* and she has contributed to several others including *FabJob Guide to Become a Makeup Artist*. She has worked in various creative industries, from floral design to photography to publishing. A professional editor and writer, she is the editor of *Monday Magazine*, an alternative newspaper in Victoria, B.C., where she writes a weekly column on current events and social trends, and covers numerous aspects of contemporary lifestyles. She has contributed to the anthologies *Women Who Eat, Three Ring Circus,* and *Breeder*.

Syndi Cannon's mother taught her how to sew, and by age 10 Syndi was making corduroy purses and selling them to her friends. Her experience in modeling solidified her interest in fashion, and she landed her first job in the industry with Mondetta Clothing. Her working there as an assistant designer took her on semi-annual trips to Europe to trend watch and shop for ideas. She aided not only in developing the brand through marketing and promotions, but was also involved in its business structure and its exceptional growth. After having her son, Riley James, and seeing a need for funky baby "stuff," she launched her unique custom design company, fortybaby, in 2002. You can see Syndi's latest designs at **www.fortybaby.com**.

Debbra Mikaelsen is a freelance writer and copywriter who has spent nineteen years working in fashion design and as a consultant to designers. She has produced women's wear, children's wear and technical sportswear, and has designed fabric prints. She is author of the *FabJob Guide to Become a Boutique Owner* and her writing has appeared in Just-Style.com, *Byline* and *International Living*.

Diana Pemberton-Sikes is an image consultant and author who has published hundreds of articles on the web about fashion, wardrobing, business attire, and making money in the fashion industry. She has also been featured in dozens of magazines, including *Woman's World*, *Weight Watchers*, and *The American Bar Association*. Her ebooks, *Wardrobe Magic* and *Home-Based Careers in Fashion*, are available at **www.Fashion ForRealWomen.com**.

Susan Wessling is an award-winning writer and editor whose work has been recognized by the National (U.S.) Newspaper Association and The New England Press Association. Her articles have appeared in a number of New England newspapers, U.S. and international magazines, and numerous education, health, and sports websites including *Encyclopaedia Britannica's* online encyclopedia. She has interviewed some of the top fashion designers in the world. Wessling lives in central Massachusetts with her partner, Pat, their infant son Stephen, and Irish Setter Clancy.

Acknowledgments

The authors thank the following fashion industry professionals for their assistance in making this book possible:

- **Maria Argyropoulos**, owner of m.andonia

- **Julie Chaiken** of Chaiken Clothing

- **Julian Chang**

- **Colleen Cimini** of PR First

- **Judy Drutz** of Dan Klores Communications

- **Mary Gehlhar** of New York's Gen Art

- **Giulietta Graci** of Anna Vi Andrea

- **Sara Graham**, designer, Sister Underwear

- **Stan Herman**, President, Council of Fashion Designers of America

- **Susan Holmes**, owner, Holmes Swimwear

- **Karen and Warren Hipwell** of Karen Warren

- **Robin C. Ikeda**, director of public relations for Miami International University of Art & Design

- **Kerri MacWher** of Barkley, Evergreen & Partners Public Relations

- **Sydney Maresca**

- **Patricia McCune**, **Kathy Collins** and **Joe Bugni** of Lee Jeans

- **Charlene Parsons** of Miami International University of Art & Design

- **Dr. Sharon Pate** of Illinois State University

- **Frank Pulice**

- **Leigh Ricker**, director of public relations for Chaiken Clothing

- **Renee Sall** of Maximum Exposure PR

- **Cathy Saman-Schneider**, designer, Sphere Trending

- **Stacey Seigler** of Expert Sources Inc.

- **Jerry Shandrew** of Shandrew Public Relations

- **Dan Soine** of The Art Institute of California, San Francisco

- **Tara Solomon**, president of TARA, Ink.

- **Leslie Snyder**, director of public relations for Prima Consulting Group, Inc.

- **Winnie Von Werne** of Lorelei Personnel, Inc.

- **Lucille Whitaker** of The Art Institute of California, San Francisco

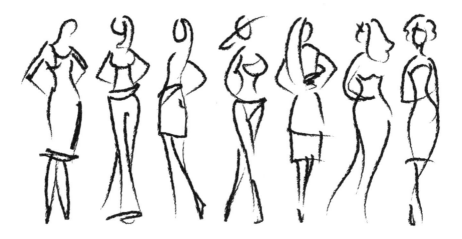

Contents

1. Introduction

Welcome to the world of fashion design! As a fashion designer, you will have an interesting and exciting career — one that many people only dream about. You will know months in advance what people all over the world will be clamoring to wear, and it may very well be your clothing that they are after.

Fashion designers inspire the way people all over the world look and feel about themselves. For centuries fashion design has touched almost everyone in some way, affecting the way ordinary people live their lives and shaping their very culture. From the caveman days of fur and leather to today's stiletto Jimmy Choos and designer sweatpants, what we wear says a lot about who we are.

In this field, there is a long history of ordinary people rising from humble beginnings to become outstanding success stories. For example,

designer Laura Ashley got her start as a secretary. Vera Wang began designing when she became engaged at age 39 and couldn't find a suitable wedding gown for the mature first bride. Miuccia Prada was studying theatrical mime when she decided to take over the family handbag business. Ralph Lauren was born into a middle-class family who lived in the Bronx, and used to buy suits with his pocket money at age 12. He is now one of the richest and most famous designers in the world.

Of course, it takes hard work, creativity and a true passion for fabulous clothes to achieve greatness as a fashion designer, but choosing this book is an important step in the right direction.

1.1 What a Fashion Designer Does

As a fashion designer, you will use your sense of style and flair for the original to design clothing and accessories for production and sale. Fashion designers conceive new looks for the items we wear, and then make their ideas real. Every piece of clothing in your closet, from your businesswear to your underwear, was invented by a fashion designer somewhere. They saw a need for that item, and so did you.

Designers are generally expected to come up with a collection of clothing for each season. Collections tend to feature variations on a theme and are usually created about two seasons ahead of time.

Fashion designers may choose to specialize in a type of clothing — for example, children's clothing, women's sportswear, or men's formalwear. You could also specialize in only one of the steps in fashion design, such as patternmaking, sewing samples, or trendspotting.

Fashion designers are involved not only with the creative process but also with the practical concerns of manufacturing and marketing apparel. They must understand the practical process of transforming an apparel concept into a tangible garment. As a fashion designer, you might spend your day:

- Browsing fashion magazines and websites for inspiration

- Shopping for new fabrics and accessories

- Meeting with clients to measure and discuss one-off projects

- Sketching ideas in a journal

- Creating patterns for various sizes by hand or with computer-aided design (CAD)

- Creating samples of your designs by sewing or having them assembled

- Meeting with sales reps or your manufacturer

- Promoting yourself and your designs to potential clients

Fashion designers will work flexible, but often long hours, in a creative and dynamic industry. They may find motivation in striving towards being the next Versace or Donna Karan, or simply working at something they love.

1.2 Benefits of a Fashion Design Career

There are many great things about being a fashion designer. While most people are attracted to the creative aspects of the job, there are also practical benefits that add to the appeal of creating fashion for a living.

Lots of Options

As a fashion designer, there are multiple career paths for you to choose from. Some designers work for top design houses such as Ralph Lauren and Chanel. Others are employed by mass-market manufacturers of men's, women's and children's apparel. Still others strike out on their own, establishing a distinctive style and overseeing fashion creation from initial concept to manufacturing and merchandising.

About a third of all fashion designers are self-employed. That third covers not only designers at the very top of the trade but also those who run their own private-label boutiques in cities and towns around the U.S. and Canada.

Job Stability

Clothing is a basic necessity, which means that there will always be a market for clothes. The U.S. Bureau of Labor Statistics estimates that employment for fashion designers will remain relatively stable through 2012. Although the clothing industry is experiencing a slowdown in the manufacturing end of things (due to a sluggish economy and the outsourcing of manufacturing to overseas companies), there is an increasing number of job opportunities for designers that will accommodate new people coming into the field.

In 2001 apparel logged $182 billion in retail sales, according to the U.S. Department of Commerce. According to the U.S. Census Bureau's Service Sector Statistics, cumulative total annual retail sales of clothing and accessory stores, including family, men's, women's, shoe, and jewelry outlets, reached more than $142 billion (unadjusted) in April 2004. These statistics support the idea that the apparel and accessories marketplace should continue to offer opportunities for fashion designers.

Earning Potential

Entry-level clothing designers in the United States make anywhere from $20,000 to $25,000 per year — admittedly not that great, but everyone's got to pay their dues. A median salary for experienced designers is about $50,000 per year, and designers for large companies, or with their own popular line of clothing, can expect to make upwards of $100,000 per year. Of course, if you decide to go into business for yourself, the earning potential will be virtually limitless.

Personal Satisfaction

Every designer interviewed for this book – regardless of experience level – was filled with a passion for the business. Making lots of money is nice, but you'll never really enjoy it unless you love what you do. Fashion design is a creative and challenging career.

Chances are, you won't ever be bored as a fashion designer. There are always new trends to follow and unusual ideas to pursue. You will also have the satisfaction of seeing your projects completed on a frequent basis, and creating products that make people feel good about themselves.

Recognition

If you like to be recognized for your achievements, then this is the career for you. You may have noticed that during the Academy Awards, the announcers often talk more about what the stars are wearing and who the designers are than about the celebrities themselves. Who doesn't like to be recognized for their hard work? A successful fashion designer can get used to this kind of attention.

Independence and Flexibility

If you're starting up your own business, then you may choose to work in your pajamas at night, or whenever or however you'd prefer. The fashion industry traditionally employs creative, open-minded people, so you are more likely to have a flexible work environment and creative, interesting supervisors than in many other types of jobs.

You Can Start Now

It is possible to become a fashion designer whether you have a formal design education or just a talent for design (and both options are explored in this guide). A degree can be very helpful in landing a job in the industry; however, some of today's top designers do not have a formal education. While you will probably want to continue learning about fashion throughout your career, you don't have to wait to begin.

These are just some of the many benefits of working in this exciting field. If they sound like a good fit for you, read on to find out how to get started!

1.3 Inside This Guide

The *FabJob Guide to Become a Fashion Designer* is arranged to take you through the process of either getting a job as a fashion designer or starting your own fashion design business. It incorporates insider tips and advice from more than 15 industry experts, including successful fashion designers, employment agencies, and fashion educators.

Chapter 2 ("A Look at Fashion and Design") is your introduction to the world of fashion and design. You'll learn about some of the key players in the industry, why people buy certain products, and why certain ideas

sell. This chapter will also walk you through the process of designing a garment, step-by-step, from concept to finished product.

Chapter 3 ("Developing Your Skills") gives a variety of options for learning about design and becoming a skilled designer. You'll find out what talents employers are looking for in this industry, and find out about formal educational programs as well as opportunities for self-study. In this chapter you'll get tips for learning hands-on skills such as sewing and drawing, as well as how to develop your creativity and ability to forecast fashion trends.

In chapter 4 ("Getting Hired"), you will discover who hires fashion designers, what positions and salaries are available, how to find out about job openings, how to prepare a portfolio and resume, and how to do well in an interview.

Chapter 5 ("Starting Your Own Business") takes you through the steps involved in setting yourself up in business as an independent designer. Whether you want to sell your designs to individual clients or to stores, we'll advise you on how to develop a business plan, evaluate your costs, get startup funding, set up your workspace, get your supplies together, and fill orders for your designs.

Chapter 6 ("Marketing Your Designs") will tell you where and how to sell your designs. You'll learn how to reach your target market, what promotional tools you need, and the techniques you'll use to make everybody want to be seen in your clothing.

Finally, chapter 7 ("The Road to Success") contains a variety of success stories to inspire and inform you about career paths others have taken. The book is rounded out with a selection of resources for further study, and for keeping up with the ever-changing world of fashion.

When you are finished with this guide you will know what steps to take next and where to go from there. By applying what you learn here, it's just a matter of time before you'll be where you want to be… in an exciting career as a fashion designer!

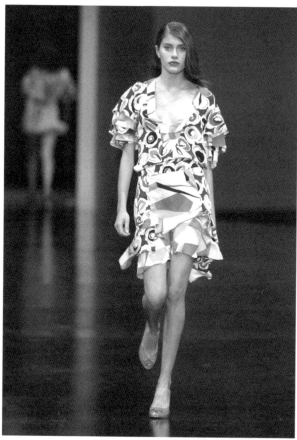

Design by Louis de Gama
Photo by Rui Vasco, courtesy, Moda Lisboa

2. A Look at Fashion and Design

This chapter starts with a look at the world of fashion, to give you an understanding of the industry. Fashion has always been cyclical, so if you know where fashion has been, you'll be better able to predict where it will go.

This chapter will also walk you through creating a garment step-by-step, from concept to sewing on the tag. Even if you plan on hiring a manufacturer, this information will help you understand how the process works, so you can alter your designs with manufacturing or assembly in mind.

2.1 What is Fashion?

Since prehistoric times, human beings have clothed their bodies for protection from the elements. Even today, it is probably the most practical reason for wearing clothes. You wear shoes to protect your feet, coats to keep warm and hats to shield yourself from the sun.

There is more at work, though, in what we choose to wear than simply protection from the environment. One of the main things that influence the average fashion decision is communicating and reflecting the complex levels of who we are, how we perceive ourselves, and who we want to be.

2.1.1 Why We Buy

As a future fashion designer, it is important to know why people buy certain types or brands of clothing if you want to influence them to buy yours. Here are some of the reasons we come home with bagfuls of the latest fashions.

Our Emotional State

When you look good, you feel good! One reason people buy brand-new outfits for important occasions is for a higher level of confidence regarding their appearance. What you are wearing can also reflect your current mood or state of mind. People who are happy and feeling optimistic might choose bright colors and wear something that says "Look at me!" but someone who is feeling blue will probably opt for a subtle outfit that is unlikely to attract attention.

Cultural Identity

Where you're from and what religion you practice can shape the way you dress. Some religions require that women dress modestly and cover their heads with scarves. Some cultures may traditionally dress in bright colors and light fabrics or wear a certain style of body jewelry. People who have spent time in a particular culture may retain those style preferences even if they are no longer in the country where the styles are popular.

Social Standing

You wouldn't expect to see a politician's wife sporting a nose ring and wearing a leather biker jacket. Neither are you likely to see a middle-class housewife wearing Prada to the grocery store. Your image in society and where you are on the economic ladder are both factors that will sway your decisions at the shopping mall.

Our Careers

Police officers, nurses and waitresses wear uniforms, but all career clothing is a "uniform" of sorts: lawyers wear suits, and rock stars wear outrageous outfits. Office workers might dress in a business-casual style, while telecommuters may own a nice selection of sweatpants and pajamas. What you do for a living and where you do it will clearly affect the way you dress for eight hours each day.

Who We Want to Be

There comes a time in everyone's life when they look back and say "What was I thinking!" Were fads like rainbow suspenders, leg warmers and ripped-up jeans really a good idea? Who cares! They were hip at the time, and especially when you are young, you are liable to follow any fashion trend as long as it is popular with peers you admire and want to be like.

These days, celebrity images in the mass media influence consumer buying habits and exploit a consumer's interest in staying on top of popular-culture trends.

"All fashion business is built around celebrity," says Stan Herman, president of the Council of Fashion Designers of America. He cites the recent phenomenon of the celebrity-designer: in 1998, hip-hop musician Sean "P. Diddy" Combs launched his Sean John line of urban-oriented sportswear.

Fashion itself has also crossed genres in recent years: in 2000, hip-hop clothing label FUBU launched FUBU Records, a joint venture with Universal Records.

2.1.2 The Cycle of Fashion History

As a fashion designer, it is useful to have an understanding of the fashions that have taken the world by storm, particularly during the past century. You'll find that, given long enough, most styles come back into fashion before long, and it's important to recognize these trends early to stay ahead of the competition.

Take a look at some of the trends of 20th century fashion that have influenced what we wear today:

Fashion Trends

1900s In London, Edward VII, too fat to close the bottom button of his vest, leaves it open, starting a men's fashion practice that persists to this day.

1910s In Paris, Coco Chanel opens a millinery (hat shop) catering to society women. Her simple hats lead to a revolution in women's clothing, from form-fitting couture to relaxed and casual.

1960s Designer Mary Quant invents the miniskirt; Twiggy becomes the first mini-model.

1970s John T. Molloy publishes "Dress for Success," prescribing that people dress for the job they want, not the one they have.

1980s In New York, Brooke Shields' Calvin Klein ads lend momentum to designer jeans.

1990s Body piercing, a favorite of punk and Gothic fashion since the early 80s, goes mainstream.

For a detailed look at 20th century fashion trends decade by decade (from 1900 to the 1970s), you can visit the fashion history pages at the Vintage Vixen Clothing Co. website at **www.vintagevixen.com/fashion history.asp**.

2.1.3 Fashion Categories

There are a variety of categories of fashion listed below, based loosely on how much the consumer pays for the items, and how their worth is perceived. You can start your fashion career right now by thinking about which of these types interests you, so when you look for work or plan your own business you can focus your efforts accordingly.

The haute couture category is strictly custom-made, as would be any custom designs from independent designers, while the rest of the categories are known as *prêt-à-porter*, which is French for ready-to-wear. These fashions come in standard sizes so they are less expensive and can be produced in larger quantities.

> **TIP:** Even if you custom design fashions, you cannot call your designs *haute couture*, because that designation can only be used by the design houses that currently meet the strict standards of the Syndicale Chamber for Haute Couture in Paris (see section 4.1.1 for a list of them).

Haute Couture

Translated from French, *haute* means high while *couture* means sewing or dress-making. Haute couture fashions are custom-made for individuals. Prices are expensive (a suit may be $20,000 and an evening gown $60,000) so these fashions are normally only seen on the fashion show runway or the very wealthy. While relatively few haute couture garments are made, they inspire the design industry on a whole.

Designer

This is the most expensive ready-to-wear apparel that's sold from houses like Chanel, Donna Karan and Armani. Like haute couture, you'll see designer fashions on the fashion show runways. Designer clothes are normally sold by wholesale to a retailer such as a boutique or department store, where they are purchased by wealthy people.

Bridge

These are the lines that cost more than the Better category (see below), but less than the Designer category. They typically include a designer's

less expensive lines, also known as diffusion lines, like Armani X and DKNY, or those brands that fall between designer and better, like Ellen Tracy and Adrienne Vittadini.

Better

Better lines are nationally known brands that cost more than average but less than Designer or Bridge. Liz Claiborne, Jones New York, and Anne Klein are all examples of the Better category. Private-label merchandise that carries a retailer's name or unique line, such as Nordstrom's Talbots or JC Penney's Worthington apparel also falls into this category.

Moderate

Moderate lines are reasonably priced lines sold by many nationally known sportswear brands like Dockers, Levis, and Guess?, and by other companies that also make Better lines. Some private-label merchandise qualifies as Moderate, including Macy's Charter Club and JC Penney's St. John's Bay lines.

Budget or Mass

This is the least expensive of the wholesale price zones and is usually sold by mass merchandisers and by discount stores. Private-label merchandise sold in this price range includes Wal-Mart's Kathie Lee and Kmart's Jaclyn Smith lines. Because this is the area of greatest production, the Budget or Mass category employs the greatest number of fashion designers, and so is a good place to find work.

Custom

This distinction covers any clothing that is made one-at-a-time for clients by independent designers who are not haute couture houses. The price range for custom designs varies, but is usually at the high end because of the time it takes to conceive and assemble a one-off design.

2.1.4 Fashion Centers

Fashion centers are the hot cities for fashion design. They are home to the world's leading design houses, and places where the latest fashions turn up on runways during the city's fashion week.

For many years, Paris was the world's leading fashion center. Stan Herman, president of the Council of Fashion Designers of America, describes Paris as fashion's "think tank," but says that it no longer holds the monopoly on the industry that it once did. These days, there are just as many French designers working in New York as there are American designers working in Paris. Europe's other great fashion center (Milan, Italy) continues to have a reputation for "knowing how to make clothing people like to wear," says Herman.

New York is another worldwide leader in the fashion industry, and un-questionably the top fashion center in North America. Los Angeles is now seen as America's second leading fashion center. In the U.S., At-lanta, Chicago and San Francisco are what Herman calls satellite mar-kets, while smaller markets are located in such cities as Charlotte and Seattle.

Canada's top cities for fashion are Toronto, Montreal and Vancouver. Other hot spots for fashion throughout the world include London, Sydney, Sao Paolo, and Hong Kong.

While most of the top designers work in one of these cities, fashion designers also work in hundreds of other cities throughout North America and the rest of the world. If you love fashion and don't want to move, you might start a fashion design business in your town or city.

2.2 Designers You Should Know

Any list of who's who in the fashion world will necessarily be subjective. It's like asking, "What's the best movie ever made?" The answer will, of course, depend on who you ask. Still, it's important to be aware of some of the giants in the industry.

If you are applying for jobs, employers will expect you to be familiar with top designers, and if you start your own design business you can learn from their success. Following are some of the trendsetters who have influenced fashion in a big way.

Giorgio Armani

Italian-born Giorgio Armani got his start in fashion as a window dresser at an Italian department store. He started his own freelance design busi-

ness in 1970 and established a menswear line in 1974. He added a line for women a year later.

Richard Gere wore Armani's clothing line in the movie *American Gigolo*, and Armani has been dressing celebrities ever since. His deconstruction of the jacket in the 1970s and the resulting easy-to-wear yet luxurious pieces for men and women are his trademarks. According to Forbes magazine, Armani is the world's wealthiest designer, and he is also intimately involved in his privately held business.

Tom Ford

Many people consider Tom Ford the most influential fashion designer in recent history. He was born in Texas in 1962, and moved to New York as a teenager with design on the mind. He joined Gucci in 1990, and turned their business around with his sleek, glamorous designs — he then did the same for Yves St. Laurent when Gucci took control of them.

In addition to designing clothing, Ford has had a controlling hand in developing controversial yet effective ad campaigns. He publicly credits his success to his personal energy and a secret of sleeping only three hours a night. In April 2004 he parted ways with Gucci, and is currently unaffiliated with any haute couture houses.

Tommy Hilfiger

Tommy Hilfiger started selling clothes in 1969 — he would drive to New York City to buy bellbottom pants, and then back to his hometown near Cornell University to sell them to eager students. He opened ten retail stores in upstate New York before moving to the Big Apple, where he found investors to back his design business. His clean preppy designs for men were popular even before rapper Snoop Dogg wore them on *Saturday Night Live* in 1994.

From there, the Hilfiger line became baggier and street-wise, and grew to encompass designs for women's and children's wear, as well as other "lifestyle items" like sunglasses and furniture. Tommy Hilfiger designs are self-described as "traditional, with a twist" and "for the people," and the company has partnered in this decade with icons such as the Rolling Stones and Britney Spears.

Donna Karan

As the daughter of a tailor and a model, Donna Karan is a designer with fashion in her blood. After graduating from the Parson's School of Design, she had early success in her career as a designer for Anne Klein.

In 1985, she started her own company and hit the big time with her Essentials line — seven pieces of clothing that every woman should have in her wardrobe. Today, the Essentials line includes almost 200 coordinates, and Karan's bridge collection, DKNY, is sold in major department stores worldwide.

Calvin Klein

Even people with no interest in fashion know the name of Calvin Klein. A former student of New York's famous Fashion Institute of Technology, Klein brought designer jeans to the masses and took the idea of using sex to sell products to new, controversial levels. Among his peers, he is respected for his minimal-chic designs and has influenced the works of such designers as Miuccia Prada and Donna Karan.

Coco Chanel: Fashion Legend

Gabrielle "Coco" Chanel got her start in the fashion industry in the 1900s. Often called the 20th century's single most important arbiter of fashion, Chanel's contributions to the wardrobes of generations of women include jersey suits and dresses, the draped turban, the chemise, pleated skirts, the jumper, turtleneck sweaters, the cardigan jacket, the blazer and her signature, "the little black dress."

Coco herself was seen in Venice wearing bell-bottomed trousers and started the "pants revolution" for women. Chanel also designed stage costumes for such plays as "Antigone" and "Oedipus Rex." In 1922, Chanel introduced a perfume, Chanel No. 5, that remains popular today. It was the first perfume to bear a designer's name.

Ralph Lauren

Founder of the Polo line of clothing, Ralph Lauren got his start designing ties in the 1960s. He favored a wide tie; his client, Bloomingdale's department store, did not. Lauren stuck to his vision and eventually Bloomingdale's and many other stores were buying his wide ties.

Ralph Lauren became synonymous with classic, sophisticated shirts and suits, and sold an image of wealth and taste with every item of clothing. His line has expanded to include women's clothing, fragrances, and home furnishings; a staggering innovation in the 1980s, though nothing new today.

Miuccia Prada

The Prada company started making handbags in 1913, but it owes its current popularity to Miuccia Prada, the granddaughter of the founder, who reluctantly took creative control in 1978. Miuccia Prada is known for combining unusual materials in unconventional ways, and putting out products that look simple, but are exquisitely crafted and wear well. Prada purses are simple, understated, and admired by those who know them —they are currently a "must-have" for celebrities and models.

Although originally Prada was a name for leather handbags only, this designer line now includes shoes and women's and men's apparel.

Oscar de la Renta

A native of the Dominican Republic, Oscar de la Renta started his professional life in the world of fine art, and left home at the age of 18 to pursue painting in Spain. Eventually, his interest in sketching steered him toward fashion, and he ended up in New York, where he designed the couture collection for Elizabeth Arden in 1963. He launched his own line of ready-to-wear apparel two years later.

Since then, his name has been on everything from perfumes to Barbie dolls to fine china. His diverse talent sparked the trend-setting gypsy and Russian styles of the '70s. His flouncy, Latin-inspired skirts have been worn by everyone from Jackie Kennedy to Sarah Jessica Parker.

Other Designers

The list above is just a starting point, and you should be familiar with a variety of fashion trendsetters in addition to those listed above. Websites can be a good starting point to research particular designers. About.com has information about "Designers A-Z" at **http://fashion.about.com/od/designersaz**. Profiles and biographies of fashion designers can be found at **www.infomat.com/whoswho/index.html**.

2.3 How to Design a Garment

Now that you know a bit about the fashion industry, let's look at the design process that takes place within it. In this section, we'll walk you through creating a garment, from inspiration to final product.

If you work for individual clients, you may design one garment at a time, or possibly a few pieces that will make up a significant part of a client's wardrobe. However, in the garment manufacturing industry, most of the time you will be designing not just one garment, but a collection that will be sold and delivered as part of a season. This chapter will lead you through the process for both types of design.

Remember, though, that this guide should not be your one-and-only source for learning how to make clothing. You will want to pursue some of the training explained in chapter 3, either as self-study or formally, since fashion design is a hands-on trade you'll need to practice on your own. Let's get to work!

2.3.1 Define Your Idea

Before you start working on a particular design, you need to decide where you are headed with it, at least generally. If you are working for a client, you will base your design on their input. If you are working on clothing you plan to sell to manufacturers or boutiques, you will consider these answers in relation to the market you hope to reach with your designs, and how it fits into your collection. You will need to ask the client or yourself the following:

- What is the purpose of this garment?

- Who will wear this garment?

- What unique style will you give it?

- What is the budget and timeline?

Purpose of the Garment

The purpose of the garment will affect the design. Rarely would you see a running pant or ski pant with a dramatically flared leg, just as it would be impractical to have a wool overcoat with a waistline so fitted that you couldn't wear a warm sweater as a first layer.

What is most important about your design? You'll need to set priorities. Consider durability, quality, mass-production, and individuality. For example, your client or intended market might value uniqueness and individuality over practicality, so you could work with an expensive, delicate material. The purpose of a garment is widely varied, from loungewear to outerwear, clothes for parties and clothes for poolside. Section 6.1 goes into more detail about the various subcategories of clothing you might choose to specialize in.

In couture or individual dressmaking, it never hurts to ask a client what they hope you'll create, and doing so can eliminate a lot of confusion. If your client envisions a dress resembling Audrey Hepburn's in *Breakfast at Tiffany's*, she's not going to be terribly pleased if you design an equally lovely outfit that resembles Catherine Zeta-Jones' costumes in *Chicago*.

Who Will Wear the Garment

The end user affects the design as well. For example, women's trousers may have either a fly front, or a zipper at the side or back to allow for a smooth, flat front. On the other hand, men's pants for obvious reasons should always have a fly front. Infants' clothing has a separate set of requirements; for example, clothing for kids under two years of age should make allowances for diapers and easy changing.

If you are producing this garment to sell to retailers, you will want to determine the main market for this garment. Is it for men, women, or children? Many designers automatically turn to women's wear, but remember that men's wear is a rapidly growing market, with many men becoming as fashion-conscious as women. And of course as long as people keep having babies there will be a need for well-designed children's clothing.

Giulietta Graci says that it's important to keep your target audience in mind when creating a design. "If you're creating a dress for an 18-year-old, you have to think young, sexy, and fitted," she says. "But if you're creating a fashion for a 40-year-old, you have to make it more classic."

Choose a Style

It's important to remain true to your personal tastes. After all, one of the reasons that designing is such a "fab" job is that you get paid to express your creative style! But remember to consider marketability as well. If your personal style is highly unusual, you might be limiting your market to the small group of people who "get" what you are trying to achieve. And remember, ultimately the goal of each garment is to sell.

It never works to be all things to all people. Develop your style, whether sporty, classic, elegant or sophisticated. Try to decide what sort of look your designs should project and then be consistent, regardless of the type of garment you're working on.

Sometimes ideas seem to come out of nowhere. You'll notice them occupying a place in your mind as firmly as if they had been there all along. Or sometimes you might think you are blank for inspiration, and only when you allow yourself to start drawing do the ideas start to flow.

More often, ideas result from a film you saw or a friend's great new outfit, a visit to the art gallery or a secondhand store. A vintage tea cup, colored robin's egg blue with chocolate stripes, might inspire an aqua dress with brown piping. As you walk through the woods and your feet stir up a pile of dead leaves, you might be reminded of the rustle of a taffeta evening gown. A fabric print design might have its origins in a piece of gift wrap you see in a shop, or in a length of wallpaper in an old house.

Anything can inspire a fashion concept, whether it relates to color, texture, pattern, or silhouette. And as with most things, the imagination gets stronger with practice. As you begin to think more about clothing design, you'll find yourself discovering ideas in unexpected new places. Chapter 3 ("Developing Your Skills") gets into more detail on developing your creativity and finding inspiration in the fashion world.

A very important part of defining the style is the silhouette or cut you have in mind. Cuts may vary from form-fitting to concealing, slim-fit to baggy,

and can vary even more when dealing with specialty clothing, such as "big and tall" menswear or maternity fashions. A fashion silhouette can resemble the flapper dresses of the 1920s or the full skirts and short jackets of the 1950s. The nature of fashion is that most silhouettes will come around again and again, with a new twist featured in each incarnation to make it current.

The shape of the person you are designing for will influence the silhouette. Not all women look like runway models; there are even 18-year-olds with figures that need the help of some flattering style lines. Your garment might need to draw attention away from large hips, or you might want to enhance a flatter chest by soft gathers through the bust. Women with a thick waistline might want attention drawn to some other part of the body. A great book for learning about the art of flattering different figure types is Mary Duffy's *H-O-A-X Fashion Formula*, which offers a clear method of identifying a woman's figure based on the letters H, O, A, and X, and learning to dress her type.

The chosen cut of a garment will vary not only according to the age group and shape of your market, but with the dominant trends as shown on each current season's fashion catwalk. If your design style is classic, such fads will have minimal influence, but if you're attempting to design a truly fashionable product it will be important to keep abreast of trends.

Budget and Timeline

Your couture client will probably have a price in mind, which will affect the types of materials you might choose and the intricacies of details you plan to add. For mass production, your budget will depend on what the market will bear — how much the final consumer is prepared to spend on your design. Section 5.6.3 will give you information about how to figure out what this price might be.

Also, you'll need to know if the finished garments are meant to be worn this summer or next winter. The intended season will affect choices in fabric weights and probably colors, and will influence the demand for short sleeves or long. You'll need to know how soon you'll have to produce your sketches and samples in order to deliver your collection at the right time of year. For a detailed timeline of the fashion production cycle, see section 5.6.

2.3.2 Choose the Materials

Once you've defined the garment, you need to determine the materials to be used. The process can often work backwards, too. You don't always go looking for a fabric to suit one single design sketch. Quite often you need to design a collection, and you fall in love with a fabric that inspires four to eight individual pieces, or more.

When thinking about creating a line, you can't just think of how one piece works with your customer but rather how multiple pieces work together. Your goal is to sell all of the pieces in your collection, so you have to give your customer a reason to invest in the entire line.

If you work in couture, a client might have material already secured and request that you design something to be made from it. Other times they might simply have a fabric in mind as a preference.

The Fabric

Choosing the appropriate fabric for any given garment is the single most important design decision you can make. Working with the right fabric will make the design process much easier; the styles will often suggest themselves as soon as you see and handle the fabric. The point being, says Giulietta Graci, "If you have the right fabric, the line will sell itself."

Matching styles to appropriate fabrics will often be an obvious choice. Anything worn as a first layer next to the skin will sell better if it feels soft and silky. You probably wouldn't choose a tweed for lingerie, anymore than you would design a business suit in satin. It might seem difficult to imagine a raincoat in a summery daisy print, and a light, gauzy fabric is unlikely to work for an extremely tailored dress. Garments that carry a high price tag, such as wool coats, tend to do better in neutral colors and solid fabrics that won't date or limit their wearability. Bright colors for children's wear generally sell better than black.

But remember that every rule can be bent or broken. This is especially true in the world of fashion. Once you understand the elements of design, you will enjoy experimenting with the creative process and stretching the boundaries of fabrics. That's how designers come up with such attention-getting surprises as evening gowns done in camouflage prints!

Cost will also likely be a factor in the material you choose. If your goal is to produce as many copies of your design as possible, you may opt for a less-expensive fabric in order to make the finished garments widely affordable.

As you begin to work with textiles, you'll be amazed to see how differently various types of fabric perform. Matching a fabric to its purpose is a simple matter of comparing its proposed use to the fabric's characteristics. In general, knit fabrics are more clingy and have greater stretch — these lend themselves to body-conscious garments, intimate apparel and active sportswear, although higher-end knit constructions can also make beautiful dresses and skirts. Woven fabrics have more stability, although many are now being made with spandex yarns for built-in stretch.

Imagine how the fabric you choose will lay on the body. A fabric that crinkles or pleats, for example, can create texture and shadows that affect the tone and shade of the color in sections of the fabric. Wool, silk, linen, and other natural fibers are classics that will always suggest quality. Technology has also resulted in some luxurious and high-performance synthetic fabrics.

As a fashion designer, it's important to know as much as possible about the characteristics of common fabrics so that you can make informed decisions when purchasing your materials. If you are not already familiar with the qualities and characteristics of common fabrics, you'll need to study up. More tips and resources for working with textiles will be provided in chapter 3 ("Developing Your Skills").

Color and Pattern

Color and pattern is the "message" of your fabric. As a designer, you should always know the "in" colors and patterns. Many top designers even consult color forecasters to stay ahead of the trends. Fashionistas will take consumers by surprise, suddenly deciding that brown is the new black, or that plum is the new navy. Pastels tend to come and go, and neon shades are usually a sign of a passing fad. Pay attention. You would be better off not trying to sell a collection of hot, tropical limes and fuchsias if the design divas have clothed their models in six shades of sand and decided that brights are passé this season.

Of course, there are those colors that never really go out of style. Black is for any occasion and any time of day and white is a classic for summer. Navy, grey and various shades of khaki, beige and tan make up the neutral palettes that rarely date themselves.

Certain kinds of color will automatically suggest a quality or mood to the garment. Navy, grey and burgundy combinations tend to be classics for school uniforms or business attire. They suggest reliability and seriousness. Lavender, rose and powder blue are feminine, quiet and non-threatening. Brights such as lemon yellow and turquoise tend to be cheerful or playful, while brown is earthy and trustworthy, or sometimes sophisticated in velvet or silk for eveningwear.

You should also consider what customers are likely to buy over what your personal preferences might be. Many people have a desired "palette" or range of colors to match their skin tone. An earth-tone palette, for example, would include browns, mossy greens and neutrals like beige or wheat, while a tropical palette might include bright turquoise, hot pink and lime green.

"Women like to match clothing to their hair, eyes, and complexion," says Graci. It's important to balance your collection with a selection, so that something is sure to appeal to every buyer, but be careful not to offer so many choices that you end up having to buy small amounts of many different colors of fabric, which can become costly.

When you choose a fabric color, think about how it will relate to other colors in other fabrics in your collection. Envision how your line will look in an agent's showroom with all the various pieces hanging together. There should be some harmony within each collection. You can test this by playing with small swatches of potential fabrics and deciding which ones you like together. You might also go to a paint store to get paint chips and move them around in order to see how different colors work together.

Have fun with color. Break rules. A sleeveless black shirt looks great with a summer tan (or fake tan!) and warm winter white can look wonderful on a dreary grey day. Pink and green can not only "be seen" together, they can look fantastic. The trick is to combine similar color values — for example, a hot pink with a bright green would in most cases look better than a muted dusty rose with an intense kelly green.

A talented designer will often be able to pull off the unexpected. Trust your instincts. If you're uncertain about something, let it sit for a day or two. Come back to it before making your final decision.

The same applies to mixing patterns, which are any details that break up a solid color. A pattern can be stripes, checks or plaids, or it could be a surface print of paisleys, florals or polka dots. Sometimes the pattern will actually sit on the surface of the fabric, as with embroidery. And the pattern can be subtle, with the design element done in the same color or nearly the same color as the base fabric. This results in more surface texture than visible pattern.

It might seem a strange concept to combine polka dots, stripes and plaids within the same garment, yet some very high-end international designers have done this successfully. Missoni's signature style for years has been a brilliant mixing of patterns and textures. Study the work of different designers who do this, and consider what makes it effective. You'll probably find that the key is balancing the proportions and the rhythm of the various patterns, and matching the intensity of colors.

When considering a large pattern, you need to visualize how it will look when it's a finished garment. This can be difficult to do when you're looking at a length of fabric. But some bold florals or over-sized plaids will look odd on a small garment, such as a tank top or a pair of shorts or a baby's dress.

It helps to make a "window" out of manila or some other kind of stiff paper. Draw a rough, actual-sized silhouette of the garment. You don't need to think about details here, just draw the sleeve and body shape, roughly the same size they would appear as a finished garment. Cut this shape out so you're looking through a "window" in the manila. You can then put this in front of the length of fabric, so the fabric fills the window, to get an idea of how that scale of pattern will work with your intended garment.

Other Materials

Design decisions don't stop with the main fabrics. You'll have to consider linings, trims (braid, lace, ribbon) and notions. Should the garment close with toggles, buttons or snaps? Snaps are generally more casual

and are often ideal for children's wear. Buttons and snaps both come in many materials, endless designs and a range of sizes.

For some styles a zipper will be the obvious choice, but zippers also come in many varieties. It's the designer's job not only to decide how all these things should look, but where in the garment they should be placed. Some other raw materials, or "findings" to consider, will be:

Elastics: Decide on the location in the garment, the width, the color and construction — braided, knit, woven or rubber. Elastic is most commonly used in the waistband of a garment, but sometimes only in the back waist to allow for a flat front. It's also used in the sleeves of some parkas and occasionally on a blouse. Rubber elastic is usually used in the legs of swimsuits because it's more chlorine resistant. And soft, narrow elastics are sewn throughout lingerie to provide fit and comfort.

Shoulder pads: Often in coats and blazers, but depending on the trend of the day they can be used in blouses and dresses, and even T-shirts (in the 80s, thanks to the TV show *Dynasty*).

Drawcords: At waists and/or hoods to cinch the fabric tighter around the body.

Sequins or appliqués: Purely decorative to dress up an area of a simple garment.

Buckles: If your garment comes with its own belt.

Adjusters: In varying sizes and constructions for reducing the length of belts, shoulder straps, etc.

Rivets: Often used to reinforce pockets on jeans.

Eyelets: This is a metal rim that finishes an intentional hole in fabric, for inserting drawcords and laces, or for venting under the arms.

Labels:	Commonly placed at the back neck or waist of a garment. You'll want a label with your design name so happy customers will know who to thank for their garment, and where to find more styles that suit them. That same label or a separate label should indicate the garment's size, and another label will have to have fabric content information and care instructions. Many countries also require that you state where the garment was made. See section 5.5.3 for more information about label requirements.

2.3.3 Sketch Your Design

Once you've determined the materials to be used and the needs your design will fulfill, you can move on to the fun part of the job — using your imagination.

Your initial sketch can be rough, as long as it's detailed enough to generate the pattern and first sample. In the ready-to-wear business a wholesale buyer will make purchasing decisions based on seeing and handling your final sample, so the purpose of your sketch will be to communicate information to make a sample, not to secure a sale.

In couture and dressmaking, you will take time later to do a more detailed sketch with color. This will help sell your idea to the client, so you don't go to the expense of making a sample.

TIP:	The creative process is an important step in developing a new design, and it should be undertaken with fresh energy. Don't try to work when you are tired from a long day. If you wait until you've had a chance to rest and rejuvenate yourself, you will produce better results.

Do an Initial Sketch

Your initial sketch should indicate the garment's length and show the basic shape, but it doesn't have to be on a human figure. It should not be colored; a line drawing will show the clearest detail.

Have a few garments hanging in front of you when you start to sketch, so you can really study them to see what a shirt collar actually looks like, or which direction the darts point on a blouse.

This sketching process should be quick. Turn off your internal editor and let your hand do what it wants to. Feel free to be sloppy. Make mistakes. Scribble things out and start over. Experiment with different design details until you have four to six variations of the same style.

Then choose the one you like the most. Do a tidy, clear drawing with all points confirmed, using a translucent paper if necessary to trace over the best shape. Make the drawing large enough for a lot of notes and detail — it should take up at least half of a letter-sized page. Show if it's fitted at the waist, indicate the length of the hem and sleeve, type of collar, pocket construction and position, sleeve style, closure, etc. Include a back view and as many written notes as you need to communicate fullness and other details.

Once the silhouette details are working, consider your other design elements. These details contribute to the overall quality and comfort of a garment. Your preferences can be noted beside the sketch:

- What sort of closure should this garment have: buttons, snaps, a zipper?

- Does it need any lace or braid?

- Will it require a logo or other design embroidered or screen printed somewhere?

- What about stitch details? Consider double-needle, single-needle, contrast, or edgestitching.

- How will the seams be treated? Professionally made garments don't leave the seam allowance as a raw edge, and most mass-produced garments have serged seams, although there are other ways to finish seams.

Include as much detail as you can. Don't leave anything to guesswork, especially if your pattern or first sample is being sewn by someone else. The more information you give them about what you have in mind, the less likely you are to be disappointed when they are forced to make design decisions of their own.

If you're hoping to sell a collection of separates to a boutique or department store, repeat the initial sketching process until you have a few pieces

that work together, can be mixed and matched and merchandised together. For a basic women's career collection you might have three or four tops, pants, a skirt, a dress and a jacket. These can either be in the same fabric or can share fabric combinations (i.e. the pant, skirt and jacket can be in one fabric, with the tops and dress in a coordinating fabric.)

Of course, if you're hoping to sell your design on the strength of a drawing, you'll want to make it more polished. Even so, it helps to have worked out the style lines and details for your designs first by the quick, freestyle sketching process described above. Then you move on to a colored, professional-looking drawing.

Fashion Illustration

A professional fashion illustration can be shown to your couture client to get feedback on the ideas they like. If you are mass-producing your garment, you will skip this step and make a line plan instead (we'll cover that next).

To begin, use a pencil to draw two figures side by side of the type of body for which you are designing the clothes (man, woman, or child). Keep in mind that a pose, such as standing with one hand on a hip or with one foot in front of the other, will be more interesting to work with and will create a more dynamic finished design than a figure simply standing with their hands at their sides.

Study poses in fashion magazines, or get a friend or family member to pose for you if you like. Also, refer to section 3.1.3 on sketching for the proportions used in fashion drawing — the head is usually disproportionately small and the legs are enviably long.

The first figure should be a front view; the second figure should be a side or back view of the same body. This is important, because obviously your design will have a front and back when it is finished. By completing this step, you will be able to illustrate the entire look at once. The different views don't need to have the same pose, but it helps if they are somewhat similar. If you like, you can do one from the side as well.

Once you have your figures drawn in pencil, begin to sketch in the basic shapes of the outfit you want to create. Start with large, blocky shapes, using quick, loose movements of your hand. Don't make extremely heavy

lines, just lightly sketch where you think the outlines should be. Pay attention to the points on the figure's body that will be important references for the finished design — that is, the shoulders, apex of the bust, the waist, hips and knees. You may want to mark these points with a faint horizontal line, so that you have a visual reference for your design.

Keep sketching, using large shapes and loose lines, until you have a similar look on both (or all three) figures. At this point, you are not trying for perfect detail but to create the overall impression of the outfit. Draw directly over the figure you've sketched — you'll be able to erase the figure lines later to make it appear as though the outfit is opaque.

When you're satisfied with the outlines of the outfit, begin to erase some of the figure's body lines to give the overall impression of the design. Using an artist's eraser, rub away the lines that don't contribute to your design, and leave the ones that you like best. If you like, you can trace over your chosen lines with a graphics pen, which has waterproof ink and will allow you to paint directly over it while still showing through.

Once you have the basic design created, you may want to begin working in some color by shading lightly with colored pencils, washing large areas with watercolor paint or even gluing on scraps of colored paper.

Once you have your design's outlines and colors "blocked in," as it's called, you can begin to add details like collars, cuffs, belts, accessories, buttons, trim and any patterns or textures you might want to be reflected in the fabric. Use a sharp pencil for these details, but still draw lightly until you're certain of where you want the details to be. You can also include details with strokes of colored paint (gouache watercolor paints are an especially good way to layer color) or with colored pencils or markers.

Once your sketch is complete and you are happy with the results, assign the design a name and a style number (these are for your reference). If the fabric has been determined, staple a small swatch to the final sketch.

A Line Plan

A line plan shows all of the garments in your collection according to fabrication. Developing a line plan to show the collection's grouping can be a useful internal tool for sharing information with your patternmaker

and sample sewer. It will eliminate cutting room errors if you show the garments within each fabric group together.

To make a line plan, divide a poster-sized piece of paper into columns. Each column should represent one fabrication. Then use a photocopier's reducing features to shrink your original drawings down until they are of a size to fit in the columns. (Or better yet, scan your drawings and use a computer program to shrink them and lay out your line plan.)

Place the drawings in columns according to the main fabric used. For example, you might have a skirt, jacket and pant in wool crepe as one part of your collection. These will be shown in a vertical column under a swatch of the crepe. The next column could feature two blouses and a dress in a print fabric that works with the crepe. Attach swatches to the top of each column and assign style numbers below each garment design.

This is the line plan for your collection. It will help patternmakers and sample sewers know which styles will be sold together, keeping details like topstitching consistent, and making sure that the pattern for the jacket in a collection has sleeves long enough to cover the sleeves of the blouse it is intended to be worn over.

2.3.4 Determine the Size

If you are making a sample for mass-production, you can refer to a size chart and make your garment match the measurements of the chosen size. Most in-depth pattern-making books include size charts that will give you basic measurements for standard sizes for men's, women's and children's wear. See section 2.3.5 for a selection of these books to choose from.

However, "standard sizes" are not truly standard, so sometimes manufacturers assign their own set of measurements to correspond to their size labels. That's how one designer's size six becomes hugely different from another designer's size six. If you're following someone else's pattern or garment, go by the actual measurements rather than the size as labeled.

Many designers will use a favorite model as their standard sample size, whether they call her a four or a six or a two. She has the body proportion

that best complements their line, and her shape isn't too far from the average customer who will buy the garments. Sometimes this is a professional, paid fit model, but it can also be someone you know, ideally a friend or relative who will be readily available when you need them to try something on.

The hourly rate of fit models will vary greatly; your neighbor might be prepared to do it in exchange for a sample garment once you've finished with it, whereas if you hire a professional model through a modeling agency the price could go up to over $100 per hour, depending on the level of experience and the prestige of the agency.

> **TIP:** Live models do things like gain weight and become pregnant, and if you're working with children, obviously their size will change every six months to a year, so it's always a good idea to have a few fit models listed in your phone book.

Often, if you work in tailoring or couture, you will custom-make a garment to fit your client based on his or her measurements. To measure someone, stretch your cloth tape measure firmly (but not too tightly) around the model's body to get the following measurements. The measurement will be the number where the end of the tape overlaps with the main part of the tape. Your measurements will include:

- length of garment from neck to hem

- length of arm from shoulder to wrist

- bust/chest

- waist

- fullest part of hip

- distance from waist to hip

- shoulder width (from shoulder to shoulder and also across the back)

- upper arm (bicep) at fullest part

- inseam (from ankle to groin)

- height from floor to waist

Record these measurements and refer to them to determine the model's standard size. Section 5.6.4 has a sample client contract that you can use as a standard form, with space to record these measurements. For additional information on measuring, the *Threads Magazine* website offers an excellent tutorial for beginners at **www.taunton.com/threads/ pages/t00150.asp**.

2.3.5 Pattern Making

Patterns are generally made either by drafting by hand or with a computer, or draping fabric over a dummy or model and pinning it in place. Pattern making is a skilled technique that takes a fair amount of practice, and possibly some training, especially if you are looking to use pattern making software (see chapter 3 for education options). Many fashion designers hire an experienced patternmaker to do this step of the design process, preferring to focus energy on the design.

Many designers will first develop a "block" pattern or set of blocks that will be used to create new designs. Blocks are simple, basic patterns, usually for a fitted shirt with bust darts, a fitted skirt or a simple pair of fitted trousers. These patterns can be manipulated to create more complicated styles or different silhouettes. Later they can be graded to different sizes.

As you build your library of patterns, you will have more styles at your disposal to use as blocks for making new, similar-fitting styles. Then you won't always have to revert to these initial, simple blocks but will save time, for example, by using a single-breasted blazer block to create a double-breasted blazer with a different collar. Or you'll use a Capri trouser block whose length was perfect to make a Capri pant with different pockets, a wider leg or slim hem, and decorative seam details.

A number of reference books address various elements of drafting, draping and grading patterns, including: *Pattern Making by the Flat-Pattern Method*, by Norma R. Hollen and Carolyn J. Kundel, *Patternmaking for Fashion Design*, by Helen Joseph Armstrong, and *Couture Sewing Techniques*, by Claire B. Shaeffer.

Drafting

In manufacturing the pattern making technique most often used is drafting, which is making flat pattern pieces from measurements provided. Excellent CAD (computer aided design) software is available to assist with drafting and marking patterns of different sizes. Some programs also have an illustration feature. If you are technically inclined, these computer programs can save you time and costly mistakes in patternmaking. See chapter 3 for more information on using computers in fashion design.

You can also draft patterns by hand, without computer technology. You'll need a large table, a roll of kraft-weight paper and a roll of something stiffer, like manila. You'll also need a set square (a tool that looks like an L-shaped ruler) to make perfect right angles, and a set of French curves, which are metal or plastic curved shapes that you will trace around to generate smooth flowing curves required for sleeves, hips, yokes, etc. Most of these tools will be available at graphic design or art supply stores. Some fabric stores might also carry them.

The kraft paper will be for the actual drafting of your pattern. Once your pattern is the right size and shape on kraft paper, you'll transfer it (by tracing over it with a tracing wheel) onto a heavy card or manila. This is the pattern you will actually use to cut the fabric, and the heavier card will withstand years of being handled. Putting the pattern on manila also makes it easier to work with later, if you decide to adapt it to develop a new style.

Patterns can also be made by measuring a finished garment. Maybe you found the perfect jacket in a thrift store, or you love the way a certain pair of pants you bought fits through the seat, but you know you can make the shape of the leg more attractive. A skilled patternmaker can draft a pattern without taking the original garment apart. They will take the relevant measurements and draft a new flat pattern with seam allowance added. This is called "knocking off" a garment.

Draping

Draping refers to the process of using lengths of material to drape around a dress-maker's form – or a willing helper – to give you an idea of how a fabric will "fall" (hang from the wearer's body). Many couture designers prefer draping to drafting, especially for certain fabrics and style details. The result will be a tailor-made fit for the client. You can use this technique to develop your flat pattern or, if you are creating a one-of-a-kind item, to build the item itself.

A dressmaker's dummy or dress form is a molded torso that is generally made of foam rubber and muslin or other covering. It is meant to replicate the measurements and form of a human body and is usually on a stand. The entire form is generally adjustable so that you can create different heights and varying bust, waist and hip sizes on the same structure. The forms are available in male, female and children's shapes.

The form is used to test the fit of assembled or partly-assembled garments, and, to a lesser extent, to provide a place for garment pieces to be put together while on a body. Remember that it's better to use real people to test your garment eventually, because when you're ready to fit your first samples they can move around in the garments and tell you if anything feels too tight, if a slit skirt is too revealing, etc. Dress forms can't move around and they can't talk to you.

If you are planning a garment of woven fabric, do your draping with woven muslin or another cheap material with a visible weave. If you are planning a garment of knit fabric, use a cheap knit fabric of the same or similar weight to the fabric to be used in the finished garment. You will not use your "real" fabric until you have a pattern you have made and tested with this cheaper sample fabric.

Before you begin the draping process, you need to notice the grainline of the fabric you will be using — a step that is extremely important to the appearance of the finished product. The lengthwise grain is the long threads that form the "warp" of a woven fabric. These are the stronger, longer threads. These threads don't stretch easily, and most components of garments are cut with the lengthwise grain perpendicular (at a right angle) to the hem, or the floor, when the garment is being worn. When you make a pattern, whether by drafting or draping, you should indicate grainlines on the pattern pieces so that it is clear which way the piece is supposed to be laid and cut.

On the next page, you will find step-by-step instructions to help you through the draping process.

After draping, the next step to a finished design is to make a pattern from the draped fabric. You never know when you might want to use the same style again, either to create something with a different fabric or to refer to as a block you'll use to create a new but similar style.

Leaving a seam allowance of 3/8- to 1/2-inch on all sides, you would trace around the shapes you have made with pins and markers in the draping process, transferring the shape of the material to pattern paper. The places where you made tucks and darts will be places where the finished material will be sewn together. Places where you have more than an inch or so of extra material tucked up will be cut away, leaving an inch or so for a seam allowance. The edges of these will be sewn together to create the finished garment.

When you cut your pattern pieces out, you will notice that you've created just one side of the garment. To create the other side, simply use the same pieces reversed left to right. Of course remember to accommodate any asymmetrical design details by making a new pattern piece if it can't simply be mirrored.

Steps for Draping

1. Adjust your dummy or dress form to match whichever set of measurements you are using.

2. Cut a piece of muslin up to several meters or yards in length, depending on the type of garment you are making — shorter if you are making a blouse or longer if you are making a dress. You don't want to make the fabric too short for your purpose or the piece will be wasted, but leaving it much longer than necessary will make it more cumbersome to work with.

3. Find the center of one edge of the material you are using for draping. Mark this point with a pin, and pin it firmly to the shoulder line on your dummy's left shoulder (to your right if you are facing its front). This will help ensure your drape is even.

4. Smooth the fabric over the dummy's back in the way you want it to fall (i.e. loosely or snugly). Pin the fabric to the dummy along the dummy's center back line, holding it in place. This will indicate the center line of your back pattern piece. Do the same with the front, pinning the fabric to the front center line of the dummy.

5. Starting at the back, begin to tuck the material into the shape you want it to take, using small, evenly spaced tucks and folds. These tucks will be larger at the edge of the material and taper to points at the fullest points of the dummy's contours (these are also called "darts"). The excess material will be on the inside of the garment. Pin the tucks into place with rows of pins along the fold lines.

6. Mark the points of the darts and the edges of the folds with a fabric marking pen. Also mark the waistline and the middle points between the shoulder and the waistline.

7. Once the body of the garment has begun to take shape and resembles the design you have drawn, you may carefully remove the draping material from the dummy by unpinning the points where it was attached. Carefully unpin it and lay it flat onto a piece of pattern paper spread over your worktable.

This is just a basic introduction to the steps in using fabric to drape patterns, as it is a very intricate process. One excellent book on the topic of draping is *The Art of Fashion Draping*, by Connie Amaden-Crawford.

2.3.6 Make Your Samples

When your pattern is ready you will want to test it for fit, construction and appearance by sewing a "muslin" or "first sample." The purpose of this first sample is to catch any pattern mistakes or design flaws using a cheaper fabric to make it, such as muslin. With a muslin, you can mark the fabric with a marker, cut it apart and put it back together. Fitting a muslin on a dress form will allow you to immediately see where you may need to make alterations, and the pieces of your muslin will provide you with a handy basis for your finished pattern pieces.

After fitting, perfecting and tweaking this first sample, make any necessary pattern and design adjustments. Then make the final samples from the actual fabric, using correct trims and notions, to show potential buyers.

You have a few choices to make when it comes to your samples. If you're an accomplished sewer, making your own first sample can allow you to make changes as you go, or correct pattern pieces that don't fit together as they should. Of course, it will also be less expensive to make your own sample rather than paying for someone else's labor.

If you don't have the sewing equipment or talent, or want to focus on your designs only, you can have a sample maker or sewer make one for you. You also have the option of going straight to a manufacturer to make a sample, which saves time if you plan on mass-producing, as the manufacturer works out any bugs in production while working on the sample. Then you'll have the confidence of knowing the same factory that made your approved sample will also be making the bulk orders. They'll be familiar with your pattern, fabrics and trims, and the details you've requested.

This section will cover making a sample yourself or using a sample maker, while section 5.6.2 has information on finding and working with a manufacturer.

Make a First Sample

Regardless of who makes your first sample, you'll likely use muslin or another plain and cheap suitable fabric. Because muslin is so widely used, it is also the name given to the first sample itself once it is made. It is available by the yard at fabric stores or online.

Instead of plain white muslin, you can also try using a lightweight gingham for your sample fabric — you'll be able to make alterations simply by counting the number of checks instead of measuring. You'll also know whether the grain is right because the checks will align vertically and horizontally. Make sure that the fabric you choose to work with is similar in weight, stretch and drape to your final intended fabric, though.

To assemble a muslin yourself, pin the pattern pieces to the inside of the material, making sure that they are aligned with the fabric's grain or bias as you desire, and cut out the material around the pattern pieces.

Pin the material pieces together at the points you marked on the pattern pieces, and use your sewing machine to stitch the seams together where needed. Whether you choose to hand-sew or machine-sew your garments will depend on the amount of time you want to spend on each item. Sewing machines are inevitably faster, but there is a prestige and quality associated with hand-sewn garments. Only you and your clients can determine what this prestige is worth in terms of time and labor costs.

Remember that you are assembling the garment from the inside out, so that when you are done, the seams will be on the inside. Working with a patterned material for the first try can help you identify which is which. Put together the flat parts first – the backs, fronts, sides – and then attach the sleeves, collars and other parts. Finish with buttons and buttonholes, then press the garment to flatten and finish the seams.

Threads Magazine has a helpful online video about how to make and use a muslin at **www.taunton.com/threads/pages/tvt020.asp**.

Hiring a Sample Maker

The sequence of sewing operations can be different in mass production, so sometimes it's worth the expense of having a professional sewer construct your first sample. Most experienced sample makers also have

some experience with patterns and will be able to help work out any pattern inconsistencies before you go into production.

For example, there might be places where the seam allowance is insufficient, or some of the pieces might not fit together properly. Use these comments to make corrections to your pattern. The sewer may also throw up red flags on construction details that will skyrocket the cost of producing the garment, like odd stitching or fabrics that are hard to work with. Ask them to make notes right on the pattern pieces.

According to New York fashion designer Sydney Maresca, many manufacturers will create a pattern package for you for around $150 to $250. You give them your design, and they'll create four samples, or "grades," in muslin. A good sample maker is worth the money, so you may need to try out several before you find the one that's right for you.

Evaluate Your Sample

Remember that no first sample is expected to be perfect in every detail, nor is it just for catching pattern problems. You're allowed to change your mind, to make design improvements, change the collar or neckline or pockets. This is all part of the creative process. Make the design as detailed and as close to perfect as you can, correcting the pattern and revising the sketch before cutting more samples.

Whether you sewed the sample yourself, hired a sample sewer or had the manufacturer make it, your job as designer includes checking all of the details. Does the silhouette look like you envisioned? Does it resemble your sketch, or does the waistline need to be raised or lowered? Are the sleeves too wide or too narrow, or do they need an elbow dart? More importantly, do you like it, even if it's different from your sketch?

Check the fit on a model of the right size, and examine the garment carefully. Once the pattern is made to your satisfaction, and you have tested it by making a sample garment, label it with a design or style number, which you log in a reference book along with a swatch of the fabric to be used. This way, if the style proves popular with your clients, you can reuse the pattern – or pieces of it, like a sleeve or pant leg – for years to come without having to pay for another pattern.

A sample garment evaluation checklist appears on the next page.

Sample Evaluation Checklist

1. Can you slip two fingers inside the waist to make sure it isn't too tight? *Yes No*

2. Can the model sit down without bursting a seam? *Yes No*

3. Do the shoulders and bust fit well? *Yes No*

4. Are the legs and sleeves a good length? *Yes No*

5. Are collars and pocket flaps the right proportion? *Yes No*

6a. Is the pocket opening the correct position and size? *Yes No*

6b. Will the hand go in if that was your intention? *Yes No*

7. Is the button or snap placement okay? *Yes No*

8. Would you like to make a wider topstitch? *Yes No*

NOTE: *Topstitching* (stitching at least 1/4-inch from the edges) is usually perceived as more casual, while *edgestitching* (as close to the edge as possible) looks dressier.

Subsequent Samples

If you want to make major changes to the style or silhouette, make a second muslin. Otherwise, make minor pattern corrections as needed and do the next sample in the correct fabric. Your final sample is the important one. If you hire an individual sewer or manufacturer to sew these samples, look at the finished product to ensure it looks exactly as you envisioned. These are the pieces that you'll be showing to prospective buyers, so they need to be right.

When the salesman's samples go out, your collection is launched! Your reward will be the enthusiasm from your sales agents and the buyers as they begin to view your line. You'll soon be able to monitor the most popular styles based on the orders that start to come in.

Once the pattern is made to your satisfaction, and you have tested it by making a sample garment, label it with a design or style number, which you log in a reference book along with a swatch of the fabric to be used. This way, if the style proves popular with your clients, you can reuse the pattern – or pieces of it, like a sleeve or pant leg – for years to come without having to pay for another pattern.

Pattern Grading

When you've seen a sample in the correct fabric and you're happy with all fit details, it's time to grade the pattern (increase and decrease the pattern piece dimensions) to generate the larger and smaller sizes you'll be making for production orders. Most pattern-making books and courses will explain the steps of grading and can tell you what the increments will be for going up and down between the sizes.

TIP: If you are adapting patterns to fit a specific size, it's a good idea to make a cloth "sloper," which is like a tight-fitting shirt or other garment that has the exact measurements for that size and can be fit to your dress form. *Threads Magazine* online offers a set of instructions for how to make a sloper at **www.taunton.com/threads/pages/t00036.asp**.

You'll also need to create assembly instructions, so the manufacturer will know how to assemble the pattern pieces into a finished garment. If you've ever used a pattern to make clothing or crafts, you've no doubt used instructions of this sort before. If you hired a professional sewer to make your sample, they can assist you with documenting the steps.

2.3.7 Manufacture Your Garment

If you are having your garment mass-produced, you should finalize all the manufacturing details using a "spec sheet" that lays out the specifi-cations of assembly. Section 5.6.2 will take you through the steps of working with a manufacturer.

In couture, of course, you don't have to prepare for mass production. Instead, your last step is to make the final garment yourself, following the same process you used to assemble your sample. Remember to incor-porate any changes required, based on what you learned from sewing and fitting the sample.

Now is the moment you've been waiting for! Help your client, model, or dress form into the outfit you've created. Determine what, if any, accessories need to go with the outfit, and place them with it. If you are taking your design anywhere, be sure to place it on a sturdy hanger and slip it into a garment bag. This will protect your work and give you a professional appearance.

Be sure to take photos and keep records of sizes with corresponding measurements. Note the materials that were used and where they came from. Label each photo with information about the design. Include:

- The date it was created

- The title of the piece (if any) and style number

- What materials were used

- Variations, such as other possible sleeve styles or hem lengths

- The client's name

- The final product price

You will keep prints of each design in a separate file folder, and keep all these files together in either a portfolio case or in a large file box. This is your ongoing portfolio, which you will choose examples from when you need to show someone your work.

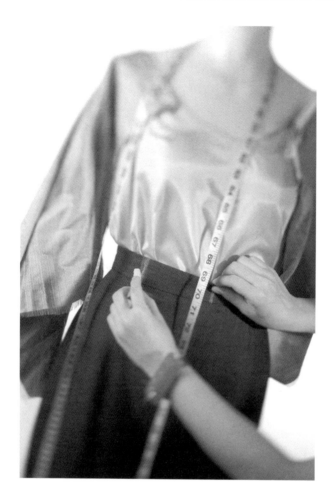

3. Developing Your Skills

Now that you have a sense of the fashion industry and a feel for the steps in designing garments, we'll take a look at some of the skills and traits you will want to develop to succeed in this career.

On the next two pages you will find a self-evaluation exercise to see if you are suited to a career in fashion design. Consider your answers to the following questions. If your answer is yes, give yourself the number of points listed after each question. Add up your total to evaluate your score.

Self-Evaluation Exercise

Points:

1. Are you hard to satisfy when shopping
 for your wardrobe? _____ (2)

2. Do you shop for everyone else in your
 family — spouse, kids, siblings? _____ (2)

3. Can you compare fabrics and tell what _____ (3)
 type of clothes they would be best for?

4. Have you ever made clothes from a pattern? _____ (3)

5. Have you ever made clothes from scratch? _____ (5)

6. Do you respond quickly and enthusiastically
 to change? _____ (3)

7. Have you ever altered a sewing pattern
 to suit your body shape or tastes? _____ (5)

8. Do you look at clothing and style critically,
 and form opinions? _____ (2)

9. Do people constantly tell you that you're
 creative? _____ (2)

10. Have you ever worked for or ran a small
 business? _____ (2)

11. Are you an organized person (on time,
 checkbooks balanced)? _____ (2)

12. Do you get a sense of satisfaction from
 completing projects? _____ (2)

13. Do you get a lot of compliments on your
sense of style? _____ (2)

14. Do you read fashion magazines and
study the layouts? _____ (3)

15. Have you ever sketched a design of a
garment you would like to own? _____ (5)

16. Do you watch fashion-oriented TV often? _____ (2)

Total: _____

Your score is out of 45 — how did you do? These questions are designed to identify some of the characteristics common to successful fashion designers, so the closer you are to scoring 45, the more you are already suited to this career.

If your score was low, don't throw in the towel yet. As this chapter will explain, many of the skills needed to design fashions can be self-taught, and no formal training is necessary to enter this field.

3.1 Skills You Will Need

A creative profession, fashion design is attractive to talented people and is highly competitive. That means it can be a challenge to find a way into the industry at the level you want. In addition to a strong knowledge base and a strong portfolio, you will need the kind of skills that will convince an employer that you are exactly what they need.

While it helps to be organized, business-oriented (if you're planning on opening your own showroom), extroverted and a trend-spotter, your strengths may lie in other areas. Here are some of the skills that make for a multi-talented, well-rounded fashion designer, and suggestions for ways you can start improving yours, starting today.

3.1.1 Communication Skills

The creation of apparel doesn't happen in a vacuum. In the real world, the creative design and manufacturing process is a collaborative effort.

"You don't sit up in an ivory tower and design," warns Stan Herman, citing the need to bring communication skills to the process of interacting with design teams, contractors, manufacturers, clients, and so on. "If you're not surrounded by people who are open-minded and filled with design in all parts of their lives, you can't compete."

While many people see fashion design as a comparatively isolated career, communication skills are essential to several aspects of the job. You may need to:

- Let a client know what you are going to design for them.

- Work with people who don't know exactly what they want.

- Explain to a manufacturer or apparel company why your designs will sell.

- Communicate to a patternmaker what you are trying to make.

- Market your skills to a broad range of buyers or a single employer.

- Work with a team of designers on a line of clothing.

Working with wealthy clients can also be a challenge to your diplomacy and tolerance, as people who can afford your services can also afford to be picky, or even difficult. Reading a book like Dale Carnegie's *How to Win Friends and Influence People* is always a good start to learn about building relationships, and a book called *Reading People* by Jo-Ellan Dimitrius will help you with figuring out what people are really telling you. Finally, if negotiation is your weak spot, take a look at *Get Anyone to Do Anything*, by David J. Lieberman.

3.1.2 Textile and Sewing Knowledge

Fashion design is a hands-on career, no doubt about it. Having a good understanding of the materials you work with and how garments go

together could be the decisive edge between you and another designer. Sometimes people manage to make it through school with little practical knowledge, so a designer who understands the physical elements of fabric and how to jazz up an outfit with specialty sewing has a competitive advantage, even over someone with a degree.

Fashion-Industry Sewing

There are conflicting opinions in the fashion design industry about whether or not you absolutely need to know how to sew to design clothing. As fashion designer Karen Hipwell puts it, "Sewing is the most crucial skill; it's like being able to write if you want to be a writer."

If you look at other design professions, though, you can argue that an architect doesn't need to know how to build a house, they just need to know how it goes together. An interior decorator doesn't need to know how to build furniture, they just need to know which pieces will complement a room. If you translate this concept to fashion design, the logic would be that you don't need to know how to sew yourself, but you do need to know how a garment goes together, what types of stitching are out there, and what constitutes quality work.

There are many places you can learn to sew, including community centers, local junior colleges and universities and, of course, design schools. Check your local Yellow Pages or the Internet for classes in your area.

While hands-on instruction will make the learning process easier, it is also possible to teach yourself how to sew with the use of a few good books or an online tutorial. Two excellent, industry-specific books are *Sewing for the Apparel Industry*, by Claire Shaeffer, and *Sewing for Fashion Design*, by Nurie Relis.

If you need help with sewing techniques, the following websites are good resources to refer to for further instruction:

- *Threads Magazine — Sewing Basics*
 www.taunton.com/threads/pages/th_feat_sewbas.asp

- *Sewing.org*
 www.sewing.org/enthusiast/html/e_learntosew.html

If you choose not to learn to sew, there is no arguing that you will run into challenges, but a career in fashion design is not impossible. Your best move would be to partner with someone you see on a frequent basis who will sew your garments for you. This person should be someone reliable, who shares your vision for your designs. Their sewing skills will be representing your work. They should be available for demonstrating techniques to subcontractors or other employees or to your manufacturer's sewer. (Not every stitch is the same, and many types of stitches may be sewn differently.)

> **TIP:** To compensate for a lack of sewing ability, you would also be wise to learn as much as possible about designing on a computer, which cuts out several hands-on steps in the design process with the use of technology. See section 3.1.4 for a more complete explanation of computer software in the fashion industry.

Knowledge of Textiles

A good fashion designer knows their textiles, and can bring together material and design in a way that is attractive, interesting, and functional. In general, you can make some assumptions about materials. A garment that is to be worn indoors will be made of thinner, lighter fabric. More luxurious materials, such as silk, satin and velvet tend to be used in special-occasion clothing. Heavy materials are reserved for outerwear like sweaters, coats, jackets and occasionally trousers.

But there is more to it than that. A great designer has a mental collection of fabrics that they sort through when conceptualizing a design. They will be able to say with certainty if a particular type of fabric will complement or contradict their concept. They will also understand that great design often comes from combining design and fabric in unconventional ways, and will always be looking for ways to use textiles in exciting ways.

This is an area where a hands-on approach to learning works best. Visit fabric stores and get in there to handle the different materials. Pay attention to each fabric's hand (that is, its feel when touched), texture (the weave or knit) and its finish. Is it smooth and shiny? Rough, starched or rubberized? You will also consider its composition, which refers to the raw materials the fabric is made of. Ask questions of the staff, and take notes if you like.

You can request swatches, or small samples of fabrics that interest you, and file them when you get home in a system that works for you (some people staple them to index cards). Use this collection for inspiration, or to show clients.

Learn the lingo when it comes to textiles so you can discuss your ideas with clients, buyers and manufacturers. For example:

- *"Synthetic materials"* include polyester, lycra, rayon and fleece.

- *"Natural materials"* include cotton, silk, wool and linen.

- *"Raw"* refers to fabric made from threads that have been left rough or unrefined. It provides a rougher texture and a less shiny finish.

You can also do some research to learn more about textiles and their characteristics. Some fabrics require special cutting and handling techniques.

A one-way print such as palm trees will use slightly more material for each garment, as the pattern pieces will have to be laid in a single direction, so that the print is always right-side up.

Fabrics with a brushed surface, or nap (such as corduroy, velvet and many types of wool) should also be cut one way. The light reflects differently on a napped surface, so if a sleeve has the nap facing down while the bodice has the nap facing up, the result may be a garment that appears to be cut in two different colors. This is not a desirable effect, but would be considered a manufacturing error.

Stripes, plaids and checks can require more fabric if you want to match the pattern at seams or down the center front opening. This creates more waste than solid colors, which can be cut with pieces pointing in both directions.

Another point to note is that stretchy fabrics will handle differently. If a material is especially stretchy, you may require less of it to cover the same amount of body space. Rarely would you use the same pattern for a stretchy and a non-stretchy fabric, or even for a knit and a woven fabric.

When choosing fabrics to use together, you will want to know what colors work with each other. One way is to take a look at a color wheel, which is discussed in the next section.

When choosing colors, always think about cost. Very bright and dark colors sometimes cost more to produce than light colors in the same fabric. The intense saturation of color requires more dye, so the mill will charge slightly more for those shades.

"Cost is the first thing you have to think about," Lucille Whitaker confirms. Often a fabric mill will let you dye your own custom color for a predetermined quantity, rather than choosing from their range.

The *Fairchild Dictionary of Textiles* contains over 14,000 definitions of fibers, fabrics and other important terms. The dictionary sells for $75 U.S. and can be found at **www.fairchildbooks.com**.

Here are some resources for you to learn more about textiles and their characteristics.

- *FabricLink.com — Characteristics*
 www.fabriclink.com/Characteristics.html

- *Tollefson Designs*
 www.tollefsondesigns.com/costumes/definitions1.html

- *DressKing.com*
 www.dressking.com/search/fabrics.htm

The Color Wheel

If you imagine all of the colors of the rainbow bent into the shape of a pie, you have a good idea of the color wheel. Each color blends into the next, offering a wide range of colors to choose from when you pick your fabric.

A basic color wheel consists of three *primary colors* (red, yellow and blue) and the *secondary colors* (violet, orange and green) that are made from combining these primaries. *Tertiary colors* result from mixing these six and all other shades.

Colors have different *values* — a term that refers to the lightness or darkness of each color. Colors can be made brighter by the addition of white — these are called *hues*. Pastel colors – such as pink, which is a lighter shade of red – are *tints*. If black is added, colors are made darker. These are called *shades*. Navy blue, for example, is a shade of blue. Black, white and grey are considered to be neutral.

The colors on the red-yellow-orange side of the color wheel are considered to be warm, energizing colors, while blues, purples and greens are considered to be cool and relaxing colors. Warm, stimulating, or intense colors attract the eye, while cool pastel colors provide a more restful place for the eye to wander.

Complementary colors are found opposite each other on the color wheel. Combining blue with orange, red with green and purple with yellow can make for a strong design impact and can be an effective detail when used with discretion.

You can get a color wheel at an art supplies or craft store, or buy one online for as little as $4 from The Color Wheel Company. Visit **www. colorwheelco.com** or phone 541-929-7526 to order one.

3.1.3 Sketching by Hand

To develop your ideas into designs, you'll need to do a lot of drawing, sketching and collage work. That's because you need to have pictures of what you're trying to create before you actually make it. Not only does it give you a clear idea of what you're doing when you get to the assembly stage, but it can also save you money by letting you work out your ideas on paper before you use costly fabrics and other materials to execute them.

Even if you're not actively designing something, you'll still want at least one sketchbook (and probably more than one) going at all times. This can be a large or small sketchbook, spiral-bound or hardcover, which you keep with you and use to sketch ideas wherever you happen to be. Use it for sketching what you see on the street, in cafés, on the bus or in nature. Your sketchbook is the first step in developing ideas for designs and your way to quickly record what you see.

In addition to rough sketches, some fashion designers will create professional sketches of their ideas, which is particularly important when you're applying for a job or presenting a portfolio to an individual client. Needless to say, it's much easier to carry a portfolio of designs than to carry an entire wardrobe of garments (although retail buyers will prefer to see samples of the real thing).

You may already have many of the supplies needed for sketching on hand. If not, a trip to your nearest art supply or craft store will help round out your supply list. A complete list of sketching supplies can be found in section 5.5.4.

Design sketching is not meant to be a perfect illustration of every detail of an outfit — so when you sit down to sketch some ideas, relax and let your ideas flow rather than worrying about getting each detail exactly right. Pencil sketches are fine, or you can get fancy with watercolors, paints or other media.

Bear in mind that you're using a two-dimensional surface for something that's going to be created in three dimensions. A pretty picture doesn't mean it will translate well onto your mannequin or model, so be prepared to go back to the drawing board (literally) if necessary.

One way to improve your sketching is to spend time practicing drawing human forms. If you like, you can even begin with stick figures. Keep in mind the proportions of each body part you are drawing: legs are longer than arms, which are longer than fingers and feet.

Check at your local art supply store or community college for information about life-drawing classes, which use live models as drawing subjects. It's a good way to practice your drawing skills and to increase your drawing speed, as the models can only hold each pose for a limited amount of time. In addition, the instructor will be able to assist you with any problems you have with your drawing.

One of the best books available to help you learn fashion drawing techniques is *The Fashion Sketchbook*, by Bina Abling. Though a bit pricy at $50, it is nearly 400 pages of instruction on drawing for fashion, and a good investment for the beginner.

Fashion Drawing Proportions

Have you ever noticed how professional fashion drawings and illustrations tend to show models with impossibly long legs and strangely small heads? It's an accepted convention in the fashion design industry to use these proportions for fashion illustration in order to emphasize the elements of each design.

Real people tend to fall into the 1:7 proportion, meaning that the measure of the top of their head to the bottom of their chin is 1/7th of their total height. Fashion illustrations tend to work with a minimum 1:8 ratio, making the head of any figure in the drawing just 1/8th of the figure's total height. The extra 1/8th of length tends to be added in the legs. It is also possible to see illustrations that exaggerate these proportions even further, to 1:10 or even 1:12.

To make a 1:8 proportioned drawing, divide your page into eight equal horizontal sections (try folding it in half lengthwise, then half and then half again). The top section will be where you'll draw the entire head. The next two sections should be the shoulders and torso, and the line of the waist will probably fall somewhere around the third division line. The bottom five sections will be reserved for pelvis, thighs, calves and feet.

3.1.4 CAD Skills

Essentially, there are two ways to make your patterns: you can make them by hand, as many in the business still do, or you can use computer software such as CAD (design software) and CAM (manufacturing software). The prevailing attitude is that CAD is the best way to go, since it's all done on screen, and you save time by not having to "go back to the drawing board."

Some CAD programs, like DressMaker5, are simple to use and are designed with the beginner in mind. CAM programs are frequently geared towards large-scale production and specialized equipment, such as the kinds of industrial cutters you would find in a large factory. Section 5.5.4

on buying equipment includes more information on purchasing these programs.

The jury is split into basically two camps regarding the use of CAD as a design tool. Those who have gone to design school swear by CAD, and with good reason. Most of the big design houses are using CAD now since the faster they get a fashion off the drawing board and onto the sales floor, the sooner they realize a profit.

However, there are an equal number of designers who refuse to use the computer to create a design. This school of thought says you need to feel the pencil in your hand. You need to be able to smear and smudge to create realistic folds and other fabric properties in your fashions and to see how shadows and other lines affect the look of the piece. This is a hotly argued subject, and you will have to decide for yourself what way works best for you.

There are a variety of software programs available that allow you to take pre-made patterns and designs, scale them to any size and print them directly onto paper. They also allow you to design your own drawings on the computer and transform them into patterns on paper. While these tools are by no means necessary, they are popular with those who want to replicate various designs in different sizes or for those who like to experiment with small variations in patterns and designs without having to re-draw the entire thing.

To use these software packages, you will need a computer system with the operating system requirements specified by each software package. You will also need a color printer and, if you are printing large-scale patterns, a plotter printer. Because these are fairly major investments (the software can cost hundreds or thousands of dollars, while a large plotter printer would start at several hundred dollars), you might want to download trial versions of the software to experiment with before you buy a specific one.

If you've never used CAD software, you can check your local colleges and universities for classes since it's taught in most fashion major programs. Keep in mind that different schools might teach different programs, as there are a lot out there.

For an idea of what these programs can do, Gerber Technology's Vision Fashion Studio is among the best software out there. You can visit their home page at **www.gerbertechnology.com** or go directly to the webpage for the software at **www.gerbertechnology.com/gtwww/ 03Prods/cad/design/fstudio.htm**.

3.1.5 An Eye for Fashion

People in the industry agree that a successful fashion designer has to have an eye for color, form and style, which inspires their unique design vision. The most successful fashion designers in the world are those who are able to recognize and create trends. Keeping up with this business should be fun, rewarding and full of challenges. The best way to keep learning is to eat, sleep and breathe fashion. Here are some ideas on how to develop your "vision."

Get out in the field

No matter how much you read, how many people you hire, or how many meetings you attend, there is no substitute for being on a sales floor, talking to sales associates and clients face to face and traveling to industry shows.

Read

Read anything you can get your hands on that deals with fashions and the industry overall. This can be trade publications or consumer magazines.

Keep an eye on retail prices

There are many factors that affect retail prices — the season, the economic climate, consumer confidence and so on. If you want to stay competitive, you may have to adjust the costs of your goods.

Follow fashion shows

Don't have the money to make it to Europe this summer for a big runway show? Most shows (including trade shows) will post updates and news on their websites as the show is going on. It's not as good as being there, but it is the next best thing.

Follow Trends

In order to stay competitive in any business, you must keep up with what's happening in your industry. In fashion, it's even more important. You don't just want to stay current, you want to be ahead of everyone else and set the trends. Aside from using information from trend companies, you can use the Internet to surf fashion sites and keep up-to-date on what's hot and what's five minutes ago.

Watching and forecasting fashion trends is a business unto itself, and a fickle business it can be. Patricia McCune at Lee Jeans watches trends by getting on the street and seeing what's out there. She regularly travels to London, Paris and Milan "to live it, see it and do it." There is no substitute for first hand experience.

While on the road, McCune also visits museums and art galleries, and studies architecture. "You have to look at the way people are wearing their hair in combination with their clothes, shoes and accessories. You must look at the big picture," said McCune.

For the rest of us who may be shy on plane tickets to Paris, another very acceptable way to trend watch is to use the services of trend forecasting companies. For a fee, these companies do the work and all you have to do is buy the book, which comes out about every six months.

Doneger (**www.doneger.com**) is one of the biggest trend forecasting companies out there. Aside from tracking fashion trends, they also follow trends in color, fabric and silhouettes. Other fashion trending companies include Promostyl (**www.promostyl.com**) and WGSN (**www. wgsn-edu.com**).

To keep up on the hottest colors, visit the websites for the Committee for Color and Trends at **www.color-trends.com** and NPD Fashion World at **www.npdfashionworld.com**.

You can order reports on the hottest trends from the west coast and Europe via **www.snapfashun.com**. And finally, Trendzine reports on retail, catwalk and street wear trends for women's fashions at **www. fashioninformation.com**.

3.1.6 Creativity

"I get a lot of inspiration from interior decorating and the things that are around us every day."

— Giulietta Graci, Designer

"I drew inspiration from when I worked at the New York Metro-politan Museum of Art."

— Lucille Whitaker, Instructor
The Art Institute of California, San Francisco

As a fashion designer, you will need to develop your creative ideas from concept to finished product by brainstorming, sketching, experimenting and drawing plenty of examples. You will take inspiration from the world around you and from your own experience and ideas. You will use that inspiration to create new designs and garments by first sketching them and then building them into actual garments that can be worn by models and ordinary people, or copied and mass-produced.

Recording Your Ideas

Ask designers where they get their ideas from, and you'll get a different answer each time. Some draw inspiration from their cultural surround-ings. Others are inspired by looking at past fashions, and still others look to architecture, furniture and paintings. Experts have debated for years whether creativity can be taught, but most would agree that it can be learned. There are a number of ways you can inspire and keep track of your ideas.

Your Visual Notebook

This is a book of ideas but with as few words as possible. Use it like a scrapbook to capture all the images that stimulate your imagination. You can use a three-ring binder stocked with good quality paper, or a large (at least 9" x 12") sketchbook. Glue into it all the magazine clippings, photographs and other pieces of visual information that inspire you. Make brief notations about the included material to jog your memory later. Along with the cutouts, make sketches or paintings in your notebook, develop-ing the ideas that the cuttings inspire.

Remember, this is a collection of your own personal research into design and style, so feel free to put whatever you like into your visual notebook. You'll refer to it when you're looking for inspiration or when trying to develop a theme.

Your Sourcebook

Like your visual notebook, this can be a sketchbook or a binder. However, it is meant to contain elements that can be used in specific projects — fabric samples to show textures or interesting designs and patterns that can be used in new ways. Cut out and glue into your sourcebook anything that intrigues you for its pattern, repetition, use of form, line, color or scale. You will refer to this when you need inspiration for adding an element to a design.

Your Visual Journal

You can document your daily or weekly activities in a visual way by using collage and drawing in a sketchbook. Include anything that you've seen that fits with a particular thematic interest, from movie tickets to photographs to pressed flowers to letters and postcards. It's meant to not just document your activities, but to reveal the themes you notice in the visual elements of the world around you.

> **TIP:** If you find yourself making original drawings of outfits in any of the above sketchbooks, copy them into an Ideas Book — another sketchbook, only slightly larger than your other ones. This collection of more-finished drawings can be used to form a portfolio or presentation for individual clients.

Brainstorming New Ideas

When you are working on your preliminary sketches, you may be filled with ideas and bursting with concepts that you just have to get onto paper. Or you might be frozen stiff at the sight of a blank white page that you know must be filled with something clever. Where to start? If you find yourself stalled, and you need a dash of creative inspiration, the next two pages have some tips to get you going. Try any or all of them until you find one that works for you.

Fifteen Brainstorming Tips

1. Look at the fabrics in your collection, or visit a fabric store to see what's new.

2. Place different colors or patterns next to each other, studying how they work (or don't work) together.

3. Study the pages of a fashion magazine such as *Vogue* or *Women's Wear Daily*, and copy your favorite design. Embellish and change it until it becomes your own original creation.

4. Sketch an outfit that you could convince your best friend, brother or sister to wear.

5. Cut out your favorite clothing items from a catalog or magazine, and make a collage with them by gluing them onto a piece of stiff paper.

6. Watch an old movie with the sound off. Pay attention to the clothing the characters are wearing, and try to create a modern update of their outfits.

7. Go to the library and look at books about period and cultural costumes (such as Elizabethan dresses, Greco-Roman togas, Japanese kimonos or Indian saris). Find a few elements that you can incorporate into your own designs.

8. Watch a group of teenagers at a coffee shop or mall. Study their clothing, and look for ways to adapt their most creative dress styles to your original ideas.

9. Close your eyes and choose a fabric from your collection. Use that as your starting point.

10. Visit a museum and look for patterns, motifs and design elements in historic or archaeological pieces.

11. Photocopy a piece of material several times, in several different directions and at several different settings (enlarged, reduced, grayscale). Find the most interesting shapes in the pattern, and base your design on those.

12. Go to an art gallery and look at the paintings on display. Study how their shapes and colors interact. Go home and make a sketch based on the paintings.

13. Take one idea that you've drawn in the past, and develop it into several ideas by placing tracing paper over the first design and copying it but changing at least one element. When you're satisfied with the new design, do the same thing with it. Keep repeating until you have a variety of designs based on one original theme.

14. Flip through your idea books mentioned above to find information that resonates with you, and apply it to a new set of sketches.

15. Find a length of fabric that you want to work with. Drape it around a model or yourself in a variety of ways. Examine the effects of different arrangements. Sketch what you see.

Using Other Clothes as Inspiration

Of course, sometimes the very thing that inspires a fashion design idea is another fashion design. In the garment industry, copying a design directly is known as "knocking off."

This practice is extremely common in all levels of the industry. It ranges from stealing an innovative pocket or cuff idea, to measuring someone else's garment for fit details, to copying the entire garment exactly, from style lines and stitching right down to fabric appearance, color and buttons.

There's nothing wrong with borrowing your inspiration from someone else's idea, but try to adapt it in a way that makes it your own. Consider

a basic pair of jeans. Maybe you've had them for years and you love their fit. You can measure every element of the garment to develop a pattern that will fit the same. Then you can sew them in an off-white canvas with navy topstitching and change the pocket shape. They have become your own design.

In any art or industry, it's generally agreed that imitation is the highest form of flattery. However, that doesn't mean that top designers are thrilled to find their ideas copied and mass-produced at lower prices. When someone borrows your original design, you might not like it much either. Many designers think it's okay to copy someone else, but fly into a rage when they find out that someone has copied them.

Here's another point to consider: Often there seem to be design elements in the very air that we all breathe. This results in two or more artists or designers conceiving very similar themes at about the same time, with no opportunity or intention to copy each other. So if you launch your line and discover that someone else has also produced a collection of Russian princess coats in red with black embroidery, don't be too quick to point a finger. It's possible and even likely that their inspiration came from the same place that yours did.

And when you consider all of the garments in the world that have been made and worn since clothing began, how many can be truly original? As with music and painting, architecture and literature, the work of one artist is bound to affect the work of others. This is not necessarily a negative; it's just reality.

However, there are a few mass producers in the industry who buy a high-end designer garment at a boutique or department store and take it back to the studio for analysis. They unstitch the seams, trace all the pattern pieces, and copy the fabric construction and color exactly, as well as make note of all buttons and trims. They'll sew the garment up again carefully and return it to the store to get their money back. Then they go about sourcing a cheaper supplier for materials, and sell thousands of the item the following season.

You can enter into a debate as to whether this sort of corporate espionage is ethical or just a standard business practice, but it seems quesionable that such people could actually be considered designers.

3.2 Formal Education

Despite the fact that fashion design is an unregulated industry and requires no formal credentials, some designers (and employers) prefer the solid foundation that a formal education provides. It gives your resume credibility — you don't have to prove your skills if you have a piece of paper that says you are qualified.

Whether or not you decide to pursue a formal education in fashion design depends on your personal skills and experience. If you have been working as a patternmaker for the last six years, and already design clothes for yourself, you will have less to gain from a sit-down class. If you are in love with fashion design in concept only, and have little experience or training in the apparel industry, school would be a great one-stop place to get all the background you require. If you fall somewhere in the middle, it's possible that you only need to pick up a few courses here and there to round out your skills.

Your personal situation will also have a lot to do with choosing to go to school. You need the financial stability to afford tuition and possibly give up working full time, and enough free time to study and complete assignments. If you are considering a whole program or just a few courses, here is a look at what is available. Section 3.3 looks at informal training options as well.

3.2.1 Degree and Certificate Programs

According to designer Stan Herman, the "obvious route" toward a career in fashion design is to go to school. "Both commercial and four-year colleges give you courses in fashion — everything from making clothing and patterns to working computer programs to art history," he said.

In addition to the Bachelor of Fine Arts and Master of Fine Arts degree programs offered by many four-year colleges and universities, Associate's degrees and fashion study programs are available from a number of trade or technology schools. If they specialize in fashion (like New York's Fashion Institute of Technology, also known as F.I.T.), they can be highly respected in the industry.

According to Herman, the best locations for commercial and academic fashion design study are on the east and west coasts (translation: New

York and Los Angeles), although there are well-regarded training programs in Ohio, Missouri, and the South. In Canada, Toronto, Montreal and Vancouver are the fashion hubs of the country.

In these apparel-focused locations you are more likely to have teachers who are actively working in the industry, a placement program that will get you into a well-known design company, and more employers to choose from when you are finished with your course of study.

The benefit of formal training in fashion design is that you can use the time to get a picture of how the fashion industry works, enlarge the scope of your creativity and hone your craftsmanship. Increasingly, fashion designers use computers as well as sketchpads to work out their ideas. Fashion school is an ideal place to get training in CAD or pattern engineering computer skills.

Perhaps most importantly, you can use your training to develop a portfolio, which functions as a show-and-tell resume. You can be sure that every prospective employer and investor will want to see it.

3.2.2 How to Find and Compare Them

You can do online research to compare different schools and their programs, and see what they have to offer you, using the resources below. In addition, many schools now have their program guides and requirements online or available for downloading as PDF files.

The Princeton Review website has a listing of schools offering a Fashion Design major. Schools marked "most popular" means that fashion design is one of the three most popular majors at that school, a good indicator of the value of the program. At the time of publication, the webpage for fashion design programs is **www.princetonreview.com/ college/research/majors/Schools.asp?MajorID=109**.

For general information about art and design and a list of accredited college-level programs in the U.S., visit the National Association of Schools of Art and Design website at **http://nasad.arts-accredit.org**.

Fashion-Beauty.com also has a list of fashion schools and formal training programs, including choices in Canada and other countries outside of North America at **www.fashion-beauty.com/fashionSchools.html**.

3.2.3 Tips on What to Look For

Fashion schools and programs vary greatly; finding the one that works best for you will be a matter of choice and need. For example, if you're a great sewer but light on technical skills then you'll want a school that offers more technology-based programs and classes.

In fact, some industry insiders feel that a two-year associate program, or even a certificate program that runs one or two semesters, can be a better educational tool if it is more "hands-on" than a four-year program that offers a lot of theory.

The best type of program for someone with little experience is one that offers on-the-job training in the form of co-op programs or internships. Students get course credit for work they do while placed with a fashion designer or company that accepts them. These are short-term place-ments, though many times hard work is rewarded with a job offer upon graduation, or at least some networking contacts and a good letter of recommendation.

> **TIP:** If you are looking to break in quickly, some vocational schools offer certificate programs that you complete in two tiers. Af-ter completing the first tier you are qualified to find entry-level work in the apparel industry (as an associate designer or design assistant, or as a patternmaker or grader). Once you have an entry-level job, you have the option to come back part time to complete the second tier of training, which is more artistic than practical, and is designed to help you ad-vance in the field.

Also, look for a school that is closely connected with the garment indus-try — their teachers should be currently or recently working in the busi-ness, and they should mention specific relationships with manufactur-ers or design companies they do internships or training with.

Dr. Sharon Pate, assistant professor of family and consumer services for Illinois State University, advises that all aspiring fashion designers take the following classes to prepare themselves for their chosen ca-reer:

- Art

- Art fibers

- Clothing behavior

- Clothing construction

- Fashion history

- Fashion illustration

- Fashion merchandising

- Textiles

Pate also suggests the following classes for readers still in high school who want a career in fashion, or people who have some free time to take a course or two:

- Marketing

- Art (as many classes as possible)

- CAD (computer-aided design)

- Some type of home economics

3.3 Informal Training

So you don't have the time or the money to get a formal education, but you know in your heart that you were meant to be in fashion. Formal training isn't the only option for a career in fashion design. It's also possible to take the "stylist route," something that Stan Herman describes as being when you don't really know the art of fashion but have a very good eye for it, know how to put colors together and have a sense of style and a vision.

Herman, whose designs include uniforms worn by FedEx and JetBlue personnel, says it's much easier to become a designer today than it was a couple of decades ago; but he adds that it's also much more competitive. "If you're really talented, it's how you handle it that counts," he explains.

A lot of well-known fashion designers do not have a degree in fashion, including Giorgio Armani, Tommy Hilfiger, Tom Ford, and many others. This section covers a number of ways you can develop your skills without setting foot in a classroom. For further inspiration, the guide concludes with tips and advice from several self-taught fashion designers who tell you how they made it without formal training. And if they can do it, why can't you?

3.3.1 Work With Clothing in Some Way

Even if you don't have formal training in fashion design, many employers will consider candidates with equivalent experience in the apparel industry. If you are looking to build a resume to apply to design companies, this is one way to do it. Not only are you acquiring skills and knowledge that you will use as a fashion designer, but in some cases you will come into contact with designers and other people who may hire you down the road. As explained in section 4.2 on finding job openings, many jobs these days go unadvertised because someone knows someone who is looking to move up.

This advice is borne out in the varied backgrounds of some of the designers who have made it to the top tiers of the fashion industry. Ralph Lauren "was a tie salesman who had an idea, and he became the biggest fashion mogul ever," points out Stan Herman. Other examples include:

Designer	Previous Job
Giorgio Armani	Department store buyer's assistant
Coco Chanel	Clerk in a hosiery shop
Salvatore Ferragamo	Boot manufacturer
Tom Ford	Model/actor
Marc Jacobs	Stock boy for a New York clothing store
Jil Sander	Fashion journalist

"There is a whole team of very technical and knowledgeable people that someone can go and work for," says Canadian fashion designer Linda Lundström. "It could be a company that just manufactures golf shirts or evening gowns. The technical knowledge is the same: how to make a pattern, how do manufacturing and production work, and what are some of the machineries that are used. I have people working for me now that started working for nothing as apprentices. That really speaks volumes about their level of commitment."

Here are some of the more common entry-level positions related to the apparel industry, and a brief description of what they involve. In addition to these listed, consider any position that puts you into contact with fashion in some way, such as modeling, acting, fashion consulting, image consulting, or becoming a fashion stylist.

Patternmaker/Cutter/Grader

Patternmakers are responsible for turning a designer's two-dimensional drawings and three-dimensional sample garments into precise pattern pieces that can be used to reproduce the design numerous times in numerous sizes. They use computers and patternmaking software or create patterns by hand. This is a technical position that you may need to train for. You would apply to the same companies that employ designers, as listed in Chapter 4.

Useful skills for this job

- Precision

- Eye for detail

- Steady hands

- Good spatial perception

- Sewing ability

- Experience with CAD and patternmaking software

- Understanding of garment fitting

Sketcher

Some design houses offer jobs specifically for sketchers, who are the ones who translate ideas into sketches that are then used for patternmaking. You may also find work as a sketcher at some fashion magazines, which occasionally need illustrations of designs to go with their stories. You would apply to the same companies that employ designers, as listed in Chapter 4, or to fashion magazines as listed in the Resources section at the end of this guide.

Useful skills for this job

- Ability to sketch by hand

- Experience with Illustrator, CorelDraw, Photoshop and Micrografx

- Good sense of proportion, color and design

- Knowledge of fashion history and trends.

Sample Maker

Sample makers use patterns to assemble sample garments for use in fashion shows, sales and marketing efforts, and to develop and size patterns. They work quickly and efficiently to create garments of various materials and sizes and make alterations and changes where needed. You would apply to the same companies that employ designers, as listed in Chapter 4.

Useful skills for this job

- Fast and accurate sewing abilities

- Pattern reading and hand-sewing skills

- Attention to detail

- Ability to work under pressure

Boutiques

A great way to make connections in the fashion industry is to work for a local boutique that sells private designer's clothing, or high-end clothing in general. Not only will you meet designers and see how they work, you will meet potential buyers of your designs, both the boutique owners and individual clients. You'll get a sense of where fashion is right now, and where it is headed. These jobs aren't known for paying top dollar, but if you work on commission at a high-end clothing store, it beats sitting in an office typing letters for your boss — unless she's a fashion designer!

To find local boutiques, check your Yellow Pages under "Consignment," or "Clothing and Fashion," or pick up a local weekly entertainment paper and see who advertises in it — many times their ads are a who's who of hip places to shop. You can also visit your town or city's upscale shopping district and make a list of stores to apply to, or see what ads are in local fashion magazines.

Manufacturing Apparel

One expert consulted for this book said all she has to do is walk out her door (she's a New Yorker and has a showroom in the garment district), and there's a plethora of manufacturers to choose from and lots of job opportunities as well. The manufacturers, of course, are the ones who take designs from the designers then manufacture them.

Very often, top-notch designers visit their manufacturers during the sewing of the designs to assist them in making sure every stitch is done correctly. So not only can you get great sewing experience, you may also have the chance to network with designers when they're visiting the manufacturing facility. The most obvious job with a manufacturer would be a sewer, but there's plenty of other work involved.

In the last 20 years the apparel manufacturing torch has been passed principally to Asia, where depressed labor costs enable designers to have clothing produced very cheaply. This shift has reduced the amount of manufacturing done in North America, so jobs in apparel manufacturing are not as plentiful as they used to be, though they are still out there.

Check the following websites to compare lists of North American manufacturers:

- *American Apparel and Footwear Association (AAFA)*
www.apparelandfootwear.org/3col.cfm?pageID=103

- *American Apparel Producers Network*
www.aapnetwork.net

- *U.S. Clothing and Textile Factories*
www.apparelsearch.com/america.htm

- *The National Register of Apparel Manufacturers*
www.thenationalregister.com
This website allows you to purchase their directories in print or electronic form, but does not have a listing online. These directories are updated every year, and might be a good purchase to identify apparel manufacturers, sales reps, etc. in your geographic area.

Textile Companies

Some textile companies employ custom, in-house designers or textile artists whose sole purpose is to create patterns and prints all day. They sketch designs based on their own ideas as well as the desires of their clients. They may also specialize in fashion or upholstery fabrics or even in wallpaper or carpet design, and they keep on top of trends in color, design and style.

Useful skills for this job

- Drawing ability

- Computer skills

- Design awareness

- Knowledge of color/pattern

- Understanding of textile production processes

Here are two excellent resources to discover textile companies and also learn more about what's happening in the industry.

- *American Textile Manufacturing Institute*
 www.atmi.org/links/companies.asp

- *Institute of Textile Technology*
 www.itt.edu/Jobs

Garment Wholesalers

Wholesalers are companies that strictly sell apparel business to business. You may already have wholesale clothes in your closet if you've ever bought a private brand from a retail store. The retailers buy from the wholesalers, who in turn put the retailer's label on the garments and then ship the garments to the retailer's stores. Kmart's Route 66 is an excellent example of a wholesale-bought, private-label brand. To search for wholesalers, check out these two excellent sites:

- *Resale, Wholesale and Department Store Union*
 www.rwdsu.org

- *International Council of Shopping Centers*
 www.icsc.org

3.3.2 Study Fashion on Your Own

Employers are looking for would-be designers who are up-to-date on the latest fashions. Hopefully you are already passionate about fashion, and read magazines, watch television and visit websites dedicated to the subject. Now that you are considering fashion as a career, remember to be critical about what you see, and think about how you could alter or improve designs to make them your own.

Make a note of any gaps in the marketplace you discover — maybe you can't find maternity workout outfits, or a golf shirt for cooler weather. These "gaps" might be the unique niche you address when you start designing a collection.

Study the way clothing is made — take apart old clothing by ripping out the seams, then make notes about the different parts. Collect patterns and assemble them. Make modifications as you go, experimenting with materials and colors. When you come across a designer's work that you admire, study how they have put together their collection, including stitching, fabric, cut, and colors.

Any time you come across an interesting fabric for sale, ask for a sample or swatch. Attach the swatch to an index card (staple or glue it by one edge), with information about the fabric's cost, composition, place of origin and where you found it. Include information about its width and whether it's available in other colors. Organize these swatches by color in a recipe box or (as your collection gets bigger) in an index card file.

Visit websites of design schools and make a note of the courses they teach. These are the desirable skills for this profession! You can set yourself on a course of self-study, based on the topics covered by these classes. Set yourself week-by-week study goals based on what you would learn at these schools. Use the resources listed throughout this book, and add to the list as you learn more.

3.3.3 Attend Fashion Events

Attend any and all fashion shows or events that you can — fashion shows tend to take place in the spring and fall to launch new seasonal product lines.

Talk to as many people as possible about what they do in the industry. Get to know models, designers, fabric suppliers and production workers to get inside tips on positions opening in your area. Talk to designers who are in attendance or any other decision makers. If it is a trade show that is open to "industry-only," a way you might get in the door is to volunteer, even if it is taking tickets or checking coats.

Fashion events that are open to the public, such as trade shows, can be expensive, but if you use the trip as a fact-finding mission, you'll be able to do everything from sizing up your competition and seeing what's selling, to taking notes on popular displays and getting samples of the handouts. Listen to presentations and see how buyers respond. By the end of the show, you'll know exactly what you'll need to do to get your lines ready to compete. Section 6.4.3 takes a look at what to do when you are a vendor at the trade show yourself.

Try stopping by during the lunch hour or when things are less hectic, and the personnel may be more willing to chat. Ask if you can hang out with them at the booth for a bit or volunteer to assist them. If they tell you that they're just too busy to chat, don't push it, but ask for a business card

and permission to contact them for some networking. You can also give your business card to every person you meet. You never know where the next prospect will come from.

Here are some outstanding sites to visit to find trade and runway shows all over the world:

- *FashionWindows.com*
 www.fashionwindows.com/runway_shows

- *TradeShowWeek.com*
 www.tradeshowweek.com/index.asp?page=directory

- *ApparelNews.com*
 www.apparelnews.net/TradeShows/

- *ApparelSearch.com*
 www.apparelsearch.com/trade_show.htm

Private or exclusive fashion sales, called trunk shows, are also good ways to meet and talk to designers, who are often in attendance. Your local entertainment weekly or fashion section of the paper will have a listing of upcoming events that might be open to the public.

3.3.4 Design for Fun

Fashion design is one of the few careers where you can start small, designing for friends and family. The more time you spend designing clothing, costumes, etc., the more experience you will have with different fabrics and challenges to design.

Help a friend design a custom-made veil for her wedding, or make Halloween costumes for your nieces and nephews. Accessories such as handbags, diaper bags, backpacks, etc., are also good choices to make a bunch of, as they are "one size fits all." Even if you don't make the items, keep a sketchbook of your ideas for them in case you want to have them manufactured down the road. And, of course, design and make as much of your own clothing as you can. You are not just keeping busy, you are building a portfolio of work to show future employers.

TIP: If you get enough different pieces made in different sizes, you can host an informal gathering to "launch" your collection. Money made from pieces you sell can be invested in equipment and supplies to continue building your portfolio.

3.3.5 Create a Fashion Network

Without really trying, you can easily build a network of contacts to help you get hired in the fashion industry. Start by telling everyone you know (or meet) about your new career. If they seem interested enough, show them a sketchbook of your work. Everyone is a potential client, or might know someone who is looking for someone just like you.

In particular, you want to network with people in the fashion industry. Try to connect with boutique owners or store managers in meaningful ways — offer to bring them a coffee or take them out to lunch if they will take a look at your designs. Introduce yourself at the places you shop for your own clothes — chances are, you and the owner or manager have a lot in common if you are buying their selected designs.

When you meet other designers, collect their business cards and keep in touch. You may want to get together with them to put on a fashion show, or their assistant may suddenly get a job offer in Los Angeles and they will know you are looking for work.

A key factor is not to create a network exclusively with the competition, but with others in the business whose work might complement your own. For example, if you design dresses, why not network with those who make purses, jewelry or other accessories? There's nothing wrong with partnering with other designers as long as you're both making different designs.

Whenever you team up with others in the industry, make a point of asking questions. Find out how other professionals handle similar situations, and seek out knowledge that might help you to expand your business and experiences.

3.3.6 Apprenticeship or Internship

An intern or apprentice is one step below the lowest paid position at a fashion house or design company. They often begin by working for free

or for a minimal stipend. It's understood that apprentices are working for the educational experience and not for the money. It's a good way to get your foot in the door and find out more about the industry from the inside.

As an apprentice, you may be asked to do basic but essential jobs like cutting patterns, organizing files and even sweeping the floor. You will probably assemble theme boards, help with fashion shows, and possibly help create sample garments. In exchange, you will have the opportunity to work closely with an established designer, watch the design process from beginning to end, and, most important, meet many professional contacts. You will also get a sense of the environment at a particular place of employment. When considering an internship, keep a few things in mind:

Location

Since you will probably be working for little or no money, you may want to do an apprenticeship close to home. Ask yourself, if there are no places to apprentice in your area, will you be able to support yourself in another city while you do your training?

Reputation of fashion house/designer

The reputation of the company you apprentice with will affect how you are perceived by future employers. If they respect the company or designer, they will be more impressed with your training than if they have never heard of the company or designer you have interned with.

Scale of company

Is it large or small? A large company will expose you to more contacts and aspects of the business, but it may also have you doing fewer and less interesting tasks. On the flip side, a small company will probably allow you to try more activities, but you may not meet as many people.

Future opportunities at the company

Does the company regularly hire its interns? Are there many job openings there? If there are lots of positions readily available, you might want to simply apply for one of those rather than go through a low-paying (or unpaid) internship.

To pursue an apprenticeship, contact the fashion houses or designers that you are interested in (there are listings in chapter 4). A quick phone call or email is appropriate. Introduce yourself and explain why you're calling or writing, and ask if they accept applications for interns or apprentices. If not, thank them politely. If so, ask how they prefer you to follow up — with a formal application, a portfolio and resume, or other materials.

TIP: If a designer doesn't accept interns, you can also inquire about a mentoring relationship. Ask if you can have 20 minutes of the designer's time to ask some questions about the career, or job-shadow them for half a day. If the designer is simply too busy to meet face to face, some will agree to mentor you by email (look at and comment on your designs), possibly for a fee.

Some websites you can use as a starting point to find internships and apprenticeships include:

- *ApparelSearch.com*
 www.apparelsearch.com/Designer/fashion_designers.htm
 Has a comprehensive listing of established fashion designers.

- *InternAbroad.com*
 www.internabroad.com
 Offers internship opportunities in a variety of exciting international locations. Search for "Fashion Design" under "What type of internship?"

- *WetFeet.com*
 www.wetfeet.internshipprograms.com
 Search the "Fashion/Apparel" category to find a variety of fashion-related internship opportunities.

- *BigAppleHead.com*
 www.bigapplehead.com
 Click on "Fashion" to find a listing of internships in the metro New York City area.

Photo courtesy of Lee Jeans

4. Getting Hired

As a fashion designer, you have many exciting career possibilities, which fall into one of two categories:

- Get hired and work for someone else.

- Start your own design business.

As you can see from the title, this chapter focuses on the first of these two options.

The chapter begins by taking a look at the types of industries that hire fashion designers, and the types of positions available. We'll talk about how to find the job openings, how to contact the companies, the materials you'll need for an interview and how to make a great impression when you meet potential employers face to face.

4.1 Finding Your Ideal Job

There are many ways for you to begin your fashion design career. The route you take will depend on your long-term goals and the vision you have of your future success. There will also be practical considerations such as where you live, and if you are willing to relocate.

Some cities in North America and the rest of the world have thriving fashion industries and are good places to find a job, such as New York, Paris, London, Toronto, Los Angeles, Milan, Dallas and Tokyo. Put simply, if you are looking to work, you will need to know where the employers are.

But that doesn't mean you can't start your job search, and even your career, wherever you are right now. In the age of the Internet, it's possible to share digital design files electronically, search for jobs, telecommute, market and sell your designs online. There's no reason why you can't be a successful fashion designer whether you live in Tinseltown or Tinytown.

4.1.1 Types of Employers

There are a number of different areas where fashion designers can use their skills. For example, if you want to be a name-brand designer like Ann Taylor or Pierre Cardin, whose clothing everyone recognizes and enjoys wearing, getting in with an established design house will help you understand the requirements of name recognition.

If you would be happiest creating fashion lines for a large retailer's in-house brand, you would be better off getting a position that developed a broad range of skills and taught you more about the textiles you will be using.

Here is a list of companies that employ fashion designers, broken down by category. As you look them over, think about where your skills, experience, personality and preferences, not to mention your future career goals, will make the best fit.

Ready-To-Wear

Here is a listing of some of the top ready-to-wear designers. These are all the top fashion design companies and among the most highly regarded places to work in the business. Be prepared to live in New York, however, as many of the ready-to-wear companies are headquartered there.

It's possible to get an entry-level job for these companies, and you may very well find openings advertised in your local newspaper, but your best bet is to go to a company's website. The websites below will take you either directly to the career pages or, for those sites that don't post jobs, directly to the contacts page where you can acquire the proper names and addresses for sending a resume. If there is no website for the designer, a mailing address has been provided instead.

Elizabeth Arden

Website:	**www.elizabetharden.com/Corporate/ human_resources.asp**
Address:	Elizabeth Arden Corporate Headquarters 14100 NW 60th Avenue Miami Lakes, FL 33014
Phone:	(305) 818-8000 or (800) 227-2445 (toll free)
Fax:	(305) 818-8010
Email:	careers@elizabetharden.com

Bill Blass

Address:	Bill Blass Ltd. 550 Seventh Avenue New York, NY 10018
Phone:	(212) 221-6660
Fax:	(212) 398-5545

Chanel

Website: **www.chanel.com**
(Click "USA," then click on "Contact Us." Access the list of FAQs for the Corporate subject to see information about contacting Chanel for employment.)

Address: Chanel, Inc.
Fashion - Human Resources
9 West 57th Street
New York, NY 10019

Phone: (212) 715-4760

Fax: (212) 303-5728

Donatella Versace

Website: **www.versace.com**
(From "Main Menu" select "Contact")

Address: Versace S.P.A.
38 Via Manzoni
Milan, Italy 20121

Phone: 39 02 760 93 1

Fax: 39 02 760 04122

Escada

Website: **www.escada.com**
(Job information is not posted to the website, but you may contact the company at the address below.)

Address: Escada USA
10 Mulholland Drive
Hasbrouck Height, NJ 07604

Phone: (201) 462-6000

Fax: (201) 462-6440

Giorgio Armani

Website: **www.giorgioarmani.com**
(Click on "Armani/Menu" then click "Contact Us." Select "Employment/Internships" from the list and fill out the form.)

Address: 114 Fifth Avenue
New York, NY 10011

Phone: (212) 366-9720

Fax: (212) 366-1685

Gucci

(Includes Alexander McQueen, Balenciaga, Bedat & Co., Bottega Veneta, Boucheron, Sergio Rossi, Stella McCartney, Yves Saint Laurent.)

Website: **www.guccigroup.com/genInfo/default.asp? ReqView=humanResources.asp**

Address: Gucci Group
Human Resources Department
via Don Lorenzo Perosi
6 Casellina di Scandicci
Florence, Italy 50018

Phone: 055 759 21

Fax: 055 75 54 96

Jil Sander

Website: **www.jilsander.de**
(Job information is not posted to the website, but you may contact the company at the address below.)

Address: Jil Sander America, Inc
212 Fifth Avenue
New York, NY 10010

Phone: (212) 447-9200

Fax: (212) 447-9696

Email: info@jilsander.de

Louis Vuitton

(Includes Loewe, Celine, Berluti, Kenzo, Givenchy, Christian Lacroix, Marc Jacobs, Fendi, StefanoBi, Thomas Pink, Donna Karan.)

Website:	**www.lvmh.com**
	(Click on "LVHM and You," then "Join LVHM." Then, under the "Join LVHM" menu, select "Job Openings.")
Address:	Louis Vuitton North America Inc.
	19 East 57th Street
	New York, NY 10022
Phone:	(212) 931-2000
Fax:	(212) 931-2903

Oscar de la Renta

Website:	**www.oscardelarenta.com**
	(Click "Contact Us.")
Address:	Oscar de la Renta Ltd.
	550 Seventh Avenue
	New York, NY 10018
Phone:	(212) 354-6777
Fax:	(212) 382-1181
Email:	info@oscardelarenta.com

Phillips-Van Heusen

(Includes Arrow, G.H. Bass, Geoffrey Beene, Kenneth Cole, DKNY, Van Heusen, IZOD.)

Website:	**http://pvh.kenexa.com/pvh/cc/Home.ss**
Address:	Phillips - Van Heusen Corporation
	200 Madison Avenue
	New York, NY 10016
Phone:	(212) 542-5200
Fax:	(212) 366-1685

Ralph Lauren

Website: **http://about.polo.com/employment.asp**

Address: Polo Ralph Lauren Corporation
Human Resources Department
650 Madison Avenue
New York, NY 10022

Phone: (212) 318-7000

Fax: (212) 888-3290

Email: hrjobs1@poloralphlauren.com

Tommy Hilfiger

Website: **www.tommy.com**
(Click on "Help," then select the category "Corporate Facts." In the list, there are questions with answers regarding jobs and internships.)

Address: Tommy Hilfiger USA, Inc.
25 West 39th Street
New York, NY 10018

Phone: (212) 840-8888

Fax: (212) 548-1660

Email: jobs@tommy.com

Vera Wang

Website: **www.verawang.com/company/opportunities**

Address: Vera Wang Corporate Office
225 West 39th Street
New York, NY 10018

Phone: (212) 575-6400

Fax: (212) 879-1890

Haute Couture Houses

Some designers work for the famous haute couture houses. Very few couture sales are made in a year and these rarely total more than 1,500 sales for each house.

This is not surprising when you learn that only about 3,000 women world-wide can actually afford to buy clothes at the couture level, and fewer than 1,000 buy regularly. Because of this, haute couture work may be relatively hard to find... but not impossible.

Here are the current haute couture houses. If there is no website for the designer, a mailing address has been provided instead. In addition, the Elegant-Lifestyle.com website offers general information about each design house that you might also find useful at **www.elegant-lifestyle. com/haute_couture.htm**.

Coco Chanel

Website:	**www.chanel.com** (Click "USA," then click on "Contact Us." Access the list of FAQs for the Corporate subject to see information about contacting Chanel for employment.)
Address:	Chanel, Inc. Fashion - Human Resources 9 West 57th Street New York, NY 10019
Phone:	(212) 715-4760
Fax:	(212) 303-5728

Pierre Balmain

Website:	**www.balmain.fr** (Click "Contact.")
Address:	44 Rue Francois 1er Paris, France 75008
Phone:	47 20 35 34
Fax:	47 23 40 11

Christian Dior

Website:	**http://fashion.dior.com** (Click "Contact.")
Address:	30 Avenue Montaigne Paris, France 75008
Phone:	40 73 54 44
Fax:	47 20 00 60

Hubert de Givenchy

Website:	**www.givenchy.com** (Click "Fashion," then click "Contact.")
Address:	3 Avenue George V Paris, France 75008
Phone:	44 31 50 00
Fax:	44 31 50 23

Louis Féraud

Address:	21 Avenue Montaigne Paris, France 75008
Phone:	45 33 93 18

Yves Saint Laurent

Website:	**www.ysl.com** (Job information is not posted to the website, but you may contact the company at the address below.)
Address:	7 Avenue George V Paris, France 75008
Phone:	56 62 64 00
Fax:	47 23 69 73

Jean-Louis Scherrer

Address: 2 Rue De Bassano
 Paris, France 75116

Phone: 56 52 10 20

Fax: 56 52 10 21

Emanuel Ungaro

Website: **www.emanuelungaro.fr**
 (Click "Emanual Ungaro and You" then "Contact Us.")

Address: 2 Avenue Montaigne
 Paris, France 75008

Phone: 53 57 00 00

Fax: 47 23 82 31

Email: info@ungaro.fr

Jean Paul Gaultier

Website: **www.jeanpaul-gaultier.com/**
 (Click "Mode" then "Gaultierland" then "Jobs."))

Address: 30 Rue Du Faubourg Saint Antoine
 Paris, France 75012

Phone: 44 68 85 00

Fax: 44 68 85 10

Christian Lacroix

Website: **www.christian-lacroix.fr/english/sommaire.htm**
 (Click "Contact Us.")

Address: 73 Rue Du Faubourg Saint-Honoré
 Paris, France 75008

Phone: 42 68 79 11

Fax: 42 66 11 47

Email: info@c-lacroix.com

Independent Design Houses

Many fashions are created in independent design houses, which may be located almost anywhere — from big-city lofts to suburban factories, from converted houses to vast industrial warehouses.

The independent houses tend to make garments for one or two designers. Some independent designers take on contracts to design specific items for large retailers, such as Target or Zellers. These contractors may have an office where they do their work and employ a number of designers to complete each contract. They may produce the garments right on-site, or they may outsource the work (have the garments assembled in another location).

To find local designers and design houses, you can visit your city's garment or fashion district, if you have one. New York City's garment district runs from Fifth to Ninth Avenue, and 35th to 41st Street. You can see a map of the area at this website at **www.fashioncenter.com/Map.html**.

Los Angeles' fashion district is located in the heart of the downtown, between Broadway and San Pedro Streets, and 5th Street and the Santa Monica Freeway. You can see a map of the LA Fashion District at **www.fashiondistrict.org/DistrictMap.asp**.

If you are not sure if your city or the closest city has a fashion district, call your local Chamber of Commerce and ask. You can also use the Yellow Pages to find local designers by searching under Clothing and Fashion, or visit local boutiques in a trendy area of town, and ask them which local designers they work with.

You can also use the following searchable databases of design companies to find someone local, or conduct your own search for "fashion designer" and your geographic area on an Internet search engine.

- *FashionBiz.com*
 www.fashionbiz.com/fashionbiz/ListingSearchForm.cfm

- *Fashion Designers List*
 www.fashionwindows.com/fashion_designers/showall_ fashion_designers.asp

Corporate (In-house) Design Divisions

Many large retailers, such as Kmart and Marshall Fields, have their own designers who may work at the corporate headquarters or in an office where other departments of the retailer are also located. A corporate position will almost always be an office job, as these companies generally produce their merchandise in factories and in other countries.

You can visit any chain retailer location to pick up information about where their corporate office is located, or search for the company on the Internet. You can contact them about where their designs are done, and who to contact with a resume. These corporate jobs are also more likely to be listed on the job boards you'll find later in this guide.

4.1.2 Types of Positions

When you apply to work as a fashion designer, it is helpful to know what types of jobs are available. Especially when you get in with a bigger company, the type of work each position entails is more specific. In addition, some fashion designers specialize in terms of what they produce or what aspect of design they excel in.

Not every fashion designer is a household name like Gloria Vanderbilt or Tommy Hilfiger. Rather, most work out of the public eye, creating clothing that is worn by everyone from movie stars to maintenance workers. No matter what type of clothing you see being worn, there was an individual person behind the look.

As such, the fashion industry has numerous positions available and many different roles that must be filled. Figuring out where you fit in is a matter of determining how your skills match your career aspirations.

What follows is a list of the most typical types of positions and a brief explanation of the types of skills you'll need to succeed in each.

Associate or Assistant Designer

If you choose to break in to a company with little training or experience, you will probably start out on a fashion team as an assistant to their established designers. This entry-level position may be called different things at different firms, such as first pattern-maker or design room as-

Trend Analyst

Pays close attention to the existing fashion styles and trends in the industry and maps historic trends to determine what the next wave of fashion will be. They will monitor color, fabric and style trends to determine a company's direction with its upcoming collections.

Freelancers

Some fashion designers work on a freelance basis — that is, they bid on and fulfill contracts for various companies, or are contracted on an ongoing basis to complete a variety of designs for one company.

There are also manufacturers who hire freelance designers to create high-fashion originals or adaptations of current styles. The designer is usually paid a flat fee for the sketch, and does not receive commissions on number of units sold. The manufacturer is not just looking at the cost of the design itself, but how much it's going to cost to make it, the product's shelf-life and the price range. A T-shirt design, for example, will yield a very different price range than a wedding dress design.

You may also "license" your designs if you lend your name and possibly some input to a manufacturer in exchange for a small percentage of the sales. The manufacturer handles all the selling, production and distribution. Licensing deals are usually only offered to recognizable brand-name designers.

4.1.3 Salary

Like most careers, a fashion designer's salary depends on their skills and experience, the size of the company they work for, and the type of design they are doing. According to Winnie Von Werne, director of permanent placement for the New Jersey-based Lorelei Personnel, Inc.:

- Entry-level designers come in at about $30,000-$35,000 per year

- Mid-level designers make between $35,000-$45,000 per year

- Senior designers start at around $120,000 per year

- Management positions are from $85,000 up to $225,000 per year

Freelance positions vary, but can pay even more than salaried designers if the freelancer arranges a percentage of gross sales, or a per-unit payment on a product that does well. They may also be paid a retainer for their services.

Self-employed designers set their own prices or fees, but have to pay expenses as well. Their income varies with the talent, the amount of business they can handle, and their choice of clientele. Chapter 5 explores going into business for yourself, and setting your prices or fees.

4.2 Finding Job Openings

This section deals primarily with getting your first job or two — after that, your connections and experience will carry you where you want to go, whether it's to the head of the design department, or into business for yourself.

The broader your search area, the more likely you are to find a position. Your first job in fashion could come from anywhere, but if you restrict your industry preference or geographical area, you may also restrict your opportunities. With that said, it's good to be focused, know what you want and, most important, be persistent and don't get discouraged.

4.2.1 Advertised Positions

Perhaps the most traditional way of finding a job is through advertised openings. These ads can be found in a number of different places. Plan your strategy by incorporating different techniques to locate places that are hiring design professionals.

Newspaper Classifieds

Naturally, the newspaper classified section is the last place most fashion design houses will advertise, as there are many other venues, both online and in trade magazines, for them to search for new staff. But don't discount the papers, either — check under the headings "retail" and "professional" for possible positions. If there are a number of fashion houses or retail headquarters, there is a chance you'll get lucky, probably for an entry-level position.

Online Postings

Once you have a list of fashion houses that you are interested in, check their websites regularly for job postings. Often openings will be listed on a company's website before they are advertised in the paper.

You can also surf the Internet for available positions all over the country. In addition to the major job boards like Monster.com and HotJobs.com, there are many sites on the Internet that post job openings specific to the fashion industry. The following sites are worth bookmarking when beginning your initial job hunt.

- *ApparelSearch.com*
 www.apparelsearch.com/Apparel_Search_2.htm

- *Apparel Job Board*
 www.appareljobboard.com/jobseekers.htm

- *Fashion Career Center*
 Offers job listings, resume posting and an online portfolio service.
 www.fashioncareercenter.com/index.html

- *JobFactory.com*
 Many links to job sites offering employment in fashion and apparel.
 www.jobfactory.com/indus/indus122.htm

- *Style Careers*
 www.stylecareers.com

- *N.A.P. Professional Services*
 Job listings for people in the Canadian fashion design industry.
 www.fashion-career.com

- *Apparel News*
 Apparel News requires payment to access the job boards, but this site is among the best of the best and worth the investment.
 www.apparelnews.net/Class/index.html

- *Fashion Net*
 www.fashion.net/jobs

- *Jobs.com - Fashion Designer Jobs*
 employment.jobs.com/jobsearch.asp?q=fashion+designer

- *Monster.com*
 www.monster.com

- *HotJobs*
 www.hotjobs.com

- *Careerbuilder*
 www.careerbuilder.com

Placement Agencies

Agencies are another way to find work. They match candidates with employers, at a cost to the employers — not to you. Both of these agencies specialize in placing people in the fashion industry.

- *Lorelei Personnel*
 www.loreleipersonnel.com

- *24/Seven Talent*
 www.24seventalent.com/index.php

Trade Publications

Check the classifieds in industry publications such as *Apparel* and *Daily News Record*. You can also look in the back of any magazine within your area of specialization to see if they have job listings.

Websites for a few of these publications are listed below; see the resources section of this guide (chapter 8) for complete subscription information for each publication.

- *Apparel Magazine*
 www.bobbin.com

- *California Apparel News/ApparelNews.net Total Access*
 www.apparelnews.net

- *Children's Business*
 www.childrensbusiness.com

- *DNR*
 www.dailynewsrecord.com

- *Look Online*
 www.lookonline.com

- *Women's Wear Daily*
 www.wwd.com

- *Worth Global Style Network*
 www.wgsn.com

- *The Apparel Strategist*
 www.apparelstrategist.com

- *FashionUK*
 www.widemedia.com/fashionuk

4.2.2 Unadvertised Positions

An often-quoted statistic is that almost 80 percent of job openings are not advertised. That figure may be even higher in a tightly knit and highly competitive industry like fashion. Smaller design houses or boutiques may not have websites, and are unlikely to spend hundreds of dollars to post jobs at a site such as Monster.com. So how do these employers find employees?

Most commonly, by word of mouth. An employer will ask current employees and colleagues, suppliers and manufacturers, as well as friends and family if they know anyone who would be good for the job. Refer to the practical tips in this guide for networking in the fashion industry before you are hired (section 3.3.5) and when you are looking for clients as a self-employed designer (section 6.3.4). Following this advice will make you the candidate they suggest.

In addition to networking, you can also send your resume to employers who are not officially hiring. They might keep your resume on file, or might be so impressed that they give you a call. You might hit just the

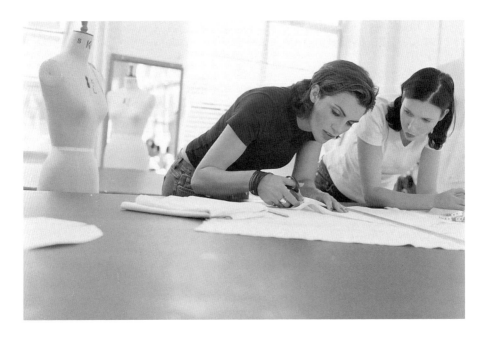

right moment as a staff member resigns, or they might be talking to a colleague at lunch that day who is fishing for candidates. The point is, you never know when a cold-call might turn into opportunity.

The first thing you do is make a list of companies you would like to work for, based on what you know about them, and where they are located in relation to you. Your ideal candidates would be design companies or designers that put out similar clothing to the garments you design your-self, but if you are just trying to get a foot in the door, you don't have to be picky. Use the resources listed in section 4.1 to find potential employers.

Once you have a list of places you would like to work, give them a call and speak to the receptionist or junior designer who answers the phone. Explain that you are a designer looking for work, and that you would like to send some information about yourself to their company. Ask who would be the right person to address it to, and what materials would be appropriate. You might get a breezy comment about how they aren't hiring, but be persistent — you knew they weren't hiring, you'd just like to be kept on file.

Send in your job-hunting materials. If you are willing to work for free, say so. If you are willing to take an entry-level job, state that too. Follow up

with a phone call a few days later to make sure the person you addressed them to received them. If you get to speak with the decision-maker, reiterate that you are asking them to keep your materials on file should something come up.

A lot of job-hunting material will advise you to ask employers for 15 minutes of their time for an "informational interview." In this interview, you as an aspiring fashion designer would bring a list of five questions to ask them about the career. The idea is that the employer will meet you, like you, and offer you the next job that came up.

Since this idea has been around now for some time, employers are no longer naïve about what an "informational interview" entails — many eager job-seekers outright ask for a job in the interview, which is an uncomfortable situation for the employer. So if you ask to come in for an "informational interview," you might be turned down.

Be honest. If you want to come in and meet with them, just say that. Tell them you won't take much of their time, or that you'd just like a few tips on how you can groom yourself for a job with their company. Just bring them a coffee, or take them out to lunch. Or take the receptionist out to lunch if the decision-maker is busy. Many times the support staff have as much to say about who gets a job as the people they work for.

If they do agree to meet with you, respect their time, and try to get as much information out of the meeting as possible. Follow up in a few days with a nice note, and ask them to pass your resume along to anyone in the industry they know of who is hiring. And in the meantime, you are still calling more employers and sending out packages.

This might seem like a lot of work, but it is the kind of network-building that pays off in the end. Ask some of your friends how they found their last job — chances are, it was through someone who knew someone who knew they were looking for work.

4.3 Job Hunting Materials

A resume, cover letter and portfolio are all essential when trying to get a job in the fashion industry. Even if you are applying for an entry-level job, a portfolio of work is helpful in demonstrating your commitment to

the business, and it illustrates the creative abilities that you will bring to your work.

In addition to a portfolio, you should send a prospective fashion design employer the same materials you would for any job — a cover letter and resume, both personalized.

4.3.1 Your Portfolio

You'll use your portfolio to show off all the fabulous things you've designed, in order to impress potential employers and clients with your creative abilities. Your portfolio can be as simple as a large folder filled with sketches, drawings and photographs, or it can be as fancy as an expensive, leather case. Expect to spend about $200 putting your portfolio together cheaply, or closer to $2,000 if you want to hire models and a photographer to document your work.

Luxurious or plain, it needs to be organized so that you can easily find what you want, and should include relevant information about each piece of work, including any awards or recognition it has received.

> **TIP:** In addition to your main portfolio which will go with you to job interviews, you can also prepare a mini-portfolio to leave with employers or clients. Make color photocopies of your drawings and bind the copies together. This way, the employer or client can review your work at their leisure after the interview is over. Another option is a CD-ROM portfolio (explained below) or an online portfolio.

What to Include

Prepare a cover page for your portfolio. It should be simple and to the point. A printed page with your name, address, phone number and e-mail address is sufficient. This page should be the first thing a reader sees after opening the inside cover. You can demonstrate your creative flair by using tasteful patterns or hand-decorating the cover page of your portfolio, but be sure to keep it simple enough that it doesn't detract from the rest of the work inside.

Our experts agree that you don't need to include every fashion that you've created, just the ones that will be of value to your target market. So for example, if you're trying to market a line of high-end eveningwear, then don't include any pictures of swimsuits. Your portfolio will always be a work in progress, and you need to customize it for each client. In general, your portfolio should include the following items:

- Sketches and drawings of your best designs, including front, back and side views

- A few working sketches, selected to show your creative process

- A variety of styles, to demonstrate the range of your skills

- "Flats," which are condensed drawings of each pattern piece of a garment, all on one page. You should be able to print one from your patternmaking software, or photocopy each pattern piece until they are small enough to be placed on one sheet of paper. Then make a photocopy of all the pieces together.

- Photographs of the finished garment being worn by a model, including front, back and side views.

- Sample "theme boards" you have created (details below)

You can buy the physical portfolio case at any art store or college bookstore. The size is up to you, but remember: since it will have pictures and sketches inside, you want to make sure it's large enough for the largest of them. A 10" x 14" portfolio is a good standard. (You will need a larger case for your theme boards, as detailed below.) A good selection of cases is available online at **www.portfolios-and-art-cases.com** and **www.dickblick.com/categories/portfolios/**.

Make all pages and pieces roughly the same size, even if it means enlarging or reducing the originals with a color photocopier. For a professional look, place sheets of plain translucent paper between original sketches to keep them from smudging against each other.

Finally, here's an article about career portfolios in general, from Buena Vista University: **www.bvu.edu/studentservices/careerservices/ students/portfolio/portfolioformatting.asp**.

Hiring Models and a Photographer

If you want to use cheap models, it pays to have beautiful friends. You can also post a note at your local college or university to advertise for a student model, or on the high end, you can go to a modeling agency and hire one.

A professional model from a good agency will run you about $150 per hour. However, you can also attempt (and this is a standard as well) to arrange the services of a model in exchange for some of your clothes to keep — and everyone's happy!

A professional photographer will run you about $250 per hour, plus the cost of developing the pictures. However, you may be able to work the cost of the photos into the per-hour cost as well; each photographer has their own system.

Since you want buyers and prospective employers looking at your fashions and not a fake photography set, you can have your photographer come to your home. Both photographers and modeling agencies can be located using your local Yellow Pages.

If you want to save money you can ask a friend who is an amateur photographer, or you can try your local college or university to find photography students. If you are confident and have a good quality camera, you can use the tips below to take pictures yourself.

Taking Pictures of Your Designs

- Display your finished garment on a model who is the right size for the item.

- Do the model's hair and makeup so that he or she looks nice but neutral. (You want the clothing, not the model, to be the focus of the photo!)

- The best way to shoot your models is on a nice neutral background. Stand the model against a plain wall, or a piece of seamless paper from a roll. Affix it high up on the wall and let it roll over the floor so that the model is standing on it.

- Set up several lights to shine on the model from about three feet away (desk lamps work just fine). The idea is to illuminate the outfit evenly, but not to get the lights in the picture.

- Take several photographs of every design you make. One should be a front view, one a side view and one a back view. Don't get anything else (like the lights) in the picture, but make sure you have the whole outfit showing. It is more important to have the whole outfit than the model's face!

- If you are using a 35 mm camera, you can get excellent results with 400 ASA film. Shoot your pictures in color. Set your camera's ASA setting to 125 for the best color saturation.

- If you are using a digital camera, be sure to hold it extremely steady. In both cases, you may want to place your camera on a tripod to ensure it doesn't move.

Including a Theme Board

Theme boards are meant to give a visual display of the mood and looks the designer has in mind. Fashion houses prepare theme boards for presentations to clients and customers and to focus their ideas for a particular season or line of clothing, and they also make up a significant part of your portfolio when you're applying for positions with fashion houses or looking for clients. Making a theme board is not unlike making a large collage.

To make a theme board, you'll need:

❑ A large piece of thin cardstock or Bristol board (24"x36" or larger).

❑ Swatches of the fabrics you intend to use in the collection you are illustrating.

❑ Any small bits of trim, ribbon, buttons, etc., that might be part of your collection.

❑ Small pieces of paper hand-painted with the colors you want to emphasize.

❑ Sketches of some of the outfits that you think best illustrate the theme.

❑ Other pieces of visual information that lend themselves to the overall mood of your collection — if you're presenting a collection of beach wear, for example, you might include beach postcards or pictures of beach umbrellas or starfish. If you're illustrating winter eveningwear, you might have pictures of snowflakes or firesides.

❑ Sheets of colored paper, wallpaper, fabric or other large, wide pieces of solid-colored or subtly patterned material to use as background. These also should contribute to the overall mood of the presentation. A beachwear board might have a sandy-looking background or a blue that looks like the sky, for example.

❑ A graphics pen, colored pencils, watercolors or markers, and glue.

To begin your theme board, place your blank board on a flat work surface. Lay out all the pieces you will be using alongside it. The theme board can be a vertical board or a horizontal board, whichever you prefer. Take your large piece of background paper or fabric and affix it to the board using spray glue. Consider using more than one piece of background material and dividing the background into bands of color, each one-third of the width of the whole.

Place the larger image pieces on the covered board, determining where they look best. Use your imagination and remember that you are trying to create an impression and convey a mood for your design. You might want a large central image, or several smaller ones arranged in a pattern like a triangle or a star shape.

Once you're satisfied with their placement, begin arranging the smaller items on the board. Consider where they fit, where they complement the other items and where their colors make strong statements. Place similar items together in groups or lines — don't just scatter them all over the board. Keep going until you're satisfied with the overall arrangement, then glue the individual pieces to the board.

TIP: For fabric swatches, glue only the top edge of the swatch so that it makes a flap. This way, viewers can interact with your theme by feeling the fabric.

On the finished board, make small notations with your graphics pen wherever you think it is necessary to explain something about the outfits illustrated (such as "beach costume" or "romantic evening out"). Use your own handwriting, and keep words to a minimum. You may want to use your colored paints or markers to make a few strokes to highlight areas you might want to emphasize.

Finally, allow your board to dry flat before you try to move it!

A CD-ROM Portfolio

If you are looking for work in a variety of places, a simple, economical and effective way to show off your design skills is to present your portfolio on a CD-ROM. The fashion house manager considering your work will be able to pop the disc into their computer, click a button and have a virtual fashion show of your designs.

You can also include your resume, your cover letter and as many photographs and drawings as you like on a CD-ROM, but a reasonable limit is between 20 and 30 images, or you risk losing the viewer's attention.

Shutterbug.net has an article that tells you everything you need to know about making your own CD portfolio at **www.shutterbug.net/features/ 0901sb_putting**.

You can make your own CD-ROM portfolio, or have it made for you. Similarly, you can have a website to refer people to, rather than a CD-ROM. Information about building a website follows in section 6.2.4.

If you think putting your own portfolio online or on a CD-ROM is too overwhelming of a task, Fashion Career Center will do it for you (for a small fee, of course) For information visit **www.fashioncareercenter.com/ portfolioservices.html**

4.3.2 Your Resume

Many employers make a decision about a resume within seconds. A resume containing too much irrelevant information will be rejected before the employer has even finished reading it. Therefore, instead of submitting a traditional resume focusing on each job you held and what you did, create a functional resume focusing on the skills, experience and, most importantly, the positive results of your experience.

Find a way to relate other things you've done to fashion design. For example, if you've done volunteer costume work for the local theater or designed costumes for your high-school drill team, mention it on your resume. If your experience is limited, supplement your resume with letters of reference and recommendation from satisfied supervisors, employers or instructors.

Something else to keep in mind is that you are applying for a job where appearance matters. Choose an attractive paper stock, lay it out nicely on the page, and make sure there are no typos. Ask someone else to look it over before you send it out.

If you need further help putting together your resume, you can find good information at the Monster.com Resume Center at **http://resume. monster. com** and Job Star Central at **www.jobsmart.org/tools/resume.**

4.3.3 Your Cover Letter

Like a resume, a cover letter should include basic information about you. At the very least, it should explain why you're interested in the position you're applying for and any experience or expertise you possess that would make you a good candidate for the job. However, don't just repeat the details of your resume in your cover letter.

Address your letter to the person you know is doing the hiring. Keep it short and to the point — two or three paragraphs should be plenty. Close your letter by offering to meet with the employer in person and providing your phone number. Print your cover letter on plain, good quality paper. Use a basic business style, and try to keep it to a single page.

Sample Resume

Donna Designer
123 Your Fabulous Street
Your City, Your State 12345
Phone (555) 123-4567
ddesigner@abc.com

Objective

An entry-level position in the fashion design industry where my experience and enthusiasm for designing fashions will contribute to the overall success of the organization.

Professional Experience

Sales Associate, ABC FashionWear
2004 – Present
- Assist clients in choosing garments that suit them
- Maintain inventory and assist in purchasing
- Put together attractive window displays with in-store merchandise
- Handle all in-store alterations for clients
- Attend fashion shows with owner to assist in trend watching

Owner/Designer, Designs by Donna
2003 – Present
- Run home-based business selling my designs to private clients
- Take designs from sketches to patterns, outsource the assembly
- Hosted a trunk show where I did $2,000 of sales in one night
- Current customer base of 60

Education

IRT Fashion Institute
May 2004
- Night study courses included fashion drawing, fashion history, and flat pattern drafting

Volunteer Experience

- Assistant costume designer, *ABC Elementary School*
- Model dresser, *Anytown Charity Fashion Show*

Mistakes to Avoid

Following is an example of what NOT to do in your cover letter:

Sample Letter 1

Dear Sirs:

I saw you're ad on Monsters.com. This is the kind of job I've been looking for. I'm pretty sure I would enjoy it and it would be good experience for me. I've already sent out a bunch of resumes without much luck so I hope you'll hire me. As you can see I have everything your looking for. Its you're loss if you don't hire me. Call me at 5555-1212.

Donna Designer

In the cover letter above, Donna has done a number of things wrong. See how many of these mistakes you noticed:

Mistake #1: Incorrect Salutation

Donna would make a better impression if she addressed the letter by name to the appropriate hiring manager. If you don't know who to send your letter to, do some research. Access the company's website (use the listings in chapter 4 as a starting point) and look for the appropriate hiring manager — you might be looking for the head designer in a small company, or the head of a particular division in a larger one.

If this tactic is unsuccessful (and some designers don't have a website), you can call the company and ask to whom you should send your resume and then address your letter to that person.

Even if the advertisement reads "Send letters to human resources," try to address your letter to the decision maker because, nine times out of ten, the decision maker is going to be the person you would eventually work for. The worst that can happen is that the manager of the design department will send your materials back to human resources. If there is no other way but to address your letter to an unknown person in human resources, avoid gender salutations such as "Dear Sirs," or the generic "To whom it may concern." Instead, write "Dear Sir or Madam."

Mistake #2: What's the Position?

The letter doesn't state what position Donna is applying for. A fashion house may very well have more than one available position at a time. Not mentioning the position demonstrates lack of attention to details, and it may delay the processing of her application.

Mistake #3: Typographical and Grammatical Errors

As an entry-level designer, you might be the one who is answering emails and writing up letters to business contacts, so show off your communication skills here. To many employers a sloppy resume equals a lazy employee who doesn't pay attention to details. It looks especially silly if you described yourself as "detail-oriented" in your cover letter.

Furthermore, don't rely too heavily on your word processor's spell check since it won't catch mistakes such as using "two" instead of "too." Your best bet is to ask a friend to read the letter for you; the most difficult part of proofreading anything is catching your own mistakes.

Mistake #4: Doesn't Mention the Company by Name

Donna could make a much better impression by doing a little research in order to say something flattering about the company or designer. A quick check on a website will give you a history of the company, its key designers, and its place in the fashion world. Read a company's website to find out what it prides itself on, and then mention something about what you've read in your cover letter. The best place to start would be in the "About Us" section of the site.

If you are up-to-date on their recent collection, you might mention its success, and how it is a fit with your own designs.

Mistake #5: Negativity

By stating "I've already sent out a bunch of resumes without much luck" and "I hope you'll hire me," Donna makes herself sound desperate. Employers may wonder if there's a good reason why no one else has hired Donna.

As you can imagine, writing "It's your loss if you don't hire me" does not make a good impression either. It sounds both flippant and arrogant — two traits that are not high on an employer's want list.

A More Effective Cover Letter

If you were a hiring manager, wouldn't you be more impressed with this letter?

Sample Letter 2

Ms. Jane Doe
Vice President, Design Division
ABC Incorporated

Dear Ms. Doe:

In response to your Sunday, January 1, advertisement in the Tribune, I'm writing this letter to offer myself as a candidate for the position of fashion designer with ABC Incorporated.

As someone who is familiar with ABC Inc.'s excellent products and reputation, I find that our professional personalities and goals for service, dedication and excellence are closely aligned.

As you will see in my enclosed resume, I have previous experience as an associate fashion designer, where I worked on a team that developed a new dress line that went on to become one of the company's hottest sellers that season.

My experience combined with my training in Fashion Merchandising equals a strong recipe for success with ABC Incorporated. I excel at multi-tasking, have a keen fashion sense, and have numerous letters of recommendation from former instructors and previous employers.

I would be delighted to meet with you or one of your associates at your earliest convenience to discuss my candidacy for the position of fashion designer with ABC Incorporated.

Thank you and I look forward to hearing from you soon.

Best,
Donna Designer

This letter addresses what Donna has done and can do for ABC Incorporated. Your own cover letter will depend on the position you are applying for, and the company you are applying to. It should also include your name and contact information at the top of the page.

Additional good advice on writing cover letters can be found on monster.com at **http://resume.monster.com/archives/coverletter**.

4.3.4 References

The best letters of recommendation are those written by former instructors, clients or employers. If you're designing clothes on your own while seeking a job, then every time you design for someone – even a friend or family member (with a different last name from yours) – ask for a letter of recommendation. If possible, get several copies on letterhead, which looks more impressive and professional.

When you ask for a letter, keep in mind that many people are busy. They are more likely to do what you ask if you can make it as easy as possible. To help get the kind of recommendation letter you want and make the job easier on the person writing the letter, you should outline the specific work you performed on their behalf. Chances are you remember exactly what you did more clearly than they do.

Also, supply a list of points that they might mention. They may comment on your resourcefulness, attention to detail or other attributes that are useful and applicable to fashion design. For example:

- You got the work done ahead of schedule

- You got along well with everyone on the design team

- You came up with many creative ideas

- You listened and delivered exactly what they wanted

- People have commented on the inventiveness and beauty of your designs

All of these things don't have to be included in a single letter. The specifics will depend on the particular job you did, but even a few glowing sentences can help you look good to a prospective employer.

> **TIP:** A recommendation letter from an internship supervisor or friends should preferably not mention that you worked for free. You want to demonstrate that your work has value, and you don't want an employer to assume the reason you received a glowing recommendation was because you didn't charge anything. Remember, good work is worth something no matter how much you were paid for it.

4.4 Interviews

So you sent out your cover letter and resume, and you've landed your first interview in the fashion industry — now what? You really want the job, but what do you do to make sure you get it? Well, if they give you a call, chances are they like your designs and your credentials. Now is the time to get them to like you too.

Think of your interview as an opportunity to show your talents, to let your prospective employer get to know you and to learn more about the place you hope to work. You will have the most success if you are relaxed, cheerful and confident about your abilities. This section will prepare you for the interview process so that you can be all of these things.

> **TIP:** Winnie Von Werne of the Lorelei Employment Agency says that you should plan to spend at least three years with this first employer, to maximize what you learn and show stability in your resume. Therefore, make sure that this is the kind of work environment that will suit you as well. Interviewing is a two-way street.

There are basically three steps to the interview process: preparation, the interview and the follow up. Each step is equally important if you want to land your dream job.

4.4.1 How to Prepare

Prepare for your interview by finding out everything you can about the designer or company you're interviewing with. Do research online or at the library. Research libraries at universities, colleges, or even the local design institutes have access to search engines like Lexis-Nexis and periodical guides, which can help you find company information and recent newspaper articles about the designers and company — ask a

librarian to get you started. You have to sound like you know what you are talking about to be taken seriously.

In addition, brush up on your knowledge of current fashions and designers if you haven't been keeping up. Take note of what trends are on the way in and what ones are on the way out. Brush up on your knowledge of various design styles, and be sure you are familiar with the fashion house's or retailer's latest lines. Warning: this may involve a shopping trip!

It also helps to know if they have any major clients and what those clients tend to need. If their client is Target or Wal-Mart, for example, they might be designing a great deal of practical sportswear. If their client is Elizabeth Taylor, they probably do a lot of work on glamorous gowns. Also check out competing fashion houses and what they are up to.

Think in advance about how you would fit into the fashion house's team. This could be fairly clear if you know you're being interviewed for a specific position. But if you're being interviewed for a general position, in which you'll likely do a bit of everything, think about how you'll get along with the other workers already there.

4.4.2 How to Dress

What you wear to this interview might be more important than it has ever been in your life. (No pressure, right?) The clothing you put together should reflect your taste, your style, and your knowledge of recent trends. It doesn't have to be clothing from the designer you are interviewing with. It just needs to show that you are up-to-date, or even in the know about what's about to break out in the world of fashion.

Whatever it is you wear (including accessories), be prepared to talk about it. Know who designed it, why it is a good piece of design, what it is made of, and how it was assembled. Even have an idea of how you might alter or improve it.

You might consider wearing something you designed to an interview in order to impress the interviewer, so long as it is tasteful and fits with the company's overall dressing style. If it is outlandish and runway-style, Winnie Von Werne of the Lorelei Placement Agency says don't do it — you run the risk of putting off a more conventional employer.

Also, think about the message you could be sending when you wear your designs to an interview. "I think I'm better than you and all your competitors, so I wear my own designs to important occasions," says Von Werne. It's not a given, but it is a possibility.

One of the best ways to figure out what to wear is to make a trip to the designer's office before you interview, if possible. This might be when you are dropping off your resume and portfolio. Make a note of how the employees dress in the department you are applying to, or at least the people you see coming and going. If you look like an employee at the interview, you position yourself that way in the employer's mind.

If you're totally stumped, the rule of thumb is to dress more formally than normal, as it is better to err on the side of too dressed up than comparatively sloppy — you can always pull out the sandals and T-shirts for after you have the job.

A few additional dressing tips that apply to any interview:

- Appear neat and clean — men should be clean-shaven, or well-trimmed if you have facial hair.

- Buy the best quality clothing you can afford to wear.

- Highly polished shoes still make a positive impression.

- Don't wear any cologne or perfume — some people are sensitive.

- Practice wearing your interview clothes until you are comfortable in them. Your focus should be on the interview and interviewer, not on adjusting your new clothing.

4.4.3 Make a Great Impression

Here are some tips to help you make a great first impression:

- Show up on time, or better yet, show up ten minutes early.

- Introduce yourself with a strong handshake and a smile, and know how to pronounce the name of the person or people you are meeting with (an earlier call to the office will clear this up).

- Plan on spending at least half an hour to an hour for an initial interview and allow for the time in your schedule. You don't want to be a clock watcher during your interview or, worse, have to cut the interview short so that you can make another appointment.

- Try to be positive, confident and relaxed. Think of it as a conversation, not an interview.

DynaStaff.com has an article with tips on how to relax before an interview: at **http://dynastaff.com/intv_reduceanxiety.htm**.

4.4.4 Questions to Expect

Here is a list of common interview questions, with suggested answers from our panel of experts. It's a good idea to prepare some answers of your own before the interview. It's also helpful to role play an interview with a friend so your answers will come naturally.

Q: Why do you want to work for our company?

Fashion designers, of all people, do not want a cookie-cutter answer, so do your research. Read the company's website in advance, and give them as honest an answer as possible. Hopefully your research has turned up similarities between the designer or company you are interviewing with, and your own design concepts and ideas. Express informed admiration (but not fake flattery) for the company or designer, what they have done, and where you think they are headed.

Q: What are you doing now?

The employer wants to know if you're currently in the business. If so, they'll want to know if your current duties and responsibilities match those of the position you're applying for. Be sure to tell them about projects you are working on if you have been designing on your own.

If your last job was not as a fashion designer, be prepared to point out similarities between what your job entails, and what you will do for them. For example, if you have worked with engineering software, explain that you believe it will therefore be easy to pick up the clothing design software they use.

Q: What kind of position are you looking for?

The employer is trying to get a feel for what interests you in a position. You can be relatively honest about wanting a position with stability or growth potential, but don't go on too long about what you personally want and need from a job — e.g., every Tuesday and Thursday off, or a company car. Try to match your answer to what you think the position will entail, so long as it fits within what you are looking for.

Q: What experience do you have with _____?

Depending on the company, they may want to know your experience with designing, computer programs and so on. Be honest about what you do and don't know, but offer to learn, even starting before the job does. A quick learner with a good attitude will often have an edge over a more experienced but less pleasant person. While you can learn basic information on the job, attitudes can't be taught as easily.

Q: What are your strengths?

Your perceived efficiency is important, both in the design room and on the production floor. An ability to meet deadlines is crucial, as is creativity and an eye for color and design. You know what you are best at — match these skills to the job at hand.

Q: What are your weaknesses?

This is a self-assessment question, and it's okay to know your weaknesses — we all have them. The best way to answer this question is to put a positive spin on your answer. For example, you might say "My CAD skills aren't where I'd like them to be, but I'm enrolled in a course to improve those skills." That answer tells the interviewer two things: first, you have the strength of character to recognize a weakness and, second, you have the wherewithal to do something positive about it.

Q: Where do you see yourself in five years?

Stable employees who are in for the long-term are highly desirable. Winnie Von Werne says hopping from job to job will immediately raise a red flag with most hiring managers. If you have already done so, be prepared to explain (without badmouthing former employers or blaming coworkers) why you have moved around so much. Especially in the competitive

world of fashion design, an employee who doesn't stick around long might look like they are snooping for the competition.

Q: How do you feel about overtime?

A cheerful willingness to work is important. When fashion houses get busy, you will be working hard, doing things quickly and, in many cases, working past five o'clock. Your positive attitude will help you through these times.

Q: Define being a member of a team.

This is one of the most important questions you will be asked. Fashion design is not for loners; you have to be able to communicate and work with others. You can use examples of how you have interacted well with others in the past to demonstrate your teamwork skills. Express a commitment to doing quality work and working together efficiently.

Q: Tell me about a time you experienced conflict with a co-worker. What happened, and how was it resolved?

An ability to solve problems in a creative, appropriate manner is essential. The interviewer will not be satisfied with a hypothetical answer about what you "would" do in such a situation. They want to hear about an actual time you experienced conflict. The purpose is not to see if you have ever had a conflict (they expect that you have), but is to see how well you resolved a difficult situation and if something did not work out in the past, what you learned from it.

Q: Do you have any questions for us?

"Yes" is the appropriate answer here. Take the time to do some research, and be prepared to ask a few very pointed questions. Interviewers want an interview to be interactive, not just them sitting behind a desk spouting corporate rhetoric. You should be prepared to keep up your end of the conversation.

Find something current the company is doing or has done and ask questions on that subject. For example, "I read in one of your press releases that your revenues are up 10 percent due to increasing international customers. Was this part of a specific business plan and would this affect the way your department conducts business?"

Ask about anything that makes you curious, as long as it is focused on the fashion house at hand. You might ask any of the following:

- What are you looking for in an employee?

- What would your expectations for me be during the first six months on the job?

- What is your department/division's current plan for growth, and how would I fit into that plan?

- How does your company differentiate itself from the competition?

- What is your creative philosophy?

- How is the company organized?

- How often do members of the department meet with each other?

Save these questions for another time:

- How much will I get paid?

- Do I get to wear the sample clothes?

- Will I get an employee discount?

- What famous people wear your designs?

- What do you think about Designer So-and-So?

TIP: Personal questions, such as questions about your religion, marital status, children, and your general health are not legal in job interviews. If you are asked any of these, you may politely decline to answer, and you should steer the conversation back to your experience and abilities. For example, if you are asked about whether you have children, you might say, "I prefer not to discuss my personal situation. However, you can rest assured I will perform this job with the utmost dedication."

4.4.5 Following Up

Following up after an interview is as important as the interview itself. Your follow up should be in the form of a letter or email to the person or people with whom you interviewed. Your note should achieve three things:

- Thank the interviewer for his or her time.

- State that you wish to continue the interview process with their company.

- Make one final sales pitch as to why you're the right person for the position.

Sample Thank You Note

Marguerite Sylvie
Personnel Director
Fabulous Fashion
1234 Another Street
Glamourtown, MI 44443

Dear Ms. Sylvie,

Thank you so much for taking the time to interview me this afternoon. I enjoyed meeting with you and hope you'll agree to have me join the team as an assistant designer at Fabulous Fashion. I liked the dynamic atmosphere of your company, and spent a few minutes admiring your back-to-school theme boards on my way out. I've got some great ideas for the holiday season, and can hardly wait to put them to work.

I'm eager to make a contribution to the growth of your business — please give me a call at 333-4444 as soon as you've had a chance to make a decision.

Regards,
Donna Designer

4.4.6 Discussing Salary

If an employer is interested in hiring you, they will bring up the issue of salary. To maximize your offer, try to get the employer to state a figure first. If you are the first one to mention a specific salary figure, you risk low-balling yourself or, worse, pricing yourself out of consideration.

A fashion house may have a salary range already set. If that's the case, you should ask if it includes benefits and, if so, which ones. Benefits could include practical things like medical insurance, or enjoyable things like extra vacation time, flexible hours and even sample clothing to wear.

If you feel you need to ask for a higher starting salary, it helps to point out the skills and experience you'll be bringing to the business. Explain how those abilities will contribute to the shop's bottom line. It doesn't hurt to ask for more money than you're offered, but be realistic.

When you're discussing salary, it helps to know what the going rate is for similar work being done in your area. In addition to the salary figures in section 4.1.3 of this guide, you can find salary information online at **www. salary.com** (allows you to search for salary ranges based on job description and location.) and **www.salaryexpert.com** (average salaries in Canada and the United States).

5. Starting Your Own Business

Fashion design is a creative business. For some people, an office job or working for someone else is a stifling choice that limits their creativity, and they need the freedom of being their own boss. If the confines of a traditional job cramp your style, then you'll be happy to hear that 3 out of 10 fashion designers are self employed — almost five times the average for most professional and related occupations, according to the Bureau of Labor Statistics.

Before you can get to the fun part of having your own fashion design business, though, you have to plan and prepare. The many details involved in starting your own business can be overwhelming, but you can avoid the paralyzing effects of having too much to do by creating a checklist and taking things one step at a time. This chapter of the guide will cover each of these steps:

- Writing a business plan

- Determining start-up costs and getting funding

- Handling business matters

- Renting studio space, or setting up a home studio/office

- Buying needed supplies and equipment

- Getting an order fulfillment system in place

Depending on the scope and size of your personal plan, not all of the steps in this chapter will apply to your business. You might be planning on making all of your own clothes, so you don't need to hire a manufacturer. Maybe you will work out of your home and won't need to rent a workspace. Take things at your own pace, and plan accordingly, but don't limit yourself — you never know how big you will grow.

While some businesses simply don't do well, just as many businesses fail because they didn't plan to grow as quickly as they did. Once you've considered all the details and have the necessary elements in place, you'll be able to hit the ground running. Why be a starving artist when you can be a successful one?

5.1 Creating a Business Plan

Business planning involves putting ideas on paper. It's an important step not only for getting funding from a bank, but also for focusing your attention and helping you define your business. If you make the effort to draw up a good plan now, you can be confident that it will pay off in the future.

If the prospect of writing a business plan sounds daunting or confusing, hang in there. We'll go through the process step-by-step, and include resources for further help writing your plan and mini-samples so you can get an idea of the style and content of each section. (Your actual plan will in most cases be much more in-depth than the samples.)

First of all, your business plan will be divided into these four main sections, as well as a few items we'll cover together at the end: a description of your business, your marketing plan, your financial management plan, and your management plan.

5.1.1 Description of Your Business

A description of your business is just that — a description of the design business you plan to start and run. The trick is to include the unique and special things about your business so that everyone who reads your business plan will know you're on to something really fabulous.

You'll need to state whether you'll be operating a product-based or service-based business, or a little of both (as discussed in chapter 6), but chances are if you are writing an in-depth business plan, you have opted for selling a product.

Don't be afraid to get specific about the types of clothes you'll be designing. If you are going to specialize in bridal gowns or handbags, for example, state that in your description. The idea is to paint a picture of the business you plan to start, as well as how you plan on operating and producing the service and/or product. Describe how your clothing will be produced. You may wish to highlight the resources to be used (supplies and equipment) and the process involved in the production of your clothing.

Will you have employees? As an entrepreneur, you should decide what your true strength is and where you need assistance. Many "creative types" need help with financials and numbers, so it may be a good idea to hire or contract an accountant. Margins and profits need to be watched closely to keep the business viable, so you can't neglect these things because you don't understand them.

You may also want to only focus exclusively on researching trends and designing the line, and have the assistance of someone who can do all the technical construction and sourcing required to make and market your collection. You should also explain what the legal structure of your business will be. Will you have a sole proprietorship, for instance, or perhaps a partnership? You'll learn more about types of businesses a little later in this chapter.

Also in this section, you'll need to explain why your business will be profitable, and how your fashion house will be different and better than any others in the area. What do you plan to offer that will have clients beating down your doors begging for your designs?

Describe your business hours. As a fashion designer, you'll most likely need to have flexible hours to accommodate the schedules of your clients and to meet deadlines. But if you plan only to work from 10:00 a.m. until 2:00 p.m. three days a week, you should make that clear. Also, you should identify the planned location of your business, the type of space you'll have and why it's conducive to your business.

Sample Description of Business

Deziine is a full-service design studio for women's clothing.

Deziine will create a prototype from customer specifications or from Deziine's own ideas. Once the prototype is made, the customer can then license the product and market and manufacture it as their own. This service is especially useful for stores and manufacturers that do not have an in-house design studio, or that need to go beyond their own design departments because they need new ideas or need increased productivity.

Deziine creates designs per specifications given to them by a manufacturer as well as creates designs independently that have marketable value to other companies. These companies can take it upon themselves to search for the right company to market and manufacture the product.

Deziine is a sole proprietorship that was founded by John Smith. John's design studio is based out of his home in Capital City. John has one office assistant who helps with accounting, bookkeeping, and order taking. Deziine's hours of operation are Monday through Saturday, 8:00 a.m. to 6:00 p.m., and will remain open later, when necessary, to allow for time zone differences.

Deziine's competitive edge is creative imagination and industry expertise. With more than 15 years of design and sewing experience, John has learned to provide creative solutions to design and manufacturing constraints. John is able to approach a project from a different angle, especially from a cost-benefit analysis, and see it from concept to completion.

Conclude the description of your business by clearly identifying your goals and objectives and supporting them with information and knowledge you've acquired about being a fashion designer. This is important, because it's here that you're explaining exactly why you're starting the business and what you hope to accomplish with it.

5.1.2 Your Marketing Plan

A potential investor or partner will know that how well you market your business has a lot to do with the degree of success you'll experience. A good marketing plan will define your market with concrete facts, and show that you know your customers.

Your marketing plan must address the existing market for your designs (a market analysis) as well as how you plan to spread the word about your company (a market strategy).

Market Analysis

In order for readers to understand your business plan, they need to understand your industry. The purpose of a market analysis is to describe the industry that your business will be operating in. You must collect accurate, relevant, and up-to-date information related to the fashion industry. Your market analysis should include:

- A description of your target market (customers, geographically and/ or type)

- The principal factors that your customer considers when purchasing

- The benefit that customers get using your company rather than others

- Industry trends (past and future)

- A description of any weekly, monthly or seasonal sales patterns that might affect the market

A sample market analysis appears on the next page.

Sample Market Analysis

The fashion industry is an ever-evolving fast-paced business where ideas are created constantly to keep up. Apparel manufacturers and retailers are constantly searching for new ideas and fresh outlooks on design and manufacturing processes to stay ahead of the game.

Apparel manufacturing remains one of the most in-demand businesses today. According to the American Apparel and Footwear Association, apparel sales for 2004 reached $320 billion, representing a 10 percent increase from the previous year.

Deziine's customers can be divided into two different groups:

- Manufacturers who need some design assistance and do not have in-house designers.

- Retail stores who want to purchase ideas from a variety of designers and then manufacture and market it themselves in their own stores to create a private-label brand.

As with most industries today, apparel manufacturers and retailers are constantly looking for ways to save money. This has led to cutting in-house design staff and contracting work out to freelance designers for manufacturers, and spearheading their own private labels for retailers.

Deziine can provide seasonal designs for both manufacturers and retailers, producing designs for spring, fall, and holiday lines. Because Deziine has not only design expertise, but also manufacturing knowledge, its designs will be both fashionable and cost-efficient.

Market Strategy

Once you've used the marketing analysis to explain your industry, the marketing strategy will indicate specifically how your business will fit into the industry. You'll need to explain how you'll promote and advertise your business, making sure that whatever means you choose accurately portrays the image you want to convey. It should include:

- A description of your competitors and your competitive position

- Your planned pricing (versus your competitors)

- Your promotional plan and strategy (media advertising, trade shows, direct mail, etc.)

- Distribution strategies (where customers go to buy your product, how you will distribute your product, and provide customer service)

Sample Market Strategy

Deziine's competition are local and national design firms and independent contractors. Most of these established firms are national and do not provide the customer service and face-to-face service companies desire today.

Deziine will focus only on a local level in the beginning to build their clientele, and expand to a regional level, but only within a geographic area that will allow frequent, customized, personal service. Along with Deziine's creative and manufacturing knowledge advantage, it will be the attention to the customer that wins client confidence.

Personal contacts are essential to any entrepreneur starting a business, and this is where Deziine will devote most of its promotional energy, as the name needs a face in the design industry. Making personal contact with a firm that is planning to launch a label may secure a design contract. Meeting with brand manufacturers who need assistance on their design team can have more impact than mailing out a small brochure.

Deziine's potential customers will see advertisements in trade publications (which are targeted to only industry personnel) consistently and repeating the same size ad over a six-to-twelve month period. Deziine will also use a professionally designed web page to advertise the company and showcase its portfolio of work rather than printing brochures and catalogs.

Deziine will also attend seasonal trade shows in the U.S. and Europe to do some personal, face-to-face networking and keep up on what the current trends are.

5.1.3 Your Financial Plan and Projections

A strong financial management plan is crucial to getting the funding you need. For this reason, anyone who is not good with numbers should consider hiring a business consultant to help them develop accurate financial figures, especially if you are going to turn around and use your business plan to request a loan.

It is critical to remember that any plan, no matter how well thought out, may need adjusting in practice to meet market conditions. In business, anything can happen at any time. Those who are flexible and adapt to changes in the industry are the ones who will not only survive, but thrive as well.

An investor will want to know your startup estimate (what you anticipate your startup costs to be) and your revenue projection (what you antici-pate your incoming money to be). Once you have these two documents, you will use them to break down how much money you need to make weekly or monthly in order to break even (a break-even analysis) and how you anticipate your sales to be over the next 3-5 years (an income statement). Each of these is explained in more detail below.

Startup Cost Estimate

This is the total of all the expenses you will incur before your business opens. Section 5.2 contains a list to help you determine what these costs will be. Make sure you do some research to get accurate costs. Call vendors, suppliers, and service providers and speak with someone about what you are looking for. While you can't expect to be a hundred percent accurate, you at least won't have any nasty surprises when you go to obtain services or buy equipment.

Revenue Projection

Revenue projections refer to an estimate of anticipated sales. These estimates are usually done on a weekly, monthly or quarterly basis and are used to project the amount of money required to finance your busi-ness, even on a day-to-day basis. It will show you how much money you will have month-to-month and year-to-year.

To determine what your sales will be, you will need to state how much of the market you plan to start with (a percentage or number of customers). Then you will explain what factors will cause the market – and/or your share of it – to grow, so that your cash flow will increase and you can pay back any loans.

To get the correct figures, be sure you verify industry data and any outside trends that may affect sales levels. Once you have your sales forecast, multiply it by the average price you expect to charge. From that, you will arrive at your projected revenue.

Break-Even Analysis

At what point does your income match your expenses and overhead? This document details the amount of sales required to cover all costs associated with selling your product (or service) on a monthly and yearly basis. When you are covering all your expenses with sales, that's called "breaking even." When your sales exceed your expenses, that's called "making a profit," which is also called "good!" Once you have this figured out, you can then determine what kind of profit potential your company has, as well as point out where to control your costs.

Income Statement

The income statement, or profit and loss statement, really just pulls together the other documents and uses them to show how much of a profit you plan to make over a period of time — quarterly, yearly, and sometimes for the next three to five years. Don't show a loss, or you won't get the loan!

The statement should cover a period that makes the most sense for your business. In fashion, there are anywhere from two to six selling seasons, so you may want to do one for each of your collections (for example, if you have a spring and fall line, do this twice a year).

Your financial plan also should address the accounting system you plan to use. Many small business owners handle their own accounting, using software such as QuickBooks (**www.quickbooks.com**), while others hire someone to set up a system.

5.1.4 Your Management Plan

Management and staffing is a very important section of a business plan. Lenders often say they invest in people, not in businesses. You will want to inform the reader of your business plan that you have the necessary fashion and design expertise and the experience and resources to be able to succeed in the industry.

Sample Management Plan

Deziine will be a sole proprietorship, owned and operated by John Smith. John will be in charge of all operational, marketing and managerial functions within the company. One employee will be employed to take care of accounting and bookkeeping, and order taking.

John Smith (President): John Smith has worked in the fashion industry for 15 years. He started his career working as a design assistant at Funky Fashions in Capital City. After eight years, he worked for a local manufacturer designing custom clothing for high-end boutiques and department stores. For the last five years, he has worked exclusively as a designer for a private-label program for a national department store. These skills will be applied throughout Deziine to foster the competitive edge required to compete in the North American market.

Deziine will employ one full-time person to do the bookkeeping. This person will be hired on the basis of their financial and accounting skills along with some experience in customer service and order taking. This person has the potential to move up in the company and oversee order fulfillment procedures.

Your management plan should address issues such as:

- Your background and business experience and how they'll benefit your fashion design business

- The members of your management team (even if you'll be the only member)

- Who will be assisting you in this business (investors, consultants, etc.)

- The duties for which you and any employees will be responsible

- Plans for hiring employees, either now or in the future

- A general overview of how your business will run

- Any labor market issues

5.1.5 Additional Material and Information

Executive Summary

The executive summary can be the most important section of your business plan because people will read it first. It may even be the **only** section they read if it isn't well done. Although it will be printed out first, the executive summary should be done last after you have completed the other sections.

The key to a good executive summary is that it should be short (two pages at most); it should highlight what is important in your plan; and it should get the reader excited about your business. A sample executive summary appears on the next page.

Other Items

Your plan should also include the following extra material and information:

- **A cover sheet:** This identifies your business and explains the purpose of the business plan. Be sure to include your name, the name of the business and any partners you might have, your address, phone number, email and other pertinent information.

- **Table of contents:** This goes just under your cover sheet and tells what is included in your business plan. Use major headings and subheadings to identify content.

- **Statement of purpose:** It is important to have a long-term vision of what you want your fashion business to become. Some businesses use this section to highlight their business philosophies and/or to show the importance that their business places on developing good relationships with customers and employees.

- **Supporting documents:** Include your personal (and business, if applicable) tax returns for the past three years, a personal financial statement (get a form from your bank) and a copy of a lease or purchase agreement if you're going to buy or rent office space. You can also include your resume, and a portfolio of examples of your design ability (sketches and/or photos).

Sample Executive Summary

In a time when most products, including apparel, are being mass produced, there is a need for individuals to not only feel unique, but to have proper fitting clothing. Deziine will address this need.

A sole proprietorship owned and operated by fashion designer John Smith, Deziine will sell its designs and prototypes to stores and manufacturers. It will initially operate as a home-based business, and will graduate to a small downtown showroom after two years.

John will be in charge of all operational, marketing and managerial functions within the company and will acquire a bank loan for $50,000 to buy sewing equipment and software, run an advertising campaign to launch the line, and purchase materials and supplies.

Deziine would like to gain a market share of 3.5 percent in its first year, rising to 15.5 percent by the third year. Of the 3.5 percent, it is anticipated that 1 percent will come from local shops and boutiques, 1 percent will come from new customers, and 1.5 percent will come from licenses with manufacturers.

The market for custom women's clothing design is roughly $8 million per year. Our research indicates that there is potential for another designer in this market that specializes primarily in fashion-forward styles.

5.1.6 Business Plan Resources

Many entrepreneurs use the United States Small Business Administration (SBA)'s business plan outline as a model when writing this document. You can find it at **www.sba.gov/starting_business/planning/ basic.html**.

The Canada Business Service Centres (CBSC) also provides a sample business plan and other helpful resources at **http://bsa.cbsc.org**. American Express offers a user-friendly guide at **www133.americanexpress. com/osbn/tool/biz_plan/**

5.2 Financial Matters

Financial matters are at the heart of every business, and there's no getting around it. With all the uncertainties associated with starting a business, there's one thing you can be sure of: you're going to need money to get your business up and running and to keep it operating smoothly. Let's take a look at your money matters.

5.2.1 Your Expenses

To begin, let's look at what your major expenses will be when you start up your fashion design business. Note that not all these expenses will apply to your business, but they are the big ones to keep in mind.

Operations Equipment

This will include a computer, software, printer, scanner, fax machine, telephone, cell phone, commercial sewing machine, serger, and any necessary drawing equipment. It is a good idea to go to one shop to get all your computer and electronic needs, as you should be able to negotiate a package deal.

For a commercial sewing machine and serger, check for secondhand or demo models which will still give you good value. You can expect to spend in the range of $5,000 on these items, depending on what you may already have on hand (for a detailed equipment and supply list, see section 5.5.1).

Website Development

Registering your website name, creating and developing your site, and hosting fees will likely cost you several thousand dollars. This is mostly a one-time fee for building the site. You should be sure to have a clear outline and/or storyboard of how you intend the site to look and function, as changes and additions can result in extra fees.

Trade Show Booth

You can always just use the table and curtains that the trade show provides with registration, but having a booth strengthens the image you want to portray. These booths cost several thousands of dollars, minimum, to have made, and fees to attend the show will range from several hundred to more than a thousand dollars. Attending trade shows will be covered in section 6.4.3.

Advertising

As advertising will cost you thousands of dollars, be sure to clearly define who you want to target and advertise with a publication. This money can be wasted if you have not done your research, and sometimes may take a few mistakes to refine. You should aim to be **repetitive** and **consistent** in your advertising so potential customers begin to recognize you, which is why this is such a major expense.

Fabric

How much you will spend on fabric depends on how much production you have going on, but be aware that this is your "raw material" and will be a major percentage of your expenses. At a bare minimum you will need to make some samples to show potential buyers and customers and also to offer fabric selections to different styles. You can always keep an eye out for well-priced fabrics, and learn to shop wholesale to save the tax (see section 5.5.2 for information or purchasing fabric).

Printing

Even if you have purchased a good printer that can print good quality brochures, line sheets (illustrations of your collection, descriptions, price, availability, etc.), and catalogs, you will still need to purchase the right paper, have the right photos, etc.

Forgotten Expenses

In any business, items and situations often arise that were not considered, and therefore, no one planned for them. Here are some expenses that often catch new fashion designers off guard:

- Mistakes in production

- Proper labeling

- Trend or fashion consultant fees

- Wrong fabric shipped/ordering errors

- Linings and notions to produce a style

- Equipment repairs and maintenance

- Travel and trade shows for research and promotion

- Warehousing

- Shipping

- Sample production

- Packaging

- Deposits and COD payments required for new accounts with utilities or suppliers

- Direct mail lists

You may consider hiring a graphic designer to assemble your idea, and look at building a relationship with a printer who can give you a discount for repeat business. Count on this costing you a few hundred to a few thousand dollars. Section 6.2 has more on printing costs and options.

Other Major Expenses

Other major expenses can include:

- Rent ($1,000 or more if you don't work from home)

- Legal advice ($100 or more an hour)

- Insurance

- Licenses

- Permits and memberships

- Stationery and office supplies

- Utility deposits

5.2.2 Your Budget

You will need to prepare two budgets before you start your business. The startup budget includes all the costs necessary to get your business up and running. The operating budget includes ongoing expenses, such as advertising, utilities, rent, etc.

If you begin your business in your own home, then your initial startup costs might be nothing more than the necessary supplies needed to make your fashions. However, even if you don't have upfront costs for merchandise, you will have other costs such as money you may want to invest in finding buyers of your goods.

Additionally, once you sell your goods to a retailer, it will be your sole responsibility to pay up front all the costs of having your line manufactured and delivered to your retailers. While manufacturers are always willing to negotiate payment, you will need to have some cash in the bank for this part of the process.

TIP: Many entrepreneurs fail because they underestimate the expenses of doing business, or they project their income based on wishful thinking rather than solid research. The standard rule of thumb is to have three to six months living expenses set aside over and above your start-up costs.

See the worksheets on the following pages to help you start thinking about your budget.

Startup Budget Worksheet

Your startup budget should include at least the following (some expenses will be particular to your situation):

Licenses and permits $_____

Deposit on lease for office space $_____

Insurance $_____

Supplies and raw material $_____

Consulting fees for start-up $_____

Launch advertising and promotions $_____

Utilities (electricity, water, etc.) $_____

Payroll expenses $_____

First loan payment $_____

Internet connection $_____

Personal manufacturing equipment $_____

Office equipment $_____

Phone service $_____

Website development $_____

Design software $_____

Cell phone $_____

Drawing equipment $_____

Furniture $_____

Operating Budget Worksheet

Your operating budget should include at least the following (some expenses will be particular to your situation):

Three to six months of personal living expenses $_____

Insurance $_____

Rent $_____

Ongoing loan payments $_____

Ongoing advertising and promotions $_____

Sales commissions $_____

Manufacturing $_____

Trade show attendance fees $_____

Legal and accounting fees $_____

Supplies $_____

Utilities $_____

Dues and subscriptions and memberships $_____

Taxes $_____

Website maintenance $_____

Maintenance and repairs of equipment $_____

Business development (travel, meals) $_____

Conferences and seminars $_____

Inventory purchases $_____

Postal/shipping $_____

Research and development $_____

Storage $_____

5.2.3 Keeping Expenses Manageable

Many fashion designers work freelance or part-time from home until they can get established. It used to be that working from home was viewed as less professional than working in an office. However, with so many companies hiring contractors rather than employees, the image of working from home has been upgraded. You can always apply for funding to expand your business when you are better established.

Keep a tight handle on your finances until you get a feel for what it takes to run your business. Here are some tips on how you can operate on a shoe-string budget, if necessary:

- Find creative ways to cut expenses, such as doing trades with contractors (you trade them clothes for their services) or making the most out of a piece of fabric by using scraps to dress up other outfits.

- Do your homework and know where you can be generous and where you can take shortcuts, such as whether it's more eco-nomical for you to buy your own copier or use a copy shop.

- Some expenses are ones that will save you money in the long run, such as purchasing software that will increase your efficiency, speed and ease of design. Also, don't skimp on promotional items such as stationery and brochures that are the outward face of your business.

- Use friends as models and photographers for catalog, merchan-dising manuals, print ads and fashion shows.

- Provide a design consulting "service," along with a small amount of product if you wish. This means you will not have to carry an inventory or as much equipment, as you only need your expertise.

- Use word-of-mouth advertising instead of paying for ad campaigns. Tell everyone you meet, anytime you can, what you do. Wear some of your clothing, and give it to your friends to wear! You can find more ideas for self-promotion on a budget in Chapter 6.

- Collect Air Miles as often as you can, as you can use the points to offset travel expenses to trade shows or meeting with potential customers.

5.2.4 Funding Sources for Your Business

Depending on your start-up costs, you may find you have all the money you need to get started in your savings account. If your own resources won't cover all the things you would like to do with your business, you will need to look for financing.

The process of thinking through a plan for your business will have prepared you for discussions with banks or other lenders, to effectively present yourself as a successful fashion designer-to-be.

Getting a Loan

In addition to your business plan, a potential lender or investor will want to see a loan proposal, which outlines specifically how much money is needed, and how the money will be used and paid back. It should include:

- How much money you want

- How long it will take you to pay it back

- Details of how you plan to spend it

- How you will get the money to pay it back

- What collateral or assets you have

As many different outlines are available for preparation of a loan proposal, you may want to contact your commercial lender to determine which format is needed.

When you prepare this document, ask for a little more money than you need. No matter how good their business plan is, most people underestimate the amount of money they need. It is difficult to go back to the bank and get more money when you've just gotten a loan, and it will make the bank very concerned. Get all you need at once, even if it seems

like too much. If you do end up with "extra," hold on to it, and use that money to begin paying back the loan.

What Can Help You

Criteria that will positively affect whether you get the loan include:

- Your personal credit rating
- Your capacity to pay back the loan personally if the business fails
- The value of your collateral
- Your character (as perceived in the community)
- Your personal commitment to the business
- The clarity and completeness of your business plan
- The viability of the business concept
- Your management team
- The suitability of your personality to pressure and responsibilities of business
- Your personal experience in the industry

What Can Hurt You

Criteria that will negatively affect whether you get the loan include:

- Your business idea is ill-advised or too risky
- You do not have sufficient collateral
- An insufficient financial commitment on your part
- Incomplete business plan
- Reason for requesting loan is unclear
- You do not appear confident or enthusiastic

Business Lines of Credit

A line of credit is discretionary money lent by a bank for operating expenses. Unlike a loan, a line of credit means you pay interest each month only on what you use and as you pay off the principal it becomes available again, with no need to re-apply. The advantage of a line of credit over a loan is that you usually don't pay the interest on the part of the line of credit that you do not use.

You should establish a line of credit at a bank for your business even if you don't intend to use it. You don't want to have to go through the process of applying for a loan if you only need some short-term cash. And you never know when you may have to pay suppliers for their services before you get paid by your client. You can have, and use, that line of credit for a lifetime. Using a credit card will provide a printed monthly purchasing record for you to easily reconcile and track purchasing as well.

Getting a line of credit (or a business credit card) shouldn't be difficult if your personal credit history is good. If you've had bad credit in the past, you may run into problems, but it's still possible to get credit. Many credit card companies will issue "deposit backed" cards for those wishing to reestablish or improve spotty credit. Keep in mind that these lines of credit generally have a much higher interest rate than most, so try to pay balances off in full whenever possible.

There's not much more to getting a line of credit than applying at your bank to see if you qualify and to see if it suits your needs. It should:

- Allow you to select the features that best suit your needs

- Include simplified expense and cash flow management

- Include optional employee cards with distinct purchasing limits

- Earn Air Miles or some other rewards, if possible

You can also make purchases with an ATM debit card, but you will not get the same detailed report of what you have purchased, and it is more likely to earn your business an audit from the IRS because it looks shady. Better than paying cash, though!

Tips For Getting the Money

- Have an extra copy of your business plan available for the potential lender's inspection, and be able to speak clearly and concisely about your plans and goals.

- Get an introduction or referral. If you can get someone who is respected in the community to introduce you to a potential lender, it gives you credibility and a big advantage.

- Be professional. Shake hands, speak with confidence and look the person you're talking to in the eye.

- Dress to impress. Lenders will be trying to assess your character as much as your business plan. Dress like you are on an important interview and you will look like someone who is intelligent, organized and can be counted on to repay your debts.

- Don't just tell your banker about your business; bring samples of your clothing and show them what makes it so great.

- Show passion! Get them excited! One of the most persuasive things you can do when you are negotiating a loan is to show how much passion you have for fashion design, and that you are prepared to do anything possible to make the business succeed.

- You will have to convince them that you want to be a fashion designer with staying power, not here today, gone tomorrow. Present yourself as a "product designer" who is business-savvy, not just someone who wants to sit at home and make clothing.

- Be receptive. Even if you are turned down by a prospective lender, you may be able to get ideas and suggestions for improving your business plan. Don't be afraid to ask questions about why your loan was declined, if this happens.

You can find some additional advice about financing at the SBA website (**www.sba.gov/financing**), Nolo **(www.nolo.com**, click on "Business Financing under "Small Business") and the Business Development Bank of Canada (**www.bdc.ca**).

Factors

Boutiques and department stores typically pay 30 to 60 days after the order is delivered to them, so you may need to secure a short-term loan against the receivable in order to pay your manufacturer. This type of loan is so common in the garment industry that specialized finance companies, called factors, are often used for this purpose.

A factor is a financial institution that will buy your invoices or receivables, and advance you most of the money you are owed so you don't have to wait to get paid, or risk not getting paid at all. Of course they charge a fee for this service, which will vary depending on the credit risk of the company that owes you money, and the amount they are financing.

Factors are common in the apparel design industry, as many fashion designers would prefer to focus on the design end of things and not have to worry about collections from buyers. You may need to have your first season of orders in from retailers in order to begin seeking loans from factors, as they will need to see that you can sell to a number of good stores rather than to a single guardian angel.

Orders are submitted to the factoring company for approval, and when approved, the invoices are assigned to the factor, who supplies immediate cash, usually equal to 90 percent of the receivables' net value (the other 10 percent is usually held to cover returns, allowances, etc.). The factor then proceeds to collect payment from the customers and takes the credit risk.

For their services as a credit and collection department and guarantor of credit risks, factors receive a fee known as a factoring commission, and interest on money loaned out before collection on the receivables.

In the U.S., you can contact any of the following factor companies, or do a search yourself on the Internet to find one you would like to work with. (We cannot recommend which company, if any, would be right for you.)

- *Capital Access*
 www.capitalaccess.com

- *Continental Business Credit, Inc.*
 www.cbcredit.com

- *CIT Group*
 www.citgroup.com/main/default.htm

- *Stonefield Josephson Accounting*
 www.sjaccounting.com

You can find a short list of Canadian-specific factors at **www.factors-chain.com/members/CAN**.

Other Sources of Funding

If you don't need much money to launch your business, here are a few other places you can go to borrow some start-up cash:

Private Venture Capitalists

These are companies that invest money into private business ventures. However, they will charge you interest, and they often want a say in how your business will be run.

Private Placement Firms

These firms will try to get money from business investors on your behalf. They're sometimes called "money finders." Of course, they don't perform this service for free. They usually take a percentage of the money they find for you, or you have to agree to pay them a percentage of your profits.

Family and Friends

Borrowing from family and friends can be tricky, but if you know someone who has money and is willing to loan it to you, it might be worth considering. Just make sure you have a legal agreement that outlines all the terms of the loan. Make it clear that the loan doesn't give the family member a right to tell you how to run your business.

Your Own Savings

You can try to save some income from a day job while you freelance or work part time. Some entrepreneurs are lucky enough to have a working spouse willing to support them until the business becomes self-supporting.

5.2.5 Banking and Accounting

If you are one of those people who has a hard time keeping a checkbook balanced, now is the time to develop good habits. Tracking business finances carefully is very important for a couple of reasons. First, being sloppy about your business finances can get you into big trouble with clients, not to mention the government when tax season rolls around. Second, being particular about your finances is the best way to keep track of how your business is doing.

Open a business account at your bank, trust company or credit union, even if you use your own name to do business. Your accountant will thank you later. Use this account for paying the bills of the company and your own salary, which you then deposit into your personal account. It is extremely important to keep personal and business banking separate for tax purposes.

Get a style of business checks that makes it impossible for you not to record checks you've written. Avoid using electronic payments; you want to create a paper trail for your business account so you're able to prove your deductions at tax time, or create balance sheets that your vendors or other financial institutions may request from time to time to see at a glance where your money has gone.

You should consider hiring a part-time accountant to balance your books, unless you want to spend a considerable amount of time crunching numbers. Many small businesses, including most fashion designers, have an accountant come in for a day or half-day every week to consult for them.

An accountant for an apparel company needs to not only manage the financial aspects of the firm, but also ensure that enough profit is earned to assure the company's financial future. This would include:

- Helping you set financial goals

- Monitoring financial performance (with quarterly reports)

- Managing accounts receivable and accounts payable

- Keeping you informed on financial matters

An accountant will be able to advise you on what expenses you can deduct — but to be safe, keep track of everything. Keep ledgers that are small enough to carry on your person so you can log mileage or other travel expenses, and everything you spend during the day (remembering to keep personal and business expenses separate).

Also carry an envelope so you can keep receipts for everything you buy for the business and everything you must pre-purchase or put a deposit on for a client or vendor. Be sure to re-file these at night in the appropriate place in your file cabinet. The business receipts should be stapled to the order form for each purchase/service for a customer. No matter what system you use, make sure it works for you and that you can locate receipts for anything at any time without calling the FBI to help you find it. You or your accountant should keep track of your accounts receivable and accounts payable in a ledger book, which you can get from any office supply store, or use an electronic bookkeeping package.

Keeping close watch over your company's profit and loss statement, balance sheet and cash flow statements will help you constantly stay on top of financial triumphs and stumbles.

For instance, imagine that a client owes you $2,000 for a beautiful gown you designed that she has yet to pick up. Another owes you $600 partial payment and yet another owes you $3,200. All of the payments are overdue. You owe your computer fix-it guy $750, the office supply store $250 and your $2,000 monthly rent is due at the end of the week. If you're not carefully watching your finances, you might not realize that it's possible your bills are going to come due before you're paid for the work you've completed!

Knowing exactly how much money you need and how much is due allows you to react to the situation before it becomes a problem. You can get on the phone and request payment immediately so that you can meet your obligations.

5.3 Business Details

Details, details, details. While they can be a source of irritation, business details and legal matters concerning your business are extremely important, and must be taken seriously.

To help you sort through the business details, it may be best for you to consult with a business lawyer who specializes directly in the area of concern. Many business transactions have legal implications, so you should try to select a lawyer who you can treat as a trusted business advisor. They can advise you on the selection of a business structure, employment contracts and confidentiality agreements, trademarks, lease agreements, and ordering contracts.

Lawyers will usually charge a minimum of $100 an hour, but may save you thousands in the long run with good advice.

5.3.1 Type of Ownership

The first legal issue to consider when starting a business is the form of ownership it will have. For the most part, there are four forms of ownership:

- Sole proprietorships

- Partnerships

- Corporations

- Limited liability companies (LLCs)

Sole proprietorships are extremely common and popular among small business owners. Particularly if you plan on working from home, fashion design certainly lends itself to the sole proprietorship form of ownership. Unless you plan to partner, or have a good reason for setting up another form of ownership, your fashion design business will likely be a sole proprietorship. Read on for a discussion of each type of ownership.

Sole Proprietorship

If you decide your business will be a sole proprietorship, the buck stops with you. The good news about a sole proprietorship is that you get nearly total control of the business and all of the profits. The bad news is that you also get full liability for all business debts and actions.

A sole proprietorship is the easiest business structure to set up. All you need to do is apply for an occupational business license in the munici-pality where your business will be located. Usually, the license doesn't take long to be processed, and you can begin your operations fairly quickly.

Partnership

When two or more people decide to start a business together, they enter into a partnership agreement. There are two types of partnerships: gen-eral partnerships and limited partnerships.

A *general partnership* is when two or more people get together and start a business. They agree how they'll conduct the business. Partnerships don't have to be divided equally between all the partners. However, all partners must agree on how the profit, risk, liability and loss will be di-vided. A *limited partnership* is when one or more partners invest in the business, but are not involved in the day-to-day operations. Limited part-ners are basically investors, and they have limited say in the hands-on operations.

The biggest advantage of a partnership is the additional financial clout that two people will bring to a business. Another possible advantage, if you've chosen your partner wisely, is that you will each have strengths and weaknesses that balance each other out. Also, working with a part-ner that you're compatible with can be a lot of fun.

On the flip side, many a business has ultimately failed when a partnership sours and goes bad. If you decide to form a partnership, think very carefully about the person you choose as your partner. Partners should provide either needed money or needed skills.

If any other factors overshadow these essential criteria, it could be an unnecessary risk. For example, if partnerships are entered for reasons of friendship, shared ideas, or similar factors, considerable stress can arise for the partnership. An unhappy partnership can dissolve your business faster than you can dissolve the partnership.

Make sure you each understand the other's expectations and goals, and be sure to consult a lawyer and get a partnership agreement that covers all contingencies. The less that's left to chance, the stronger and more stable your partnership will be.

Corporation

When you incorporate a business, you form an entity that's legally separate from yourself. Instead of the business being in your name, it's registered in the name of the corporation, and the corporation is responsible for all its business activities.

Even if you started the business, once it's incorporated, you're considered an employee and a stockholder instead of a personal owner. A fashion designer may use this type of structure if they wanted to protect their personal assets from their business.

The good thing about having your business incorporated is that it limits the liability of each stockholder to the amount of their investment in the business. If the business fails or is found liable in a lawsuit, the corporation is responsible — not the individual members of the corporation.

For example, let's say that you and a partner each put up $100,000 to start a fashion label. Now, imagine something so terrible happens that you find yourselves liable for damages of $500,000. If your company is a partnership, you're responsible for coming up with a half million dollars. If your company is incorporated, however, you and your partner can't be held liable for more than the $100,000 you each invested in the business.

On the downside, there's a good amount of paperwork and legal work involved, and there's usually more people involved than with other forms of ownership. In addition, you can't name your own salary. Since the corporation is a separate entity, you can only take a percentage of its funds as a salary.

> **TIP:** You will be stuck with whatever business name you choose once you are incorporated. If you change focus or specialty later, it is much more difficult (although not impossible) to change your name than if you were a sole proprietorship.

Limited Liability Company

Organizing your business as a limited liability company combines the advantages of a corporation and the advantages of a partnership. A limited liability company is like a corporation in that it is legally separate from the person or persons who own it, and it offers some protections that a partnership and sole proprietorship do not. Partners in a limited liability company get the same personal financial protection as those in a corporation, which may make it easier to recruit investors.

However, the limited liability company cannot sell stock, or have share-holders or a board of directors. The limited partners may not participate in the day-to-day management of the business of the partnership or they risk losing their limited liability status. Note that regulations regarding limited liability companies vary from state to state, so it's best to check with a lawyer or local government for details.

5.3.2 Business Licenses and Numbers

Regardless of what form of legal structure you choose for your business, you'll need to have it registered, at least at a local level. Contact your municipal or county office for more information about registering your business. Your business name registration, or renewal of registration, will be valid for a certain number of years.

As the requirements vary, the SBA website has a state-by-state link to information for your geographical area at **www.sba.gov/hotlist/license.html**. In Canada, you can find this information at **http://bsa.cbsc.org**.

You may need other licenses as well, depending on the type of business you set up. Retail businesses that collect sales must be registered with their state's department of revenue and get a state identification number. All businesses that have employees need a federal identification number with which to report employee tax withholding information. See section 5.3.5 for more information on taxes.

5.3.3 Choosing a Name

If you're in the fashion design business, you'll want to choose a name that reflects you and your design concept in some way. In most cases, your business name should:

- Indicate what you do (e.g. Designs by Donna)

- Be easy to remember and pronounce

- Attract customers

- Be unique

- Not be currently in use by someone else

Fashion design is a unique type of business in that subtlety in naming is popular — a designer might use a catchy phrase such as "Funky Blue" or simply their own name as a business name. You don't always have to come out and say what you do like you would in the construction or plumbing business, as many times the label is on a piece of clothing that explains itself.

Some labels have the advantage of having beautiful names to begin with, such as Donatella Versace. Others have made their plain names famous — such as the late Geoffrey Beene, and Calvin Klein.

Some fashion designers create their labels using their children, spouse's and parent's names (such as Karen Warren), but the point to remember is that your label's name should also match the style of your lines. For example, if you're manufacturing $500 eveningwear then you should probably avoid naming your label "Bubba's." Think it over and choose your name carefully.

Trademarking Your Label

Registering your business name as a trademark in a specific country means that no one else can use your name, and you have the right to sue anyone who infringes on your trademark in a way that can cause you to lose money. It also gives you the basis to file the trademark in another country should you choose to export to that country.

In the fashion industry, brand names and label names play an integral role in marketing and brand awareness. When your label becomes successful, others will try to imitate or copy it, so trademarking can act as a "keep off" sign to potential competitors who may be tempted. It may be wise to protect your label or brand name in the fashion industry, especially if you have some long-term plans for the brand. Keep in mind, also, that it is up to you to police the use of your trademark and it is your decision whether to take any legal action against an offender.

A trademark is not a legal business requirement, but it does offer some protection from someone copying your label for their own personal benefit. It's really a personal decision. The process is long, but the paperwork is straightforward, and it can be done in the U.S. for around $335. You can also hire a lawyer to do the paperwork for you, for an additional fee.

If you don't decide to trademark right away, you can at least take the measure of mailing yourself a registered letter with the trademarked name inside, and keeping it unopened. It may not hold up in court, but it's better than nothing, and might be enough to get someone to "cease and desist" using a name you have worked hard to promote. For more information on the pros and cons of obtaining a trademark, procedures and applications, visit the Patent and Trademark Office online at **www.uspto.gov/web/offices/tac/doc/basic**.

For good advice on trademarks and other matters to consider before finalizing your business name, visit **www.nolo.com** and look under the "patents, copyright & art" tab. In Canada, the Guide to Trademarks, the Trademark Regulations and the Trademarks Journal can be accessed at: **http://strategis.gc.ca/sc_mrksv/cipo**.

In most jurisdictions, if you operate under anything other than your own name, you are required to file for a fictitious name. It's usually just a short form to fill out and a small filing fee that you pay to your state or provincial government. You can find links to the appropriate departments in the U.S. at **www.sba.gov/hotlist/businessnames.html.** For Canadian information visit **http://bsa.cbsc.org**.

Before registering a fictitious name, you will need to make sure it does not belong to anyone else. You certainly wouldn't want to spend your initial investment money, only to find out you couldn't legally operate under a name you had chosen because someone else owns the trademark. You can do an online search of the federal trademark database to determine whether or not a name has already been registered. See the next section on "Trademarking Your Label" on the previous page to find out how to do this.

5.3.4 Insurance

Your business will have things to protect with insurance, such as your assets, your vehicles, your equipment, your office or showroom, your inventory, and yourself!

Property insurance is the first thing you need to think about, but you may later want to consider some other forms of insurance, including disability insurance for yourself to partially replace your income if you are unable to do your job due to an injury or illness.

Types of Insurance

Business Premises and Contents Insurance

Whether your office is in your home or elsewhere, this insurance covers damage, loss or theft of property. If you work from home, it is unlikely your basic house and contents insurance will be adequate. (Be sure your existing homeowner's policy is not voided by the operation of a business on the premises.)

The cost for insuring the office equipment will probably be relatively small and may even be handled as a rider to your homeowner's or renter's insurance. Because a lot of what you produce is considered "intellectual

property," or work that is a product of your mind, you might want to inquire about how the insurance company you are considering treats paper, bills, invoices, designs, plans you have discussed with clients and put on paper, etc. You may be able to add a rider to your policy to cover the cost of reconstructing these things if something happens to your office.

Product or Service Liability Insurance

Protects you in the event you are sued by a client/customer for nonperformance of a contract or a product and any liability arising from the nonperformance.

General Liability Insurance

Covers injury to clients and employees on your premises or elsewhere either in the performance of duties for the company or involving activities of the company.

Life, Disability, Accident and Illness Insurance

Provides you with a source of income if you should become seriously ill or disabled and unable to run your business for a period of time. It provides for your family if you are their main source of income. You can often get lower rates by joining an association and qualifying for group rates.

Business Use Vehicle Insurance

Must be obtained for cars and other vehicles used in the conduct of your business.

Business Interruption or Loss-of-Income Insurance

This will allow you to continue to pay the bills if your business should have to be closed down by damage due to fire, flood, or another catastrophe.

Partnership Insurance

Protects you against suits arising from actions taken by other partners in your business.

Many different levels of coverage are available for business owners. An insurance broker (check your Yellow Pages) can advise you of your options and shop the best rates for you. You may also be able to get insurance through any professional association that you belong to.

Self-employed people can find relatively affordable insurance, as well as other small-business assistance, through the National Association for the Self-Employed. The NASE has independent agents nationwide, so you will have access to local experts on small-business insurance needs. You can visit the NASE website at **www.nase.org** to learn more.

5.3.5 Taxes

Even before you begin making a profit, you have to think about taxes. As a fashion designer, you may have to think about your own income tax, sales tax, payroll taxes on any employees you hire and, if you are incorporated, a corporation tax.

Tax Returns

If your business is a sole proprietorship or partnership in the U.S., you will file a Schedule C with your personal tax returns. You will also have to file a form to determine the amount you owe on your social security. Canadian business owners will do the same with CPP. If you have employees, you'll have to pay half of their social security contribution, plus withholding taxes and perhaps federal and state unemployment taxes.

Most experts, and probably most entrepreneurs, will encourage you to consult a good accountant, certified public accountant or tax lawyer to walk you through the complicated process of business taxes. In the meantime, some websites to check out for more about business taxes include:

- *Internal Revenue Service: Small Business/Self-Employed*
 www.irs.gov/businesses/small/index.html

- *Canada Revenue Agency*
 www.cra-arc.gc.ca/menu-e.html

- *Online Small Business Workshop: Taxes (Canada)*
 www.cbsc.org/osbw/session5/taxes.cfm

Taxes on Product Sales

In most jurisdictions, if you buy items or services at wholesale prices and then resell them to your clients for a higher price, you will need to collect sales tax and turn it over to the appropriate city, county, state and/ or country. In order to collect sales tax, you must have a resale number, also known as a tax number, a resale permit or a sales tax permit.

You are required to show this number on a certificate when you want to shop wholesale for your textiles or fabric. You will not pay sales tax at the point of purchase but will file your purchases with the state or county and then mail them a check.

This application should also be available at your city's occupational license office, but you will register it with either the country or state, depending on where you live. Again, you will have to fill out a short form with information about the nature of your business. There is usually no charge to register, and the certificate will be mailed out to you within a few weeks.

Either quarterly or monthly, you will fill out a form that lists the total retail dollar amount (not wholesale) of the merchandise you purchased during the relevant period of time, calculate the tax owed and mail the check. File these forms on time, or you risk being assessed some hefty fines and interest on the amount owed.

It is very important to note that the tax is on the resale value, not the wholesale price. When you shop for wholesale items, you will want to make a habit of noting the retail price. If there is no retail price listed where you purchase the item, you can double the wholesale price to get the retail price.

In turn, you will collect the sales tax from your buyers so you won't be out the money unless you sell to your clients at a marked-down price. In some states and provinces you will also be eligible for a vendor's compensation (commission), which means that you can keep a very small percentage of the tax you collect as payment for being a "government agent."

When you purchase items wholesale, you may also be asked to fill out a blanket certificate of resale by the seller. This simply means that you

understand the situation and agree to pay the sales tax on the items you purchase.

You can take a look at the rules on paying and collecting sales tax at your own state's website. You can find state and local tax links at **www.taxsites.com/state.html**.

In Canada, the process is quite similar. You will want to contact your provincial department of finance to apply for a vendor's license or permit for the purpose of collecting provincial sales tax that is applicable in most provinces. Also, businesses with revenue exceeding $30,000 a year must register with the Canadian Revenue Agency for a business number in order to collect the Goods and Services Tax. Visit the CRA website at **www.cra-arc.gc.ca** for more information.

5.4 Setting Up Your Workspace

Compared to tasks like buying insurance and applying for business licenses, setting up your workspace may seem like a stroll in the park. It's important, however, to put some thought and effort into your setup, because you're likely to be spending a lot of time there.

Many people have encountered problems and headaches because they neglected to thoroughly check out property and rental terms before leasing, or they didn't put a lot of thought into the efficiency of their home office.

5.4.1 The Right Space for You

Most fashion designers choose one of these two options for a work environment, or some combination of both:

- Working from home (office, workspace, limited sales to individual clients)

- Renting a showroom (office, workspace, wholesale display)

You can be creative in choosing space that works for your business. For example, if you work from home but would like to promote your work to buyers, you can hire a sales rep who rents their own space in an apparel

mart. You don't have to pay for the space, but you will get the attention from buyers.

You can also consider sharing work/office space with like businesses (e.g. graphic designers). You can help each other with the like skills you share, and you may attract more customers being in the same office. Plus it's a little more social than working from home.

> **TIP:** Selling your designs in a retail store in a high traffic area allows you to merchandise your product the way you have envisioned it, and have increased sales due to location and visibility. This will likely not be something you can afford until you have a solid few seasons of selling under your belt, and an established clientele, as running a boutique is a job all in itself.

5.4.2 Working from Home

A home-based operation is best if you are starting small, either selling your finished garments to boutiques or private clients only, or selling your designs to manufacturers or other companies. Obvious benefits of working from home include:

- Lower startup costs

- No commuting headaches

- Setting your own work hours

- Flexibility for family time and care

Another big plus is that you can deduct from your income taxes a percentage of your rent or mortgage payment and a share of utilities and maintenance costs. There are various methods to make those calculations, but by far the easiest and most acceptable to the IRS is to use an entire room and to use it for no other purpose.

In the U.S., IRS Publication 587 has information on how to compute the calculation and file the deduction. You can find it online at **www.irs.gov/ pub/irs-pdf/p587.pdf**.

TIP: There is nothing that raises a red flag faster with the IRS than claiming too many square feet as "designated office space" on your tax returns — and no quicker way to guarantee an audit. You've been warned!

Before you start a home-based business, check with your local municipal government for the zoning regulations in your neighborhood. It shouldn't be a problem if all you're doing is cutting and sewing in your basement. Most will, however, prohibit you from posting a big "Fashion Designs by Me" sign in your front yard. Play it safe — it usually takes nothing more than a phone call to your city's zoning office or city administrator to find out any zoning restrictions in your area.

In addition to the legal aspects of a home-based business, working there will require some cooperation from family members and friends. Set regular office hours and make it clear to all that during those hours you're working and not able to chat until the end of the business day.

You need personal discipline as well, as you can become easily distracted at home and slip into doing housework or personal things rather than being in professional designer mode. Look at some options for working out of your home, even if it's at someone else's home, if you need the professional atmosphere of a studio or office to put you in work mode.

5.4.3 Setting Up Your Space

Whether you are working from home or out of a small office you rent, you could essentially design with a notebook on your lap, or using software on a computer. If you are doing any garment assembly, you will need anywhere from 100 square feet to 300 square feet minimally, to allow for larger items like a table or sketch board, racks to hang garments on, a computer desk, and shelves for fabrics. Remember that space is key to staying organized!

If you are lucky enough to have a studio or a separate room in your house where you can work on your designs, you will find it easier to leave your projects at the end of the day. A dedicated space eliminates the need to pack up everything each time you need to use the dining room table for dinner!

Consider dedicating a basement room, laundry room or a spare bedroom to be used as your design studio, or if you don't have that space in your home, you can look at renting a small office.

Make sure you have access to at least three or four electrical outlets for your equipment (a detailed list of supplies and equipment is coming up) and decent overhead lighting. Keep in mind that you might want to expand your business to include employees, and try to choose a space that will allow you to accommodate another body in the room.

Decorate your space just like any other office space… as long as it's friendly and professional, you can't go wrong. Don't forget amenities such as a small refrigerator to store soda, water and snacks to offer clients or other visitors.

If you're working within a limited budget (as most start-up entrepreneurs are), be creative with your furnishings. Sure, you can run out to Ikea, a retailer that's well known for reasonably-priced, stylish-looking furniture, and get yourself set up with office furniture, but why not check out some auction houses or secondhand furniture shops? Who knows what great antique desk might be waiting for you? Many times, you can find something unique for about the same price as a desk from Ikea.

You may also want to consider a mug rack to hang on the wall (for hanging up your scissors, measuring tape, etc.), a wastebasket for your sewing and cutting area and several bulletin boards with push pins for tacking up sketches and notes.

5.4.4 Renting a Showroom

A "showroom" is a place where you work, similar to an office or studio. A showroom is not a retail store, although you may occasionally sell to individual clients there. Showrooms are often located in "apparel marts" — large office buildings filled with apparel sales reps who are selling to retailers, and independent fashion designers working on their designs.

Be aware that apparel marts are not suitable retail stores; they are only for those who are crafting and selling to retailers and the occasional private client.

Finding a Showroom

Larger cities like New York, Atlanta, Dallas, Miami and Los Angeles all have fashion or garment districts where the apparel marts and manufacturers are located (for the most part). Being close to or in an apparel mart or garment district not only saves you time driving to places but also keeps you on the pulse of what is happening in the industry.

How much a showroom will cost depends on your geographic location. In the New York garment district, you could expect to pay $2,000 per month in rent for about 2,000 square feet of space.

If you live in a city that buyers frequent to order product for their stores, and/or when you have experienced some successful seasons of selling, that would warrant the cost of a showroom in an apparel mart. If you have sales reps selling your line, they will usually have a showroom already and your line would be an addition to their showroom.

If you do decide to rent office or warehouse space to show your lines to prospective buyers, then the key is to look for a place that's convenient. Take into consideration accessibility and how often you'll have to be there. Remember, the more time you spend away from designing and creating lines, the less money you're going to make!

An excellent source for finding apparel marts in your area is the Apparel News website at **www.apparelnews.net/Links/marts.html**.

Setting Up Your Showroom

Most designers make their showrooms an all-in-one space, meaning it's their office, the place they show their garments to buyers and other customers, where they design their fashions and where they ship their fashions to their customers. So the showroom will be a little bit office, a little bit retail and a little bit workspace.

Setting up a showroom is not as complicated as setting up a retail space. A wholesale buyer will be more interested in your fashions, professionalism and ability to deliver than the look of your showroom, but you still want to make it nice and professional. It should reflect the type of clothes you're selling.

How you set up your showroom will only be limited to your space, configuration of the rooms and your imagination. This is an old business, and your showroom does not have to look like Saks. Just make it nice and functional.

Some showroom space is even rented out as one big, open room, similar to a warehouse space. This is wonderful since you can buy or rent movable partitions, and you can lay out your showroom anyway you like. Here are the main elements you'll want in your showroom:

Office Space

Depending on the size of your space, you can have your reception area or your office space in the front part of your showroom. It's where you will keep your computer, phone and other equipment, and it's where you will conduct business.

Workspace

You'll want your workspace – meaning the place you actually sketch, cut and sew – in an out-of-the-way part of your showroom.

Product Display

Most designers keep this very simple. You can have racks on wheels to hang your garments on and let the buyers look through them. You can also display your fashions on mannequins. Depending on what stage of negotiations you are in, you may even have live models wearing your clothes for the buyers.

Lounge Area

If you have the space, it's nice to have a place where you can sit with buyers and discuss business that is more comfortable or casual than your office or desk. You can have a nice table and chairs here, and sip drinks and show your line sheets and portfolio. This space is usually in the "middle" of your showroom.

Dressing Room

This can be as simple as a curtained area for changing clothes, but it is nice to have if you bring private clients to your showroom. You'll want mirrors so they can see themselves in your designs.

5.5 Equipment and Supplies

The equipment and supplies you need will be dependent on the scope of your business. If you decide to make your own clothing you will need all the equipment and materials to produce the clothing.

If you decide to get your clothing made at a manufacturer, or if you decide to sell your designs or prototypes to another company who will then market and manufacture your designs, you will not require as much production equipment, just the equipment and fabric to develop and design one style.

In either case, you should have a way of keeping close track of inventory, whether it is raw materials or finished goods. You can purchase software that comes with scanners and bar code printers to label, scan and keep track of what you have... or don't have. You can use the section that follows as a checklist for what you may need, and then read more about these items in the more detailed list that follows.

5.5.1 Supply and Equipment Checklist

Design Needs

- ❏ Computer system
- ❏ Printer
- ❏ CAD/CAM software
- ❏ Fax machine
- ❏ Digital camera
- ❏ Scanner
- ❏ Work table
- ❏ Plotter
- ❏ Desk lamp

- ❑ Sketch books

- ❑ Figure templates

- ❑ Regular pencils

- ❑ Kneadable erasers

- ❑ Ruler

- ❑ Colored pencils

- ❑ Small paintbrush

- ❑ Watercolor paints

- ❑ Felt-tip markers

- ❑ Graphics knife

- ❑ Cutting mat

- ❑ Graphics pens

- ❑ Adhesives

- ❑ Masking tape

- ❑ Layout paper

- ❑ Drawing paper

- ❑ Presentation card

Storage

- ❑ Drawers or bins to organize your supplies

- ❑ Storage space for materials

- ❑ Storage space for clothing samples

- ❑ Filing cabinets for storing paperwork

Manufacturing Needs

- ❑ Fabrics
- ❑ Sewing machine
- ❑ Serger machine
- ❑ Dressmaker's form or dummy
- ❑ Iron and ironing board
- ❑ Full-length mirror
- ❑ Notions, ornamentation and trims
- ❑ Embroidery machine
- ❑ Labels and tags
- ❑ Pins
- ❑ Marking and pattern wheels
- ❑ Pattern paper
- ❑ Measuring tools
- ❑ Scissors
- ❑ Seam ripper
- ❑ Needles

Business Needs

- ❑ Logo
- ❑ Stationery (letterhead and envelopes)
- ❑ Business cards
- ❑ Brochures

- ❑ Telephone

- ❑ Bank account checks

- ❑ Accounting ledger

- ❑ Sales and purchase invoices

Other Office Supplies

- ❑ Large desk

- ❑ Guest chairs

- ❑ Work chair

- ❑ Meeting area/table

- ❑ Fax machine

- ❑ Photocopier

- ❑ Calculator

- ❑ Miscellaneous office supplies (Post-it notes, paper, paperclips, file folders, etc.)

5.5.2 Your Fabric Supply

Each piece of fabric that you purchase is an enormous investment into your career, as the fabrics you use are the hallmark and the substance of your designs.

Fabric is your main raw material, but you will hopefully cover the cost of purchasing it by selling the garments you make with it. There is no general price for fabric, as it depends on the quality of fabrics that you invest in. It can be anywhere from $1 to $100 per square foot, depending on what kind you choose — you can use silk, or you can use cotton.

How much fabric you should have on hand to start your business depends on how many items you plan to have in your collection or line. It may be wise to plan to only purchase fabric to make the sample until you

have an order from your client or customer. You can show them swatches of suggested fabrics for certain styles and have them choose, and then purchase what you will need to fill the order. On the other hand, you may choose to always purchase fabrics that you like even if you have no specific project in mind. If you like it, it will get used sometime and it is convenient to have it on hand.

Choose your fabrics based on the types of designs and clientele you are working with. You may consider tapping in to services such as color forecasting companies and trend forecasting companies to determine what fabrics to use.

Usage, to a large degree, will dictate your choice of fabric. If you are making evening gowns, for example, you will want to invest in silks, satins, taffetas and other light, shiny and luxurious fabrics. If you are designing practical work clothes, you will probably want to have on hand a good stock of canvas, denim, heavy cotton and even acrylic and polyester. If you are making clothing designs for children, you might want to have a selection of light cottons and knits printed with colorful designs.

Finding Fabric

You can find new fabrics and materials at fabric and craft stores, at fabric wholesalers and online, and you may also come across used fabric that will suit your purpose. Fabric and craft stores often have sales that offer significant discounts on materials. Take advantage of these opportunities to stock up on materials that you might be able to use, even if you don't have specific plans for the material right away.

Search vintage and secondhand stores, church sales and thrift stores for interesting fabrics. Often, other people's abandoned sewing projects can be found in the miscellaneous materials sections of these establishments. Don't limit your search to the fabrics section, however. Investigate other departments with an eye for items made from interesting material. You may come across a pair of curtains that can, in true *Sound of Music* style, be made into clothing.

There are trade shows specifically for fabrics that you can and should attend. These shows are only open to people in the apparel trade, and can be a wealth of information on new products and a great place to network with people and companies in the industry.

Online fabric retailers allow you to shop for a wide variety of materials that can be shipped to your home. The disadvantage is that you are unable to actually touch or examine the material you are buying (although some online suppliers allow you to order sets of swatches for a small fee). On the plus side, shopping online is convenient and allows you to peruse a larger quantity of styles and colors than might be available at your neighborhood fabric store. Some online fabric retailers include:

- *BuyFabrics.com*
 www.buyfabrics.com

- *Bridal Fabric*
 www.bridalfabric.com

- *Distinctive Fabric*
 www.distinctivefabric.com

- *The Fabric Club*
 www.fabricclub.com

- *Fabric Depot*
 www.fabricdepot.com

- *Fabric Mart Fabrics*
 www.fabricmartfabrics.com

- *Fabrics Net*
 www.fabrics.net/outlet

- *International Fabric Collection On-Line Store*
 www.intfab.com

Buying From Wholesalers

Fabric wholesalers offer a number of advantages. You have the option to do custom prints or patterns, or have the fabric dyed a specific color — and you also save sales tax on your end. However, if you are not manufacturing large quantities of product, you may run into the challenge of meeting minimum yardage requirements to shop wholesale.

Usually a designer would have to commit to minimums which can be much more fabric than is required, and either hope for sales or be stuck with a surplus of fabric.

Fabric wholesalers can be found through your local Yellow Pages or the Internet. When you become a member of any apparel or fashion association you will receive trade information and lists of wholesale suppliers that you can contact. Sales reps from wholesale suppliers, who usually work on commission, will make it their job to send you new product information and contact you when clearances are available.

You will learn, too, that everyone knows someone somewhere who can help you in sourcing any particular fabric or other supplies for your business. Be sure to ask people and network and you should get pointed in the right direction. You may also be able to find helpful information at websites such as Textile Web (**www.textileweb.com**)

Keep in mind that to shop at a wholesaler you will need to have a business license and tax identification number (see section 5.3.5 on taxes).

5.5.3 Manufacturing Needs

Sewing Machine/Serger

Your choice of a sewing machine will depend largely on personal preference. There are many brands available (Elna, Singer, Janome, White, Baby Lock and Pfaff are just a few of the many brands out there), and they come in a range of prices, from under $200 (like a Sears Kenmore model 12916) to $5,000 and more (a Husqvarna Viking Designer 1). A solid, reliable machine with basic features will cost between $300 and $600.

At minimum, you will need a machine that has the ability to do basic stitches such as buttonhole, zigzag and hemming. If you do a lot of work with knit or stretchy fabrics or if you want a finished seam, you will also need a serger, which is a sewing machine that trims the fabric on the outer edge of the seam as it is sewn. This is an especially useful tool for creating quick prototypes. You can buy a new serger for between $200 and $500.

Dressmaker's Form or Dummy

Custom designers tend to have several forms available, so that they don't have to constantly switch between measurements. You can buy dressmaker's forms through fabric stores or online. Although a single form can cost upwards of $150, it is an important investment.

To choose the type of dress form that is right for your needs, the HWW Mannequins site explains the different types of dress forms at **www.museumfiguren.nl**. You can order your own dress form at SewTrue.com (**www.sewtrue.com/Dressforms.html**).

Iron and Ironing Board

You will need a sturdy ironing board, which you may already have, and an iron that has a steam option and multiple temperature settings for various fabrics (silk needs a cooler iron than linen, which needs a cooler iron than cotton). Some irons also double as steamers, which make it possible to steam wrinkles out of hanging garments or fabrics and is a nice feature to have. As mentioned earlier, buy the best quality product that you can afford. Expect to spend at least $50 each for a good iron and ironing board.

There are also numerous other items available to assist you in your different pressing and ironing needs, from hams (stiff oblong pillows used to facilitate pressing small areas) to small boards used to press sleeves. You can find out more about these specialty items at **www.sewtrue.com/ PressingSupplies1.html**.

Full-Length Mirror

Naturally, you will need a full-length mirror for viewing your designs when you try them on yourself and so that your clients can see the designs from both sides at once when they're on a model. If you do not already have a mirror, a home remodeling store like Home Depot is your best bet for a variety of inexpensive choices (under $30).

Thread

You'll need thread for your sewing machine and for any hand sewing you might need to do. Choose colors that match or blend with the colors of the fabrics used in your designs. When in doubt, choose a shade that's slightly darker than the fabric, as the thread will look lighter when it's spread out across the cloth.

However, some designers like to use their stitches to highlight certain seams or details. If this is your intention, choose whichever color suits your project the best. You can also get transparent thread, which is useful when it's important to hide the seam.

Thread is sold by the spool. Depending on quality and the length of the thread (usually measured in meters, although some threads are sold by the pound), costs usually range from $3 to $8 per spool.

Sew True offers a variety of threads and explains their different uses at **www.sewtrue.com/Thread.html.**

Notions, Ornamentation and Trims

You'll need a number of items that are not fabric but are important to the structure of a garment.

Zippers, buttons, interfacing (material used to strengthen seams or hems), elastic, hooks and eyes and even, technically, thread, are called *notions*. *Ornamentation* and *trim* refer to any part of the garment that isn't integral to its structure, but is used to add to its overall attractiveness and appearance. Examples would be sequins, decorative buttons, and lace trim.

While the notions, ornamentation and trim you use will depend largely on the types of garments you are constructing, it is helpful to have a variety of these items on hand. Stock up on zippers in various lengths and colors. Collect buttons wherever and whenever you have a chance (you can even clip buttons off old garments destined for the rag bag), and make sure you have a good selection of elastic in various widths (from as narrow as 2 mm to as wide as 2"). Doing so will save you the chore of having to run out to the store every time you need something to complete a garment.

You can buy a hardware organizer cabinet – the kind with numerous small drawers for nails and screws – and organize your purchases according to purpose and color. That way, you'll have your own personal "store" ready for browsing whenever you need a fun accessory. You may also want to invest in an embroidery machine, as garments often include embroidered decoration or trim that is costly to outsource.

For accessories, ornamentation, trim and numerous other items, Sew True is a great online supplier of sewing and patternmaking materials. You can find a list of their products at **www.sewtrue.com**.

Labels and Tags

You will have to design a label to use to identify your garments. This label is usually a woven label sewn in on the back (neck) of garments, but also can sometimes be used on the exterior of the garment as a decorative detail.

You will also need to include a fabric content, washing and care instruction label and country of origin label and size labels. Refer to your country's labeling act to ensure you are following federal procedures especially when shipping out of your country.

You can also apply for an RN number (or CA number in Canada), which is what textile companies use to meet provisions of the Textile Labeling Act requiring consumer textile articles to be labeled with the identity of the person by whom or for whom it was made.

If you wish to apply for this number, you must do it through the Federal Trade Commission (in the U.S.) or the Competition Bureau (in Canada). The number must be clearly marked on the labels attached to the clothing. Only textile retailers, wholesalers, manufacturers and importers are allowed to register for a CA or RN number. The cost is about $100.

- *Threading Your Way Through Labeling Requirements*
 www.ftc.gov/bcp/conline/pubs/buspubs/thread.htm

- *RN Numbers (U.S.)*
 www.ftc.gov/bcp/rn/

- *CA Numbers (Canada)*
 http://competition.ic.gc.ca/epic/internet/incb-bc.nsf/en/ cp01034e.html

Pins

Dressmaker pins are made of hardened steel and are capped with either a small ball or a rounded nail head to prevent them from sliding through the fabric. You might also want to have a pin cushion or a pin box in which to hold them all. While they are re-useable, they're also prone to ending up all over your workspace. Keep a small U-shaped magnet handy for quickly picking up any stray pins from the floor of your workspace. It beats stepping on one in bare feet!

Marking and Pattern Wheels

A marking wheel is a small wheel of chalk with a handle that is used for marking straight lines on delicate fabrics. Related to the marking wheel

is the pattern marking wheel, which is a small wheel with sharp points (like a spiked pizza cutter) that is used for marking pattern paper by pricking lines of small holes into the paper. You can purchase these at craft or fabric stores for under $10.

Pattern Paper

This is a thin, strong tissue paper that you mark your patterns onto before they are then cut out and pinned to the fabric for your design. Sold by the roll or by the yard, it costs about $1 per yard, and you can find it at most fabric and craft stores.

Measuring Tools

You will need a measuring tape for taking measurements of yourself, the models or the clients for whom you might be designing garments. Choose a durable plasticized cloth or fiberglass tape that has well-marked inches on one side and centimeters on the other. You can find these at fabric stores, craft stores and even dollar stores for under $3 each.

A styling curve (also called a varyform curve or styling design ruler) has curved edges that you can trace along when you're creating a pattern on pattern paper. It ensures that your lines will be precisely curved and accurately measured. A dressmaker's rule helps you make even spaces between pleats, buttonholes and tucks. An L-square helps you make sure you have the right measurements on your flat pattern.

Again, Sew True is a good resource for more information about each type of measuring tool and for ordering online. Visit **www.sewtrue.com/ RulersMeasuring.html**

Scissors

It's a good idea to have several types of scissors on hand when designing your fashions. Fabric shears make a straight cut and are sharp enough to easily slice through several layers of fabric at once. Pinking shears create a jagged edge and are used on fabrics that are loosely woven or have a tendency to unravel easily. Sewing scissors are small and fit easily in your hand for trimming threads or clipping buttonholes.

Seam Ripper

This is a small, hand-held tool with a U-shaped tip that is used to slide between a seam and cut the threads holding the seam together.

Needles

You will need sewing machine needles as well as hand-sewing needles. Needles are sold in various sizes, from very fine and small-eyed (for close stitching and beading work) to long-eyed (for embroidery work) and large (for working with heavy or coarse fabrics). You'll need a variety on hand.

Fabrics.net has an article titled "How Do You Know If You're Using the Right Needle?" that explains how to know if you're using the correct needle for your project. You can find it at **www.fabrics.net/SarahNeedle Selection.asp**.

5.5.4 Design Needs

Computers and Software

You will want a computer with as much memory as you can afford to run the graphics, drawing or CAD software. You will also want to purchase a printer, which will cost anywhere from $75 to $600 depending on what quality you require and whether you plan on printing your marketing materials. Talk to your local computer shop and let them know what your requirements are and what software (design and graphics) you will be using. They will be most helpful in helping you select the right purchase for its purpose.

If you are not running design software, you can get computers for as little as $500 at Wal-Mart, and a good color inkjet printer for as little as $75. A digital camera or scanner would be a good idea as well, so you can share pictures of your line over the Internet.

Most computers will come preloaded with the software necessary to run your business. In addition to CAD software (see below), you will most likely use these programs in your fashion design career:

- **Microsoft Office:** For your memos, stationery, mailing and various word-processing needs.

- **Quicken or QuickBooks:** For your bookkeeping.

- **ACT! or Filemaker Pro:** For keeping a client database.

CAD (Computer Aided Design) Software

The latest technology in fashion design software facilitates style development and fabric design, pattern design and grading, production management, and even digital printing on fabric for short production runs to mass production equipment and software. Some also have equipment packages to aid in manufacturing the designs created in their CAD programs. The latest programs offer the ability to change colors, fabrics, features, and sizes on screen. What you spend on the software will be paid back to you by the time you'll save using this technology.

The really big companies are Gerber, Lectra, Assyst, and Fashion CAD, and you can usually select and customize a price package that best suits your business. They might range from a cost-effective software ($500) that would enable you to assemble a collection digitally on a storyboard for presentations (suitable for freelance designers) to large full production software and equipment that can run into the hundreds of thousands.

For a listing of CAD hardware and software solutions, including business applications, you can refer to the Apparel News CAD links page: **www.apparelnews.net/Links/cad.html**.

> TIP: Be sure whatever CAD software you purchase not only meets your design needs, but is compatible with your computer system and also offers training and installation of the software.

Plotter

A plotter is nice to have if you plan to use software to print full-sized patterns. You don't need to buy a big expensive wide plotter, as long as it is a roll feed plotter, as opposed to sheet feed. With a roll feed plotter (24" wide, for example) you can output your pattern layout in long strips. So for 42" material you could output in 2 strips and tape them together.

A cheaper option is a dot matrix printer with a wide 16" cartridge, which will do long "plots" on cheap computer paper. If you use a desktop printer, it will "tile" the page-sized pieces and then you have to stick the pages together to make a complete pattern.

Don't forget the paper size that fits your plotter, and suits your needs. Some plotters will use every kind of paper, including recycled paper, regular paper, plotting paper, newsprint and others. This can be a cost-saving advantage when purchasing a plotter.

TechExchange has a good article about the various types of plotters available: **www.techexchange.com/thelibrary/Plotters101.html**.

Work Table

This would be for cutting and piecing together material and/or making your sketches. This can be a large regular table you may already have, or an adjustable table for sketching. It is nice to have a large enough table to cut fabric instead of being on your knees on the floor. Look to spend $60 to $800 for adjustable tables, depending on size and features.

Desk Lamp

For detailed tasks, a good adjustable lamp that attaches with a clamp to the desk keeps your workspace clear, and can provide a well-lit work area without shadows. Cost is $30 to $80.

Sketch Books and Notebooks

A good fashion designer, like any artist, will have a selection of sketch books on hand for making quick sketches and notes about the things they see and the things that inspire their creativity.

Keep a small sketchbook in your purse, briefcase or backpack for use when you're away from your drawing table, and keep a larger one in your workspace. Sketchbooks keep your work organized, and allow you to track your ongoing work either thematically (for example, you could have a sketchbook for life drawings and another for hat design ideas) or chronologically (organized by date or season).

Figure Templates

As mentioned earlier, if you have trouble drawing the human figure, you can use figure templates instead of sketching your own people for each design. It is possible to buy a book of figure templates that you can photocopy and use over and over again. One book to get you started is *Figure Templates for Fashion Illustration*, by Patrick John Ireland.

Regular Pencils

You'll need pencils for your initial drawings and for recording ideas in your sketchbooks. Choose HB or 2B pencils for a medium weight line, pencils marked H (hard) for a light, thin line and pencils marked B for a heavier, thicker line.

Polykarbon.com has a web page that illustrates the different lines made by all the different pencil grades at: **www.polykarbon.com/tutorials/ materials/pencils.htm**.

Kneadable Eraser

This gummy type of eraser removes pencil marks without damaging your paper. It has the added benefit of being a stress-relieving toy, as it's fun to knead when you're feeling under pressure. Art supply stores stock these for under $5.

Ruler

You'll need a straight ruler for pattern drawing and for cutting along. Choose a metal one marked in both metric and imperial measures. It should be at least 18 inches long.

Colored Pencils

You'll need colored pencils for your design sketches. Look for aquarelle pencils, which are soluble in water. By drawing on moistened paper or by spraying your finished drawing with water and stroking it with a small paintbrush, you can achieve a watercolor effect. Caran D'Ache is one good brand. You can find these at art supply stores for about $20 a set.

Small Paintbrush

You'll need a paintbrush for use with the aquarelle pencils mentioned above. At your art supply store, look for one with round (not flat) bristles and a fine point at the tip of the bristles that's about 1/4 inch wide. Store your paintbrush in a cup or jar with its bristles pointing upwards, and always clean it before you put it away.

Watercolor Paints

Watercolor paints are mixed with water to provide a quick, fast-drying paint that you can mix to create any color you like. You can buy water-color paints in solid cakes or in tubes of semi-liquid paint. They tend to be transparent, unless they are called gouache, which is an opaque type of watercolor. Both types are appropriate for use in fashion design, al-though you may find that you prefer one over the other.

Prices range from $5 to $50 a set, depending on the quality of paint. In either case, layers of color can be built up by allowing one thin layer to dry and then applying another coat until the desired intensity has been reached.

Felt-Tip Markers

Sometimes, you'll want the bold, bright colors that come from felt-tip markers. Choose a set that has a wide range of hues, including various flesh tones like light and dark browns, pinks and peaches, if possible. You should be able to find a good quality set at an art supply store for under $25. You can also get Letraset, which has Pantone matched col-ored markers that are great for accurate print or fabric color matching.

Graphics Knife

You'll need a knife to cut out delicate images for collages and for cutting out fine areas of patterns. You can use a sharp-bladed X-ACTO knife, which requires you to change the entire blade when it gets dull, or a utility knife, which stores a long blade in the handle. When the blade gets dull, you just snap off the end and slide up the blade for a fresh cutting edge. Each are typically under $5 in cost. You should always use a knife in-stead of scissors for making small holes in paper or fabric, as it gives a much more professional looking result.

Cutting Mat

A good cutting mat will save you frustration and scratched work surfaces. Choose the largest one you can accommodate (at least 11"x17"). These boards usually come marked with a grid of measured lines, which makes it easier to make precise cuts. Get one that is called "self-healing," which means the surface melds back together after it is cut. Depending on size, cutting mats cost between $20 (for a small one) and $80 (for a large 24"x36" one).

Graphics Pens

Whenever you need crisp, professional looking lines, use high-quality, black-ink graphics pens. They should have indelible ink and a fine tip (you can choose from a variety of sizes to make lines from hair-thin to the width of a pencil). Rapidograph pens are especially good for this type of drawing and can be found at most office supply stores.

Adhesives

You'll need a glue stick or spray glue for attaching small pieces of paper to collages and presentation boards. You'll also need white glue (Elmer's, for example) or rubber cement for gluing fabric samples to presentation boards. Expect to pay between $1 and $8 per container, depending on the glue.

Masking Tape

Three-quarter-inch or one-inch wide masking tape comes in useful for both presentation boards and for holding your papers in place on your drawing table. Available at hardware, dollar, craft and art supply stores for under $2.

Layout Paper

Layout paper, or vellum, is a smooth, translucent kind of tracing paper that allows you to see an image beneath it so that you can copy the image by hand. You can buy it by the sheet or by the package (usually 25 or 50 sheets) at art supply stores. A good online supplier is **www. artsuppliesonline.com**.

Drawing Paper

You'll want a supply of matte-finish drawing paper that is at least 20-pound weight or more. This paper allows you to sketch and try out ideas without the constraints of your sketchbook. Choose paper that measures at least 11" x 17" in order to give you plenty of space to work.

Presentation Card

Also known as Bristol board, this is a thick, fine cardboard, and it is usually sold in single sheets approximately 24" x 36" or slightly larger. It costs around $1 per sheet and is used for making presentations and theme boards.

5.5.5 Business Needs

Stationery and Business Cards

Your stationery is more than just a supply, it's you! Image is everything in fashion, so you may want to hire a graphic designer to help develop a solid logo that consistently can be used for a strong corporate image.

You need to keep in mind the complexity of the logo so as to keep it simple, and use a minimal amount of colors so it is effective (especially cost-effective) when printing on paper for letterhead, on hang tags and woven labels, or even as an embroidered logo. Most Microsoft Windows-based software has templates for creating stationery and letterhead, or you can farm out the work to a local Kinko's or other copy shop. Chapter 6 has more information on using these tools for self-promotion.

Telephone

If your business is home-based, the best thing to do is have a separate phone line dedicated for work. This can be done for a nominal fee, and it will be much easier at tax time to declare those telephone write-offs.

Make sure your business line is off-limits to family members, and always answer the phone in a professional manner with the name of your business. Your voice mail should clearly state the name of your business, apologize for being unavailable and state what information the caller should provide when leaving a message.

Storage

You will want to consider the following for storage:

- Drawers or bins to organize your supplies

- Storage space for your materials and your clothing lines

- Filing cabinets for storing paperwork

Other Office Supplies

Here is a short list of other office supplies you may wish to purchase:

- A large desk with enough space for your phone, computer, any catalogs you may have of your line and plenty of writing room

- A few guest chairs to set opposite your desk

- A separate table for conversations and conferences (if room permits)

- A fax machine

- Photocopier

- Calculator

- Miscellaneous office supplies, such as Post-its, printer paper, paperclips, file folders, etc.

5.6 Fulfilling Orders

Your inventory of items will depend on who you are selling your designs to. If you work from home to custom-make designs for clients, you might have no inventory at all, or just a few samples to show off. If you are trying to sell your designs to boutiques and buyers, you will have a small inventory of samples to solicit orders. This kind of inventory you can keep up with by yourself, or with one or two contractors or employees. However, once you have a large order from a retail store or boutique, or are mass-producing your designs for sale, you will likely need to hire help to manufacture your inventory.

Don't wait until you have some orders to put your contractors and fulfillment system in place. Like a runner in a baton race, once you take an order from a client, you need to be able to hand it off to the next person in the process as quickly as possible so that you minimize the turnaround time. The faster you get the order in the client's hands, the faster you can get paid.

Consequently, the slower you are, the longer it takes to get paid. What's more, if you're selling to a department store or large retail chain, missing your deadline could cost you plenty. Most department store buyers will write a delivery date on the order, and they will assess penalties for every day you miss it. This comes directly out of your profit. They can also exercise an option to cancel the order, even if it's sitting on the dock just an hour from their store, waiting to be delivered.

Retail shelf life is very, very short. Missed deadlines mean missed business for the store. If you miss more than a few deadlines, word will get around, and then you'll be out of business. So don't risk it. Have your manufacturing process in place before you make any appointments to call on buyers.

Designers Todd Oldham, Cynthia Rowley and Anna Sui all tell tales of naively accepting orders for more than they could handle in the beginning, which had them chained to their sewing machines for days on end without sleep. Never promise more than you can humanly deliver, and know when to ask for help.

Timing Your Collection

If you follow what the major design houses are doing, you know that they present their seasonal collections six months ahead of time, so that spring/summer is shown in the fall and fall/winter is shown in the spring. That's done so that buyers can place their orders after seeing the collections, designers can order the fabric and get it made and shipped to the manufacturers, who can then crank out the order and get it to the retailers, who want it available in the stores about six weeks before the new season begins.

In other words, if it's September and you're just now thinking about your fall collection, you're way too late. Or you're six months early for next year, if you prefer to look at it that way. Here's the fashion calendar:

Market Opens	Collections	Available In Stores
July/August	Paris F/W Couture	October
September	Holiday/Resort	November
October	Paris Spring Ready To Wear	December/January
November	Spring Ready To Wear	February/March
January	New York Summer Sportswear and Paris S/S Couture	April/May
February	New York Summer Apparel and Paris S/S Couture continued	April/May
April	Paris Fall Ready To Wear	July/August
May	New York F/W Sportswear	July/August
June	New York F/W Apparel	September

As you look this over, you're no doubt beginning to think that you need to plan way in advance. You're right. While local couture customers might work off a short schedule, department stores and large retailers plan their seasonal purchases months in advance – which means that you'll need to, too, if you want to sell to them.

The best way to do this is to plot out an annual promotion schedule and review it regularly. If you'll be selling one-of-a-kind pieces to couture customers, for example, you'll need to start promoting seasonal items far enough ahead of time so that you can deliver the goods when needed, like holiday pieces in October or June wedding apparel in March.

If you'll be selling to retailers via trade shows, you'll need to have fall/winter samples ready in May to be delivered in September and spring/summer samples ready in November for delivery in February and March. Working months ahead of each season is the only way to make sure you deliver the goods on time.

5.6.1 Hiring Assistants or Contractors

You may be working on your own when you start up your design business, but eventually you may decide to hire people to work for you. For example, you may want to hire an assistant to sew samples for you, or you may want to hire people to handle some of the other aspects of your business, such as marketing, advertising or public relations.

The people that you hire will work for you either as employees or contractors.

An *employee* is a person you hire to perform specific tasks for a specific amount of time during each pay period. You pay your employee a mutually agreeable amount of money at regular intervals in exchange for his or her services.

You may also extend benefits to an employee, such as vacation leave, health insurance, life insurance, disability insurance and retirement benefits. You'll need to pay payroll taxes on behalf of an employee, such as local, state and local withholding taxes, social security taxes and federal and state unemployment taxes.

An *independent contractor* is a person who agrees to perform a particular job for a fee. It's understood that the contractor is not a permanent employee and will stop getting paid when the agreed-upon work is completed.

Advantages to small business owners are that they don't have to offer benefits to independent contractors or pay social security, unemployment or workers' compensation for independent contractors. This can save an employer almost one-third of the costs of hiring a permanent employee. Again, there are certain tax-related matters that apply to contractors, so be sure to check the sites mentioned in section 5.3.5 for specific information.

You will be ultimately responsible for how well your employees or contractors do their jobs, so you will need to find people you can depend on to do the job right, by the agreed-upon deadline, for the agreed-upon price.

Finding Design Assistants

As the "employer" it will be your job to supervise your helpers and ensure they get the job done to your specifications. It is important to remember that it is your name on the label, and if they don't come through in a timely manner or within budget, it's your reputation at stake. Look for someone reliable and have at least one back up for each job.

To find a good patternmaker, grader, or sample maker you can check the classifieds in trade papers and directories. If you prefer to work with someone locally, call several local fabric or sewing shops and see if they have any recommendations.

Consider Hiring a Student

One of the best ways to get good, inexpensive help is by using college students. You can contact your local university or college internship department, and talk to them about using students as interns. This is an absolute win-win for everyone involved.

For example, if you need someone to help you sew, drape or make patterns, a fashion design student at your local school might be willing to do this in exchange for professional experience. Some schools even offer college credits for outside internships. You get the help you need; the student gets the professional experience they need.

Furthermore, you can also tell the internship department that you will give the student a sterling reference for their resume and some samples to add to their portfolio. When you're a student, there's no substitute for professional experience.

Interviewing

When interviewing prospective technicians, ask to look at examples of finished work. You should also get a cost sheet, which lists how much it costs to make patterns or samples for each type of garment. Simple pieces cost less to make than complicated ones, so a simple blouse may cost $70 while a complicated jacket with a lining, odd stitching or other unusual details may cost $500.

Ask whether revisions are included in the cost of the quote. Most estimates will include simple adjustments, as sketches don't always immediately translate to paper the first time. If, however, you want a major change, like altering sleeves, neckline or hem length, you may be billed for a second pattern.

Be sure you know what you'll be paying for up front, and be sure to communicate as precisely as possible with the pattern-maker before they get started. Tell them everything, from how long you want the zipper to the size and spacing of the buttons. If they have to guess what you want and it's wrong, you'll end up footing the bill.

In order to save time, you'll want to know their rates and availability right up front. If you can't come to terms on price, it is best to know that immediately, so you can both move on. You need to know that you can depend on the contractor and that they will be willing to work overtime if necessary to keep their agreements with you.

If everything seems in order, go ahead and hire or sign a contract, but be sure to check the first pattern before allowing her to proceed with any others. You want to see the skill level before you give the go ahead on the rest of the job.

> **TIP:** Sometimes your sample maker will be your manufacturer. You'll still want to see and sign off on the samples, know of any construction difficulties or be alerted to any problems created by the pattern before you get the first order. Otherwise, it could cost you plenty.

Employer Resources

Before you hire anyone, check with your local department of labor and find out all the rules and regulations required as an employer. Excellent advice on hiring employees and contractors can be found at **www. nolo.com**. Choose the "business & human resources" tab, then click on "human resources."

Other state and federal rules and regulations may also apply to you, including health and safety regulations, worker's compensation, minimum wage and unemployment insurance.

You can find links to state governments at **www.sba.gov/world/ states.html** and check the U.S. Department of Labor website at **www. dol.gov**.

Canadian employers must also register with the government and comply with federal and provincial laws. For information on becoming an employer in Canada, visit **www.cbsc.org**.

5.6.2 Outsourcing to a Manufacturer

The most important contractor you will hire is someone to manufacture your designs. Take time to give the manufacturing process some thought, and create a system and clear contracts or order forms that go with it. All the pertinent information must be clear and precise so as to avoid errors and misunderstandings that will take time to resolve.

Each person who works on your garments (and there may be quite a few) must have the information they require so they can do their part quickly and precisely. Color illustrations and diagrams, as well as actual samples and swatches can help, and can also overcome any language barriers.

It's a good idea to develop a "spec sheet," or "specifications sheet." This can be used internally to prepare for production, or to order multiple salesman's samples if you need several sets to send to a number of agents.

The information on the sheet can also be used for costing the garment and ordering supplies, and it can become a cut order later when you're ready to produce bulk quantities. It will have a sketch of the garment and the style number, season, delivery date, fabric and other raw material information, as well as basic measurements for the sizes offered.

On the next page you will find a sample of a spec sheet to use as a template. You'll probably want to customize your own spec sheets to accommodate the sizes you'll offer, special requirements, additional trims, etc.

Spec Sheet

Date:		Description:	Jersey skirt	Season:		Cut date:	
Patternmaker:		Main fabric:		Factory:		Ship date:	

Label Information Specifications

			2	4	6	8	10	12	14
Main label:	On CB lining flat, 1" from top	Waist circumference:							
Content label:	100% cotton/hang dry	Relaxed:							
Position:	Left sideseam, 3" above hem	Length:							
Hangtag:	Pin through main label	Sweep:							
		Hip:							

Trims Accessories

Tape:	Cotton tape hanger loops 1/4"	Buttons:	6 pearl buttons up center back; positioned as template provided
Elastic:	1/2' knit back waist	Zipper:	N/A

Marking/Cutting Information

	Supplier/Article	Width	CI*	Shrinkage	Yield	Pieces	Swatch
Fabric 1:	Knitright single jersey quality J2001						
Fabric 2:	Knitright jersey quality L1005 white or black						
Fabric 3:							
Lining:							
Fusing:	Trimtex A443 woven, lightweight, white						

*CI = cutting instructions 1: 1-way 2: 2-way 3: 1 up, 1 down 4: match stripes/yield

Cut Order

Color	2	4	6	8	10	12	14	Total:
Rose/white lining			1					1
Heather/white lining			1					1
Navy/black lining								
Khaki/black lining			1					1
Black/black lining								
							Total:	3

Special Instructions

1.	Blind Hem
2.	Topstitch waist band at 1/4"
3.	All other details as first sample provided

Finding a Manufacturer

You can find manufacturers by reading or placing an ad in fashion maga-zines, through online resources, joining fashion organizations, and through good, old-fashioned word of mouth. In New York, you can find a manufacturer as easily as walking out your door. Here are two excellent sources for finding a manufacturer:

American Apparel & Footwear Association

Website: **www.americanapparel.org**

Address: 1601 N. Kent Street
 Suite 1200
 Arlington, VA 22209

Phone: (703) 797-9044

American Apparel Producer's Network

Website: **www.usawear.org**

Address: P.O. Box 720693
 Atlanta, Georgia 30358

Phone: (404) 843-3171

Consider choosing a manufacturer that is near your home or office, so it is not far for you to check samples, or drop in when necessary!

Choosing a Company

As with any vendor, it can be tricky to make a match that's beneficial to both of you. Each manufacturer is a little bit different, and sewers work a little differently at each company. Many clothing manufacturers are small, family-owned companies, so company "A" may not stitch fabric the way company "B" does. So what should you look for in a manufacturer when you're ready to engage one?

> **TIP:** You do not want to take all your styles to one manufacturer. If you run into difficulties with production or your account (credit), it will put you in a bad situation for all styles rather than just a couple.

First, you want someone who can turn out a quality product at a fair price, who has a clean, legal setup. In other words: no sweatshops, no child labor and no home workers — all of which are illegal. Not only is this bad business, but many a designer has encountered serious bad press from being associated with these types of manufacturers.

You will also want to know the general size of their business, including what equipment they have, what their sales are, and the number of employees. You may not require a large manufacturing facility to produce short runs, and sometimes this may be too expensive for both you and the manufacturer to produce. Ensure the factory you use suits both the product you want to develop and the volume you plan on producing. Find out their minimums and turnaround times.

You also may want to consider off-shore production if your volumes are high. The quality is usually exceptional, but you will have to become well versed in exporting and importing, and will most likely need to travel to the manufacturer or agent at least semi-annually, which is another cost.

Some manufacturers may specialize in a certain product, so they have fast turnaround times and expertise in that product category. Some will provide assistance with fabric sourcing and may become quite helpful in finding suitable fabrics.

It is also a good idea to have a confidentiality agreement that protects you from the manufacturer taking your ideas (whether it is design, fabric colors or fabrics) to use for their own profit. It is disappointing when you have spent time and money on finding the perfect fabric color or style for your company, and then upon a future visit you see something exactly the same in their own showroom.

Check with trade associations or ask for recommendations, then visit the facility yourself (if you can) and take a look around. Look at sample garments. Ask to see a license (required in California and New York). Finally, make sure they can deliver on time. Remember, you may be penalized for your tardiness, so you need to know how the manufacturer will compensate you for any late deliveries.

For their part, the manufacturer will ask you some questions as well. They'll want to know how many orders you anticipate. They may want to sew your samples for you, to understand your product. They'll also want

to know if you can guarantee payment, since they'll need to make their payroll. Usually, you'll need to pay when the order is shipped.

The Manufacturing Process

You will supply your manufacturer with everything they need to make your garment, including your pattern, your fabric, notions — everything. If your manufacturer lives near you, then you can take these items over personally. You can also have your fabric shipped directly as well.

Once you have selected your manufacturer, they will usually run up a sample of your line for your approval. This is where you should double-check the line and make sure to have a model try the sample.

> **TIP:** If you are not an expert sewer, bring whoever does your samples with you to meet your manufacturer so they can explain any special techniques needed. They will be able to communicate in the language of sewing and make sure your ideas flow from sample to garment.

The next step is to pass your line on to a grader, who makes patterns for your line in all the various sizes. The grader then sends back the completed set for approval and makes a "marker" to cut the patterns, just like pieces of a puzzle (to make sure they use every possible inch of available fabric) and lay out the necessary pieces and hand it off to the sewer. The number of sewers can vary, but you can expect between 10 and 40 to be working on your line at any given time. When the sewers are done with their magic, your line is ready for shipping!

Manufacturers can ship to you or to the buyer, which is usually more expensive. Since many buyers specify how they want the items packed for delivery – and again will penalize you if it's not done to their specifications – many designers have the finished products delivered back to them or to a packing agent so that they can be inspected and packed according to the buyer's instructions. This also allows them to ensure how and when delivery is made to the buyer.

How Much Will It Cost?

When you are ready to take your orders to a manufacturer, they will need to see a sample, or make a sample for approval prior to producing

multiple units. From this, they can determine what cost per unit it will cost you for them to produce. How much it will cost to run your line will depend on two main factors: the cost of your raw materials and the time it takes to produce your garment. Multiply that by how many pieces you are running, and you've got your cost.

> **TIP:** The manufacturer will mark up their cost to produce, as they need to make money too, and there can be room to negotiate here. There may be some wiggle room on price, but beware of huge discounts. It should send up a red flag that something is not being accounted for.

Raw Materials

This will be the most expensive part of creating your fashion and can get tricky. For example, you can't assume that cotton will be cheaper to manufacture than silk. Why? Because high-end cotton will cost more than low-end silk. You will supply the fabric, so you will be in control of this cost. Also, some textiles are more difficult to work with and will increase the time it takes to manufacture. The cost of raw materials includes fabric, thread, trim, and supplies.

Intricacy of Design

As in, how much time does it take, from start to finish, for the sewer to create your fashion. This is a time business; the longer it takes to sew your garment, the more the production costs. The more buttons, zippers and similar items you have, the longer it takes to sew your line and the more it's going to cost you to make.

A labor intensive piece with many different pieces to assemble and notions to attach will be more labor intensive and will increase labor costs. For a simple construction garment, at the right manufacturer who has the appropriate equipment and expertise, the labor costs can be less than the cost of materials to make the garment.

Other Costs

There are also other costs associated with manufacturing such as duties and packaging. Depending on where your garments are being made, this can make up a significant amount of your cost. You should take the time to find the most appropriate manufacturer for each style (construction) of garment to get the best value in price and quality of construction.

5.6.3 Setting Your Prices

There is no one and only way fashion designers set their prices. Basically you must ensure that all of your costs are covered in designing and producing a garment (refer to a manufacturer's cost sheet to see some of the factors you need to include) and you will then determine what kind of margin you can take — which will vary from style to style. Some styles may be designed for volume and others may not. Some styles may get a bigger margin than others also.

Usually, in the apparel industry the mark up is "keystone," meaning it is made for $25 (cost), sold the retail account for $50 (wholesale), and they sell it to the customer at $100 (retail). A general idea of how to set your prices is laid out below.

Wholesale Pricing

The wholesale price is the amount you are going to charge retailers for your garments, keeping in mind that they will have to mark up the retail price for their own profit. You need to find a price for your apparel that not only matches the wholesale price point you're striving for, but that covers all your production expenses, and gives you a profit.

> **TIP:** The formula for setting a wholesale cost is
> *Cost + Profit = Price*

Determine the Manufacturing Cost

So how do you arrive at your costs? By looking at what it costs to put each garment together, from the fabric and trims to the labor and tags. Don't overlook anything; otherwise, you'll quickly be eating into your profit. Don't forget shipping costs you incur to develop the piece, and it's also a good idea to allocate even a small amount from each unit sold back into the advertising and promotions budget. Section 5.2.2 on setting your budget can refresh your mind on what your expenses will be.

Also, remember that the simpler the style, the less it costs to produce. If you're using an expensive fabric, keep the finishing details to a minimum. Otherwise, the cost of the fabric plus the cost of the labor to assemble it may push the piece out of your targeted price point.

Sometimes having a frank discussion with the manufacturer regarding a specific garment's price can uncover ways to help lower the price by using a method that suits their equipment better, or cutting the fabric differently to use it more effectively.

Determine Your Profit

Once you know what it costs to manufacture each piece, double it. That's your profit. So if you determine that a dress costs $50 to produce, then your price to the buyer is $100. That $50 per item gives you a buffer on things like returns, charge backs and sales commissions (which you'll have to pay if you engage sales reps) plus a profit.

Don't short-change yourself, even if a buyer demands a lesser price to place an order with you. Just do the math. Sometimes, it makes good sense to say no.

Keep Your Price in Line

If your cost-plus-profit equation is giving you a price that is not in your target range, then you're spending too much on production. Look at the retail price of the lines you're going to be competing with. If you're going for a bridge price point where a pair of pants retails for $300, for example, you can guess that the wholesale price is about $150, and the cost to manufacture is about $75. See how your garment compares and you'll know whether you're high, low or right in the ballpark.

Remember that the prices you decide to charge at first are not set in stone, and you should be ready to change your prices to reflect the market. If you find that people aren't buying and you think it's because your prices are too high, try lowering them. Consider larger economic factors, as well. In a shaky economy, people tend to cut back on spending. That doesn't mean you will have to close up shop during a recession, but it will require that you think creatively about how you can meet different market demands.

Custom-Made Pricing

If you're going to sell only to individuals, where there is no wholesale price point, you will figure that cost differently. Start by determining a fair hourly wage for yourself, depending on your skill. Estimate how many

hours it will take to finish the piece. Then double it and add it to the other costs of the garment.

For example, if you decide you'd like to make $15 per hour, and it will take you 40 hours to complete a garment, that works out to $600. Double that figure to come up with your profit margin, and you get $1200. If the fabric, trims, and other materials cost $300, add that to the total price to get $1500, which is what you should charge for the garment.

When clients place orders for custom apparel, ask for 50 percent up-front to begin the order, since these pieces can't typically be sold to anyone else if the buyer decides not to claim them. The balance is due when the client picks up the order.

5.6.4 Getting Paid

Regardless of what prices you set, you want to be sure you'll get paid in a timely manner. Unfortunately, many small business owners find that collecting what they're owed can be challenging and sometimes down-right unpleasant.

Methods of Payment

You need to decide in advance the methods of payment you'll be able to accept. If you want to accept credit cards, you'll need to set up a mer-chant account. To accept Visa or MasterCard, you may have to work with a bank to get an account set up. Or, you can check out an online site, such as such as Yahoo! Small Business at **http://smallbusiness. yahoo.com/merchant** or PayPal at **www.paypal.com**.

You can also accept debit cards, which deduct payments directly from your client's bank account and deposits it into your business account. Discover and American Express set up merchant accounts nationally and internationally without the requirement of working with a local institu-tion.

You should know that being able to accept credit cards comes with a price. You'll pay either a percentage of every credit card payment or a monthly fee, depending on what arrangements you make. Still, if you are selling to individual customers, your clients will expect to be able to pay with credit card.

Individual Client Orders

It's customary to ask for a 50 percent deposit when the order is placed. Since custom apparel, by its very nature, can only be sold to the person who ordered it, you'll be out time and money if the client suddenly disappears, never to be heard from again.

On the facing page is a fill-in-the-blanks order form that spells out the specifics of the order, like the amount, the due date, the deposit and your cancellation policy. You want to spell out how client-requested design changes will be handled (additional fees) after the garment is complete and other issues of this nature.

Wholesale Orders

Write up the order, making sure you can deliver the goods on time and of the same quality as your samples. Whether you devise your own order form on your computer or use fill-in-the-blank templates you buy at your local office supply store, make sure it includes the following information:

- Date of the order

- Customer name and department

- Shipping address

- Billing address

- Number and description of each style ordered

- Cost of each style ordered

- Recommended retail price of each style ordered (optional)

- Quantities of each style ordered

- Color and size detail of each style

- Delivery dates

- Cancellation date

- Terms of sale

Client Order Form

Customer Info:

Order#: _____ Date: _____
Name: _____ Date required: _____
Address: _____

Phone: _____

Client Measurements:

	Neck		High hip		Arm length
	Shoulder width		Hip		Arm to elbow
	High bust		Center front		Upper arm width
	Bust		Collarbone to apex		Wrist width
	Width of bust		Length of garment		
	Waist		Length of skirt		

Items Ordered:

Product	Description	Color	Quantity	Size	Price each	Price total
						$
						$
						$

Customer special requests:		
	Change buttons:	$
	Fabric:	$
	Other changes:	$
	Special request fees:	$
	Merchandise total:	$
	Shipping:	$
	Tax:	$
	Order total:	$

Payment terms:
All custom orders require 50% payment due upon placing order and 50% due upon delivery.
There are absolutely no returns or exchanges on custom made products.

Wholesale Client Order Form

Order #: _____

Bill to:
Name: _____
Address: _____

Phone: _____

Ship to:
Name: _____
Address: _____

Phone: _____

Order date:	Season:	Ship date:	Cancel date:	Terms:	Ship via:	Rep:	Buyer name:

Products Ordered:

Style #:	Style Name:	Color:	0	2	4	6	8	10	12	14	Price:	Quantity:	Total:
												Subtotal:	

If a buyer places an order, pay careful attention to their specifications. They may want the garments packed in a certain way or the label tags situated on the side of the garment instead of the top. Follow the instructions to the letter. Otherwise, you'll be penalized in the form of charge backs or discounts for not following instructions. Once the order is in production, monitor it carefully. You want to know of any delays or problems as soon as possible, so you can remedy them quickly.

You should always send a packing list with the goods, indicating on the packing list that if there are any discrepancies that you need to be notified within a certain period of time (7-10 days) and also showing what items remain (if any) to be shipped to the customer. You should then prepare and mail the invoice as soon as the goods have been shipped.

Invoice

Invoice #:	
Invoice Date:	
Customer ID:	

Bill to:

Ship to:

Date:		FOB:	
Your Order #:		Ship Via:	
Our Order #:		Terms:	
Sales Rep:		Tax ID:	

Items Ordered

Style #:	Style Name:	Quantity:	Description:	Size:	Color:	Unit Price:	Total:

Subtotal:	
Tax:	
Shipping:	
Miscellaneous:	
Balance Due:	

Remittance:

Customer ID:	
Date:	
Amount Due:	
Amount Enclosed:	

Boutiques and department stores typically pay 30 to 60 days after the order is delivered to them, so you may need to secure a short-term loan against the receivable in order to pay your manufacturer. This type of loan is so common in the garment industry that specialized finance companies, called factors, are often used for this purpose. See section 5.2.4 for more information.

Charge Backs and Returns

Remember, delivery dates are set in stone, particularly to department stores; any delays result in late fees, discounts, penalties and the like. How can you avoid charge backs, returns and other unauthorized deductions that eat away at your profits? By getting your garments to the retailer as promised and having them sell like hotcakes. Department stores tend to play a lot fewer accounting games with designers whose lines sell well.

If you invoice them and receive a smaller amount than you've billed them for, ask for a detailed accounting of the deductions. Typical reasons for short-changing the invoice include damaged merchandise, non-compliance with shipping orders and tardy delivery. If you can't work it out with the department store, you may choose not to sell to them again. Keep an ear to the grapevine with your industry network to avoid the worst offenders.

It is a good idea to inform your customers of your Returns and Policy guideline. For example, outline the reasons that you as a company will accept items returned, such as defective merchandise less than three months old, wrong style or color shipped, items damaged in transit, or received past cancel date. Also, clearly state the reasons a return will not be accepted, such as shrinkage, home laundering marks, security tag holes or ink marks, or anything that has been altered to fit. (These are non-manufacturing defects.) Clearly outline who to speak to, how to properly mark boxes and packing slips and the preferred method of shipping. Most garment companies use Return Authorization Numbers to track and log returns from customers.

You should do enough follow up with your stores to know what worked for them, what needs to be changed, and why the style was not as successful as it could have been. This is knowledge you can only learn season after season, and making these "mistakes" can only make your line stronger.

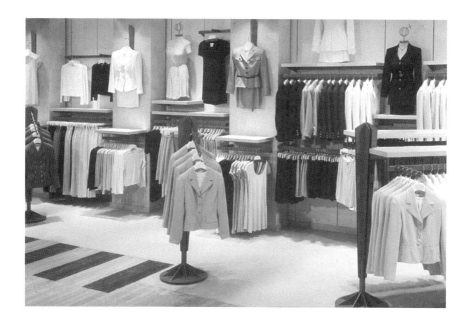

6. Marketing Your Designs

"Whether you're selling fashion or insurance, you need to make sure your targeted consumers understand what your brand is about. Once they know those values, everything becomes much easier."

— Kathy Collins, Vice President of Marketing, Lee Jeans

Sell. It's a four-letter word to many creative types, but it's also a necessity if you plan to make money by designing clothes.

Fortunately, it doesn't have to be difficult. The key to marketing successfully is in understanding what it's all about; namely, frequently exposing your products to the people who are most likely to buy them. Once you know where these people are and how to reach them, it's simply a matter of figuring out what they want, and giving it to them again and again.

Unfortunately, many designers (and business people in general, for that matter) never learn this crucial lesson. They wait for clients to find them. When they can no longer stay in business, they assume it's because of their own lack of talent. But, in reality, it's because they didn't do enough marketing.

So don't make marketing an afterthought, because by then, it may be too late. Make it part of your overall startup strategy, and you can almost guarantee profits from the start. In fact, if you find a void and fill it, you can practically own the market segment before your competitors realize there's money to be made there. This chapter shows you how.

6.1 Define Your Market

Whether you intend to sell to private clients, retailers in your area or national chain stores, you need to do a little legwork before you start. If you don't understand what you are selling and who you are selling it to, you'll be out of business quickly enough, regardless of how much talent you have. To define your business, you need to answer the following with clarity and confidence:

- Are you selling a product or a service?

- What type of garments are you designing?

- Who are your clients?

- What is your general price range?

- What is your unique selling point?

6.1.1 Product or Service

Think about the type of business you want to run: are you selling a product or a service? You may choose one or the other, or your business might incorporate a bit of both.

You are running a "product" business if you sell ready-made garments or accessories to individual clients or boutiques, department or retail stores, from your own boutique, or over the Internet from your home. If you are selling a product, your clients will include wealthy individuals, boutiques and stores.

You are running a "service" business if you are selling your designs only on a freelance or contract basis. In this case, your clients would include

independent design companies, manufacturers who buy designs, or in-house design departments for retailers.

6.1.2 Type of Garments

If you are thinking about opening your own fashion design business, you probably have a good idea of the category of clothing you want to design, whether it's sportswear, business suits, baby clothes or ice-skating costumes. While you want to have a good handle on your product, try not to limit yourself, or you might find your target market is too small to support your business or allow for growth.

Are you going to design custom-made garments for individual customers? Will your collections be ready-to-wear, sold in relatively small numbers under your name? Will you manufacture mass-market clothes and accessories sold by the thousands in high-end fashion stores?

What types of garments will be included in your collection? Designers generally specialize in men's, women's or kids' clothing, and in addition to everyday apparel, the collection might include any of the following, plus any number of other possibilities:

- Sportswear

- Formalwear

- Lingerie or nightwear

- Wedding gowns

- Underwear

- Outerwear

- Neckwear

- Work clothing

- Bras

Make sure that your product line is not too narrow, because that can affect your chances of getting funding (it makes you look like you won't sell too much, which banks might not appreciate), and limit the scope of your business once it is underway. Allow room for eventual growth and expansion of your collection. If you're in the position of having to design a diverse product range, think about what you can do to put your distinctive, personal stamp on these and make the designs feel related.

6.1.3 Who Will Wear Your Designs

Knowing your customers is important because it allows you to identify their likes and dislikes and tailor your designs to accommodate them. You need to hone in on who exactly is likely to buy your designs, and if your first response is an enthusiastic "everyone," you need to re-think your plan.

Everyone is not going to want what you have, regardless of what it is. People who need prom dresses are teenage girls, not grandmothers in their 70s. Who needs a business suit? Not children, but businesspeople who must dress professionally at work.

So who is going to buy what you want to sell? Executives? Socialites? Women? Men? Get a firm picture of your ideal client embedded in your mind. You might even want to cut out pictures from magazines or newspapers of people wearing your "style" of designs, if that will help you better envision your target market.

At the large design houses and retailers, designers use in-house marketing departments, surveys, and other methods to research their markets. You know those "loyalty cards" that you are sometimes asked to use at the grocery store? Well, those are used for market research. When the store scans your card, they learn what you bought, when you bought it, and how much it cost, among other information.

NPD Group (**www.npd.com**), a sales and marketing information company, is one of the largest suppliers of market data out there.

When you are just starting out, you may need to do your own market research. Go to the mall and take note of the people who are buying products similar to yours. What do they look like? What do they have in

common? How are they dressed? What accessories are they wearing? All of these factors will help you further define your perfect customer.

One option you have before starting your own business is to meet with a fashion consultant, trend forecasting company or color forecasting company while you are developing your ideas. These independently owned companies devote their full energy to observing and analyzing the fashion scene, and assist designers and retailers in clarifying their own thinking about what will sell, and to whom.

For example, these consultants can provide fabric reports, color trend information, and style and trend reports. Tapping into firms who offer these services can be a great help in an industry where time and timing are ever important. The Infomat website has a list of these companies and their websites online at **www.infomat.com/information/research/rankings/trends.html.**

You can also conduct your own focus groups. Find willing focus group members by running an advertisement in the newspaper or on the Internet or by posting a sign at your local college or university. You can also contact family and friends (just make sure to stress that you want honest opinions) and show them your line. Getting this sort of feedback can be incredibly valuable in determining tastes and trends.

Plan to have someone model the line, and don't be afraid to ask questions of the group. Questions might include:

- Where would you expect to see a line like this one?

- Would you buy this line in a store?

- What would you expect it to cost?

- What does this pattern, color, and fabric do for you?

- What type of shoes, bag, and other accessories would you choose to wear with this line?

6.1.4 Your Price Range

As explained in section 2.1.3, apparel price points include:

Type	Designers
Designer/Couture	Chanel, Donna Karan, Armani
Bridge	Armani X, DKNY, Ellen Tracy, Adrienne Vittadini
Better	Liz Claiborne, Jones New York, Anne Klein
Moderate	Dockers, Levis, Guess?
Budget or Mass	Wal-Mart's Kathie Lee and Kmart's Jaclyn Smith

As you look through this list, you can probably pinpoint where the clothing you're thinking of designing will fit in. If not, take a stroll through a mall or click around online and study the differences in the cost categories. Note the fabrics, the construction, the styles and the colors. Look at the store décor or the website layout where they are being sold.

Unless you plan to sell your designs to a manufacturer or become a manufacturer yourself, you should probably opt for the better, bridge, designer or couture levels. Moderate and budget categories rely on volume for profit, which can be very hard to compete with when you're just starting out. Also, you want a target market that has money to spend on your apparel and won't have as hard a time paying your fees.

6.1.5 Your Unique Selling Point

"Many new niche brands today are making it with little or no advertising. They have succeeded because they differentiate themselves from the competition."

— Kathy Collins, Vice President of Marketing, Lee Jeans

Once you've determined your target market and your price point, the next thing you need to do is to find a void to fill within that market. It could be a niche you've discovered on your own, or it could be a trend that's happening that isn't being sufficiently served.

If you look at some of the most recognizable fashion brands, you'll see that most of them have found and filled niches with quality products that immediately attracted a profitable sector of the fashion buying public.

For example, the exquisite, comfortable fabrics and clean lines of designs by Donna Karan, Jil Sander, and Linda Allard for Ellen Tracy all appeal to executive-level working women. Bill Blass made his name in beautiful suits worn by the "ladies who lunch." Ralph Lauren founded his empire with elegant weekend wear for hard-working business people who wanted to look good in their off hours.

So why will people buy your clothes? What do you have that your competitors don't? Is it better fabrics? Glorious details? A solution to an age-old problem? Figure out what you have that your clients can't get elsewhere, and use that to both differentiate yourself from the competition and also make yourself more desirable to your buyers.

Here are some exercises to get you thinking about where you fit into the market:

- Make a list of all of your significant competitors and write a sentence defining their position in the market.

- Define the current position of your line. If you don't have any customers yet, then define where you want to position your line. That way you can tell a buyer "I'm not in any doors yet, but my line is defined by elegance at an affordable price, and in this down market place, shoppers want to squeeze every penny and still look fashionable." It's fine if you find a defining factor that may appeal to a smaller segment of the market. As long as those in that market segment are buying, that's all that matters!

- Identify what makes your line stand out from the rest. It can be anything from the textiles you use to the ease of cleaning ("My line is machine washable and still looks great!"). Make sure it's something that the consumer will find desirable: "My line looks great, is easy to care for, and with more and more working mothers in the workplace, this is a great advantage over my competition."

6.2 Promotional Tools

Once you know your customers, you need to determine how to reach them and catch their attention. How you execute this will vary widely depending on your target market, but the objective is always the same:

making clients aware of your company and getting them to see the advantages of doing business with you. Here are some promotional tools you can consider for your business.

6.2.1 Business Cards and Brochures

It is critical that you have business cards made up to give out to prospective clients. As a fashion designer, you will use a lot of them. In fact, you should get in the habit of handing your business card out to just about everyone you meet. Here are some ideas:

- Hand them out at trade shows.

- Leave stacks of them at boutiques in case someone wants some custom design work done.

- Give them to prospective buyers you meet with.

- Mail them out with brochures.

Most print shops will put these together in boxes of 500 or 1000 for you, for between $50 and $200. A slightly cheaper option is to have them printed at VistaPrint (**www.vistaprint.com**), where you can get 250 cards (either your own design or one of theirs) printed for $19.95.

Regardless of where you get your cards printed, you will have the option of including color, your logo, raised print, and many other nice and distinctive features. Make sure that you cover at least the basics, including your company name, your name, your phone and/or cell phone number, your email, and your website.

TIP: If you work from home, you might want to omit your address for safety reasons, or use a box number or mailing address for your business correspondence.

There will also be times, like at trade shows or small private sales, when you'll want to give out more information than a business card can provide. Brochures explain what you do, what makes your approach unique and what your rates are. It may also be a good idea to provide some brochures to retail stores where your work is sold for display, or in stores that sell related items like accessories.

Your brochure should include your company's name, contact information and web address. It may also include:

- Photographs of garments or collections that you have designed.

- A list of the benefits of your products or the services you provide.

- Comments or testimonials from satisfied customers or other professionals in the industry.

Your brochure can be bi-fold or tri-fold, in black and white or in color. You can either pay to have someone design and print the brochures for you, or you can design and print them yourself on a computer. These self-made brochures probably won't look as professional as those that are done by a printer, but they will do the job when you are trying to get your business off the ground.

If you choose to have your brochure produced professionally, but you are still on a tight budget, contact chain copy retailers such as Kinko's for pricing. You are likely to pay between 25 and 50 cents per color brochure on a run of a couple thousand, though you might be able to get a deal.

TIP: Be sure to check the proofs of every piece of promotional material you produce carefully! There's nothing less professional than sloppy writing and typos. Also be sure to check your contact information carefully, or you could end up throwing boxes of material away, or spending long hours correcting the errors.

6.2.2 Garment Samples

If you are trying to sell your designs or get orders for clothing, you need to create some samples for your prospective buyers. While private clients may be sold on your work by looking at portfolio sketches and/or snapshots of previous clients wearing your designs, retailers are going to want to see, handle and inspect samples. They'll want to feel the fabric, inspect the seams and, if possible, see how it looks on a model.

You will make your sample as if you are making a one-of-a-kind garment, or have your manufacturer make it for you so they can work out any bugs in the design before you get an order. Some manufacturers will

absorb the cost of making the sample, so long as a decent-sized order comes in based on the sample.

When you present your samples, make sure each sample is tagged with the style number, indicating sizes and available colors. Invest in a nice garment bag that allows you to pull them out easily and show them in order. Or, buy a portable garment rack that assembles and collapses easily. Don't show up with your wares folded haphazardly in a paper bag or hanging limply in a plastic bag. Remember: in this business, image is everything.

> **TIP:** At the end of the season, many designers sell off their samples at half-price to recoup the cost of the materials, and invest it in next year's product.

6.2.3 Line Sheets

If you are selling to corporate buyers or boutiques, you will prepare a line sheet for your designs that you can leave with the buyer. A line sheet is an information sheet that shows illustrations or photographs of each piece with the style number, description, fabric, color, and price listed. It will help the buyer remember what they've seen after you've left.

Large design houses and manufacturers typically have these printed up to pass out at trade shows, fashion shows and to have available in their showrooms. When you're just starting out, you could get away with scanning your illustrations or photographs onto your computer and printing out copies from your desktop. Just be sure to use a quality printer and paper so that all the graphics and text are legible.

Print them together in the same groups that you show them, so that the buyer can easily recall what they saw. For example, if Outfit #1 consists of a jacket, blouse and a pair of pants, put those pieces next to each other on the line sheet for easy recognition. Otherwise, your buyer may have trouble figuring out what goes with what. If you've ever seen an outfit in the window of a shop then gone into the store and been unable to figure out which pieces went together because they're not grouped together near the display, you can appreciate why it's done this way.

On the facing page is a line sheet reprinted with permission from Chaiken Clothing (shown smaller than actual size).

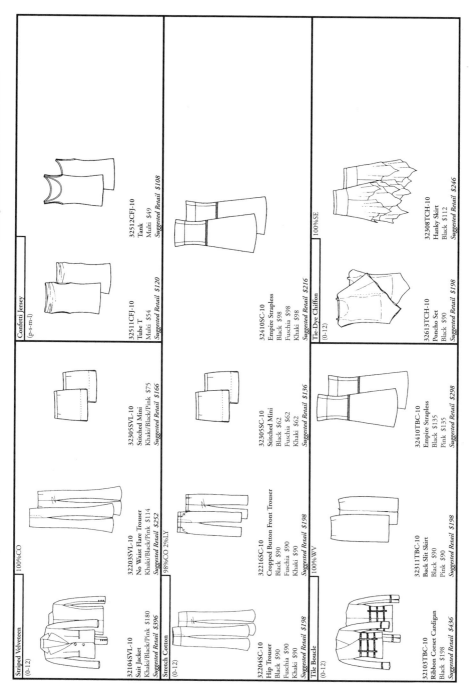

C H A I K E N Holiday/Resort 2003

Striped Velveteen (0-12) 100%CO

32104SVL-10
Suit Jacket
Khaki/Black/Pink $180
Suggested Retail $396

32205SVL-10
No Waist Flare Trouser
Khaki/Black/Pink $114
Suggested Retail $252

32305SVL-10
Stitched Mini
Khaki/Black/Pink $75
Suggested Retail $166

Confetti Jersey (p-s-m-l)

32511CFJ-10
Tube T
Multi $54
Suggested Retail $120

32512CFJ-10
Tank
Multi $49
Suggested Retail $108

Stretch Cotton (0-12) 98%CO 2%LY

32204SC-10
Hip Trouser
Black $90
Fuschia $90
Khaki $90
Suggested Retail $198

32216SC-10
Cropped Button Front Trouser
Black $90
Fuschia $90
Khaki $90
Suggested Retail $198

32305SC-10
Stitched Mini
Black $62
Fuschia $62
Khaki $62
Suggested Retail $136

32410SC-10
Empire Strapless
Black $98
Fuschia $98
Khaki $98
Suggested Retail $216

Tie Boucle (0-12) 100%WV

32103TBC-10
Ribbon Corset Cardigan
Black $198
Suggested Retail $436

32311TBC-10
Back Slit Skirt
Black $90
Pink $90
Suggested Retail $198

32410TBC-10
Empire Strapless
Black $135
Pink $135
Suggested Retail $298

Tie-Dye Chiffon (0-12) 100%SE

32613TCH-10
Poncho Set
Black $90
Suggested Retail $198

32308TCH-10
Hanky Skirt
Black $112
Suggested Retail $246

6.2.4 Website

A website gives prospective buyers the opportunity to view your wares 24 hours a day, seven days a week. It is a marketing tool that is always open for business, and with today's technology-savvy consumers, a website is often the first place a potential customer will go to get more information.

Once you create the site, you want people to find it. Make sure you include your web address on every piece of literature that you send out, your mailing envelopes, stationery and business cards.

What to Include

- Your professional bio

- A business email address to contact

- A mailing address (again, preferably not your home)

- A selection of images of your best work only

- Simple text descriptions of each piece

Also, include an "About Us" section. Let your buyers know who you are, what you do and what you can do for them like no other designer out there. This is also a good place to add information such as your educational background, years in the business and other information that adds credibility to your business.

If you include a photograph of yourself to make your sales personal, a headshot, which is just of your face and/or shoulders, is better than a full-body shot, because it avoids situations in which the viewer might make judgments about your designs or abilities based on what you were wearing in the photograph.

A good way to get additional ideas for content is to visit the sites of other designers by doing an Internet search for "fashion designers."

Technical Considerations

Setting up and maintaining a website does take time, particularly if you've never done anything like it before or don't consider yourself particularly computer-savvy. If you have no idea what's involved, here's a list of what you'll need to get started:

- A cable modem or ethernet card to connect to the Internet

- An Internet Service Provider (ISP)

- A web host, to host your pages

- A domain name

- HTML software like Microsoft FrontPage to make your web pages

- FTP (File transfer protocol) software to upload your web pages from your computer to your web host

If this seems like a lot, don't be put off. Much of it can be done inexpensively, so that you can be online for less than $150 per month — which beats the heck out of a storefront any time.

Almost all ISPs offer free web hosting service. However, these usually have space limitations, and will bombard visitors with pop-up ads and other advertisements that might turn off prospective clients. For a small monthly fee you can host your site through a service company, register a domain name and get your site listed on search engines so that clients can find you. One such company is Go Daddy (**www.godaddy.com**).

You can find out about other, similar companies by visiting Webhost Magazine's website at **www.webhostmagazine.com**. Webhost Magazine offers free, unbiased consumer reports on domain name registrars and web hosting companies (think *Consumer Reports Magazine* here). It also has a tutorial guide you can use to educate yourself about everything you need to know when it comes to the Internet and setting up a website.

Ipswitch (**www.ipswitch.com**) is the leading supplier of FTP software and provides good customer service for their product.

Getting traffic to your website means submitting it to the most popular search engines, such as Google and MSN.

Hiring a Web Designer

While creating your own website can be fun and rewarding, it can also lead to some unfortunate surprises that will cost you time and money if you've never constructed a website before. For example, Microsoft FrontPage is easy to use, but some ISP software is not compatible with FrontPage, so you need to check this before you begin building your site.

If you want to process orders directly from your site, you will be better off hiring a professional web designer. Order forms, invoices and security concerns are all complex issues that you don't want to learn about as you go along. Mistakes in processing orders will cost you sales and customers.

Further, once the site is up and running, you're going to have to make updates. A website is never done, it merely changes form. If you're not updating your content, you're not moving forward.

A simple website design and construction will usually cost you a few thousand dollars. This might be a good area to arrange to trade clothes for services.

Selling Online

One of the fastest-growing ways that new designers are finding profits quickly is by selling directly to the customer online. With Internet access and a virtual shopping cart, many designers are beefing up their bank accounts without the hassles of dealing with retail accounts.

With an "information-only" website, you can show your designs and instruct the buyer to either call you or visit certain retailers to place an order. Information-only sites work well in all markets including local ones, where someone may have heard about your couture work and wants to know a little more about you without committing to an appointment. Also, if you prefer not to set up a merchant account or risk fraudulent orders, an information-only website may be the way for you to go.

If you want to sell online, you'll need an e-commerce-enabled website that allows you to take orders and process them online. You'll need shopping cart software that can automatically figure shipping for you, and, of course, you'll need to have a fulfillment system in place. To accept credit cards you'll need a merchant account (obtainable from most banks), and you'll need a list server to automatically reply to or contact customers.

Yahoo! Small Business can provide all of these services for you. Visit **http://smallbusiness.yahoo.com/merchant** for information. Another option is to use different companies for different tasks. For example, shopping cart software is available from companies like 1stShopping-Cart.com (**www.1shoppingcart.com**) and Aweber Communications (**www.aweber.com**) offers a list server.

If you'll be shipping orders internationally, you'll need to check into what's required as far as export duties, VATS, and the like. You may also want to limit your shipment area to avoid certain countries that have a high incidence of fraud.

6.2.5 Catalogs

Mail-order catalogs have been around for over a hundred years, and while you may not aspire to be the next Lands' End, Chadwick's or Spiegel, you can certainly make a profit selling through catalogs — so long as you have money to invest to do it properly.

To begin, you'll need to show pictures of your samples, either by themselves or on models. Next, you'll need to write up a description of each style, and list the color and sizes it comes in. You'll also need to include a price. Then you'll need to have the catalog professionally printed and bound. Color photographs can be expensive to reproduce, so you'll need to factor that into your printing budget.

If you are selling to private clients, you can make your catalog available in doctors' and dentists' waiting rooms (if they are agreeable), at small sales parties, and by request on your website. Information about distributing your catalog by direct mail is also coming up.

If you don't want to go through the hassle of putting out your own catalog, you can still sell through direct mail — in other retailers' catalogs. Mail-order merchants are hungry for good product resources and their buyers will be happy to work with you if you entice them.

To begin, you need to make a list of all the catalogs that would be a good fit for your merchandise as far as quality and price. There are thousands of catalogs out there, probably many that you've never heard of before, so take a look around to see what's available. You can find a good list at:

- *Catalogs.com*
 www.catalogs.com

- *Online Clothing Stores*
 www.onlineclothingstores.com

- *Shop At Home*
 www.shopathome.com

Once you've found likely prospects, put together a presentation that will win them over with:

- Convincing sales copy

- Successful ads that you've used

- Proof of sales

- Testimonials

- Any articles that have been written about you

You can approach them directly in person, by mail, by phone, at trade shows or by contacting sales reps that specialize in representing products to catalogs. Look in the catalog or on their website for the company address.

6.2.6 A Press Kit

If you are looking for publicity, chances are it's going to find you. When a reporter calls, you want to have all your promotional materials put together for them in a nice little package called a press kit. This package should also "sell you" to busy media types who are trying to decide who to give coverage to after they have seen a thousand shows during Fashion Week.

Press kits are enclosed in folders with two pockets inside for sliding material in and out of, and a slot for your business card. You can buy large quantities of these folders at any office supply store. You can staple or bind a press kit together, but bear in mind that you can't add or remove material afterwards, so you'd best only do up as many as you need for a certain event.

Inside you would include your business card (or several of them), your brochure, and line sheets or other promotional material. You would also include copies of articles written about your designs in the past, or press releases you have sent out. You might also want to include high-resolution photos of you and your designs, on paper or on disc. Some media prefer it if you also supply them with freqently asked questions, to help them prepare an interview.

If you are highlighting a particular event such as a trade show or runway show, you would create a press release that would be the first piece of paper on the top of the information.

If you hire a PR agency to do your kit, a press kit cost could range from $7,500 to $20,000 depending on the elements and quantity of the kit. Otherwise, you should be able to put a bunch together yourself for less than $1,000.

6.3 Finding Private Clients

If you are trying to appeal to the buying public, consider using some of these methods to spread the word about your business. You will see that some methods of finding clients are better suited to your business than others, so think about what will best reach your target market.

6.3.1 Advertising

Sometimes the best way to reach your target market is to pay for an advertisement. There are several mediums in which you can place ads. You may want to try them all at least once to determine which one is best for your business.

Yellow Pages

Letting your fingers do the walking is still one of the most effective ways to get your name out there to private clients (retailers and boutiques will not find you this way).

To minimize your risk you can consider starting with a small ad, such as a 1/8th-page ad. If you can get your hands on previous editions of your local Yellow Pages, compare any ads for fashion designers from year to year. If you notice others have increased or decreased the size or the number of ads, this can give you a cost-free indication if this is the right type of advertising for you and your business.

You can either design the ad yourself, have the Yellow Pages people design it for you or farm this work out. Before doing anything, look at the current ads for themes and ideas that will make the design process smoother. As always, what you do will depend on the amount of time and money you're willing to invest. Some localities also have telephone "pages" or "books" of other types specific to geographic regions rather than an entire state.

Magazines and Newspapers

Print advertising can cost thousands of dollars, and may not generate the results you want unless you do it repeatedly. Experts say that an ad needs to be viewed three to seven times before consumers will make a buying decision, so make long-term plans for your advertising program. Chances are that running an ad only once won't give you as much business as you would hope. Develop a long-term strategy and stick with it.

If you decide to advertise in this medium, it's best to start small and place ads in your local newspaper or magazines, or specialty fashion magazines, if they are available and you can afford them.

Often, newspapers and magazines run special sections at different times during the year, which can potentially be good advertising opportunities for you. For example, if you know that in the spring they'll be running a special section on weddings, and you design bridal gowns, then that's a target-rich environment for you. Calling your newspaper's advertising department and asking for their editorial calendar is the best way to find information on any upcoming special sections.

As mentioned in the section on brochures, your advertising must tell your target market three things: who you are, what you do and what you can do for the customer. It can also be an ad for a special event you have coming up, such as a "trunk show" or private sale. You can approach a boutique that sells your clothing about combining on an ad that promotes both your clothes and their shop.

Here are some additional tips on how to create an effective ad.

- Focus your ad on the customer. Explain how they can benefit from buying your line of clothes, rather than listing what you do. "You can have the wardrobe you've always wanted" is a much more effective message than "I help people expand their wardrobes."

- Don't just tell the reader what you can do – show them. Include photographs of some of your best designs.

- Make the readers an offer they can't refuse. Your ad should describe a service or special promotion that makes you stand out from your competition. It should also include a call to action. In the ad business that's called "creating a sense of urgency." You want the reader to take advantage of your services now.

The publications you advertise in will usually design your ad for an additional cost (10 to 15 percent, on top of the cost of your ad) and give you a copy of your ad to run in other publications.

Again, remember that most colleges and universities have advertising majors. Hire student-run advertising agencies that are set up at the college and let them do the work for you — everybody wins!

Direct Mail

Once you've landed a good customer, it only makes sense to try to do business with them again and again. Since the most expensive customer you'll ever get is a new one, it's simply more cost-effective to market to people you've already done business with, because they already know what you're like.

To that end, you need to maintain a customer list and contact everyone on it from time to time. You can do this by hand, using a database on the computer or even through an online list service where you contact your customers via email. However you do it, just do it. It can be vital to your bottom line.

Send them a postcard or email every few months with pictures of your latest designs and a note saying something like any of the following:

- "Stop by our showroom to see our newest designs."

- "Place your orders now for spring (fall, holiday) apparel."

- "The holidays are coming...Do you know what you're going to wear?"

- "Yes, we do gowns for weddings...and christenings, bat mitzvahs, pageants, and proms. What dress can we make for you?"

A little creativity goes a long way. By putting your name in front of satisfied customers again and again, you can be sure they'll return, and, they'll refer you to others.

If you don't have a list of established customers and want to aggressively distribute your catalog or brochure, you can rent a list of names of prospects that have bought similar products in the past. Targeted lists of wealthy clients might include:

- Country club members

- Executive associations

- Local business journal subscribers

- State or regional magazine subscribers

Names are purchased in lists by the thousand, and you can only use the names once, unless the prospects become your clients. Prices vary depending on vendor, target market and "freshness" of list, so again, you'll need to ask around and do your research to make sure you have a good list. Popular list renting services include:

- *Accurate Leads*
 www.accurateleads.com

- *Info USA*
 www.infousa.com

- *USA Data*
 www.usadata.com

Once you have the names, don't just affix each label to a catalog and mail it out. Instead, select a random sampling of names, perhaps 500 or 1000, and mail to just those names to begin with. Measure the results. If they're as you expect, finish the mailing. If they're not, analyze why. Is the catalog not working? Is the merchandise not enticing? Is the list bad?

Change something and try another mailing with a second random sample. It's important to test, because mailing out catalogs is expensive, and if you have a piece that doesn't work for whatever reason, you'd probably prefer to learn that by paying the postage on 500 pieces instead of 5,000 or 50,000.

If you find that you can't afford postage to send your catalog or brochure, you can also get postcards printed. You could use a photo of one or several of your designs on one side of the postcard and include a limited time discount on the other side. Use words like "unique," "one-of-a-kind," "made to order," etc. to entice them to pick up the phone and schedule an appointment. Why send postcards? Because they're cheaper to mail than envelopes, and they're almost universally looked at — particularly if they're hand-addressed.

To learn more about tried-and-true direct sales techniques, pick up a copy of Dan Kennedy's book, *The Ultimate Sales Letter*.

6.3.2 Write a Press Release

Getting the local press to write a story about you is a great way to get business, since stories are often perceived as being more authentic than advertising. Many people will surmise that if the newspaper or local magazine is covering you then you must do good work.

When you are looking for free publicity, however, remember that journalists deal with story solicitations every day. They know when they are being pitched an article idea for no other reason than someone is looking to get a free plug. Editors and journalists have a responsibility to provide their readers with timely, accurate and newsworthy information, while avoiding publishing self-serving articles.

How to Get it Published

The good news is, as long as your pitch is newsworthy, it can get published. Don't send out a press release telling them you're Jane Smith of Jane's Couture and now you're open for business. Who cares, except you?

Instead, send out a short press release that describes the advantages of custom-made clothing, like unbeatable fit and one-of-a-kind apparel. Or, if you've won awards for your designs or have a unique product, use the press release to say what awards you've won and how you can use your expertise to dress the people of your city like no one else can. What's in it for your customer? If you answer that question in the form of a story or announcement, you're much more likely to persuade the media to cover your story.

Have a point and get right to it. Busy journalists seldom have the time to read endless paragraphs about your business, how you make life better for everyone in the world and what your place is in the market. Your opening paragraph (what is called the "lead") of your release should be kept to 25-30 words and get straight to the newsworthiness of the story. Here is an example of an effective lead:

> *Donna Designer, who has been dressing fashionable women in Bigtown for five fabulous years, will be the keynote speaker at Friday's Fashion Design Conference at the Anytown Convention Center.*

Let's look at what 28 words tell the reporter or editor:

- *Who* Donna is

- *What* Donna has done and is going to do

- *Where* Donna is speaking

- *When* Donna is speaking

- *Why* Donna is speaking

History and other information is okay to include in the release — just put it at the end. Think of when you read a story in a newspaper or magazine — if the first few paragraphs don't grab you then you're not going to read it, and neither is the reporter to whom you send the press release.

At the end of your release, make sure to include all of the necessary contact information. If you are putting your own release together, then make sure you have your contact information listed. If you have a public relations agency make the release for you, then the agency's contact information will be included on the press release, and the reporter will contact the agency. The agency will then contact you to make arrangements for an interview.

It is standard practice to follow up a press release with a phone call or e-mail to the reporter. However, since journalists see literally hundreds of releases a day, try not to wait more than a few days before making the call.

Formatting Standards

For most releases, write "For Immediate Release" at the top of the page, unless the material being released is somehow time-sensitive. The format of a press release directed to the print media should:

- Start half way down on the page

- Use margins of 1 to 1-1/2 inches

- Use a bold-faced, centered headline

- Include a web address where more information is available

- Be double-spaced

- Include professional photos if possible and applicable

- Put the most important information first

- Be no more than two pages

- Use action verbs

- Have "-more-" at the end of the first page and "###" at the end of the piece

- Be directed to the appropriate person

- Limit paragraphs to one topic of two to three sentences

- Not be stapled

- Have date, topic, and contact information above the headline

PublicityInsider.com offers tips on writing a press release at **www. publicityinsider.com/release.asp**.

Where to Send Them

Newspapers and magazines will list their editors and reporters on their mastheads, so you can easily find who should receive your release. Since you're in fashion design, then the fashion editor will most likely be your target. Also, since most publications have websites, you can find contact information there as well. Some publications even have a dedicated email address to specific departments in the newsroom.

For an excellent listing of the major newspapers and magazines in the United States and Europe, visit the following page at JournalismJobs.com: **www.journalismjobs.com/newspaper_links.cfm**.

Sample Press Release

FOR IMMEDIATE RELEASE March 4, 2006

Contact: Donna Designer
Company: Designs by Donna
(204) 555-1212
ddesign@donnasdesigns.com
Fax: (204) 555-1213

Designer Reveals Fashion Secrets

Donna Designer, who has been dressing fashionable women in Bigtown for five fabulous years, will be the keynote speaker at Friday's Fashion Design Conference at the Anytown Convention Center.

Spring fashion is the theme of the Anytown Fashion Design Conference on Friday, March 8, 2006. Donna Designer is an expert in the three wardrobe secrets women must know to project a successful image, which she will share with attendees, along with tips for using them in the working world.

The event is being presented in conjunction with the Anytown Boutique, where Donna Designer clothing can be purchased. The event will be held at the LaBaron Hotel, 314 W. Bijou. The doors open at 11:30, followed by lunch at noon. Cost is $18 to attend.

Donna Designer's clothing line, Designs by Donna, is aimed at the mature working woman. Her smart, casual look is world-renowned, and her clothing is sold both nationally and internationally.

For more information on the conference, or to pick up tickets, contact the Anytown Boutique at 555-1234, or visit www.anyboutique.com.

###

6.3.3 Get Some Free Publicity

Let's take a look at several ways you can sell yourself without actually buying an ad. If some of this seems overwhelming, remember that you can also hire public relations professionals to help you out. These people are experts at promotion and getting a name out there to the press. What money you might save doing publicity yourself, you probably lose in time that could be used to create your fashions.

Be Seen as an Expert

There's nothing like self-promotion, and one of the best ways to get your name out there is to establish yourself as an "expert source" for information. Journalists use experts in their stories every day, but they don't always have time to search for them.

If you want to get national publicity, one service worth looking into is PR Leads, which notifies you by email about reporters who need to interview experts for stories they are writing. Every day they get upwards of 100 requests from reporters for top daily newspapers, like the *New York Times* and *Los Angeles Times*, as well as leading business publications like *The Wall Street Journal*, and top women's magazines like *Redbook* and *Glamour*. You can subscribe to PR Leads for $99 per month, which includes 30 days of email coaching. More information is available from Dan Janal at **www.prleads.com**.

Write Columns or Articles

You can start small and offer to write a column for your local community newspaper. What you want to remember is to give the readers real information and not just promote your business. For example, you could write an article for the fashion section of your local paper on the newest trends coming out for the current season. The story is interesting and useful to readers, and you get your name out there (and perhaps your business name and web address) in a published byline.

You can also volunteer to write an article for a fashion website. Some of these pay, others don't. The key is getting your name out there, and these publications are very good about allowing you to plug your business in the form of a biography about you.

You will most likely have to write a column first, then hand it off to the appropriate editor to demonstrate your ability to write. Also bear in mind that this isn't about money, it's about exposure for you and your business. So if they offer no money, do it anyway. At the end of your column or story, they will include a short biography of who you are, what you do and how to contact you. Consider it bartering services.

Contact TV and Radio Producers

If you've always wanted to be an on-air personality, here's your chance. Phone the appropriate producer at your local stations and let them know that you would be happy to provide your expertise for their audience.

It's best to begin at small, local television and radio stations and work your way up from there. You will probably be asked to send some information regarding your qualifications as a designer; this is where your promotional materials and your website come in. After you've provided the necessary materials, give the producer a couple of days before you follow up and ask for an appointment.

Producers, like editors at newspapers, are often bombarded with local folks who have something to say, so be sure to use your best "hooks" to grab the producer's attention, and make it clear that your expertise is valuable to their audience.

For a listing of television and radio stations in the United States, visit **www.journalismjobs.com**.

Have Students Spread the Word

Some schools have chapters of an organization called the Public Relations Student Society of America (**www.prssa.org**). This student organization is part of the national organization the Public Relations Society of America (**www.prsa.org**). Some of the college chapters have student-run public relations agencies that hire out their services in exchange for professional experience.

So if you're looking for ways to get press about your line or your company, this is a great way to get it done for little or no money. Further, a faculty advisor oversees the students to make sure the students are staying on track and doing the work properly.

Dress Local Celebrities

Have you ever wondered why famous designers jump at the chance to dress A-list celebrities for red carpet events? Because if the gown is a crowd-pleaser and the designer's name is mentioned, thousands of copies will be snapped up all over the world. It worked for Charles Frederick Worth, the "father of haute couture" when he dressed the Empress Eugenie in Paris in the 1850s, and it works to this day.

Radio personalities, large business owners, TV news anchors, etc., need to look fashionable as part of their job, and can't be seen in the latest offerings from Kmart. If you give them your custom designs for free or at a reduced cost, they may snap up the offer and your phone will ring off the hook from the publicity. In addition to simply wearing your clothes, you might even get an on-air mention or a credit at the end of a TV show.

At the very least, they'll be able to tell anyone who asks where they got their outfit.

See if there is a local celebrity who you think would suit your designs. Maybe they already dress similar to the styles you are working on. Scour the local society pages of your newspaper to see who is constantly being photographed in public appearances looking fabulous.

Approach them professionally about the possibility of wearing your designs — this may involve contacting their employer or press agent first, to schedule a meeting and discuss what you have to offer. Have your best samples ready for them to try on in their size. If you reach an agreement, put in writing what you plan to offer and what you expect from them.

Make Charitable Donations

A great way to get publicity is to donate products to charitable organizations. They can auction off your clothing, and you get your name mentioned and your product viewed by exactly who is likely to buy it — the wealthy. Plus there is good karma in being associated with a charity. It makes people feel good about you, and they associate your designs with a cause they believe in.

Most times charitable organizations will find you, but if they don't, check the Social or People pages of your local newspaper to find events the wealthy attend, or look in the Yellow Pages under "Societies" or "Charitable Organizations."

To save on up-front costs, you can donate last year's sample garments (which you don't need anymore), or donate the "service" of a custom design with a value up to a certain amount, so you can meet the buyer personally and possibly sell them a more expensive garment, or additional work down the road.

6.3.4 Network with Potential Clients

Some people get cold feet when the topic of networking comes up. They imagine making cold calls or arranging meetings to make sales pitches to people about your wares. But networking should be a part of your marketing plan that is casual and enjoyable.

Networking is about meeting and interacting with people in the industry in either a social or business atmosphere for the purpose of mutual assistance or support. Focus on the word mutual — the relationship should benefit you both.

While some people you meet may have an immediate need for your goods (or know someone who does) in most cases you will be laying the foundation for future business. By establishing relationships through networking you can be the one people think of when they do need a designer.

Who to Network With

If you're a designer and you want to get your name known, then you have to get on the collective radar. But you simply will not have the time to network with everyone who might possibly be interested in your line, so confine your attentions to your target market.

Who you network with will depend largely on your target market. If you are marketing to teenage girls, you need to find ways to infiltrate and be a part of their social groups. You might set up a temporary booth with samples of your designs at the mall, or arrange to make a speech about fashion design careers at the local high school.

If your market is brides-to-be, you'll want to attend bridal shows. If your market is local professionals, you could join your local chamber of commerce, Kiwanis club or Rotary Club. If your market is baby clothes, you'll want to spend time in kid's clothing stores, mom-to-be groups, and mom and tot groups.

People who buy custom-designed clothing are usually wealthy. To meet wealthy people, you can attend or volunteer at museum and art gallery openings, or charity and political fundraisers. Check the Social or People pages of your local newspaper to find events the wealthy attend, or look in the Yellow Pages under "Societies" or "Charitable Organizations." Focus your searches on the wealthier areas of town, and join branches that are local to them. You might see if you can find a way to socialize at a local golf or country club through a friend or colleague, or become a member yourself.

Whatever your market, you'll need a valid reason to interact with them — not just for selling. If you have kids of your own, you can easily meet other parents and sell them your custom kidswear, but if you don't, you have to be a bit more creative — maybe by offering a seminar for parents of children (in a wealthy neighborhood!) on back-to-school shopping, for example.

An excellent way to get referral business is to make contact with other professionals who are likely to have customers who could use your design services. Contact bridal shops, image and pageant consultants and event and wedding planners. Explain your business concept, and ask if you can leave a stack of business cards and/or brochures at their facilities. You might also offer a referral bonus, which can be a percentage (maybe five percent) of the order, or a flat fee like $25 or $50.

Personal Shoppers

Personal shoppers buy clothing and other items for wealthy clients, either on a contract basis, or as a service provided by retailers. Personal shoppers can be a great source of business for you if they dress their clients in your designs.

If you want to find a personal shopper, go to your local large, upscale retailer and talk to a personal shopper there — many personal shoppers who work for retailers also run private businesses as well. Befriend one at a retailer (offer them some free clothes to start!), hand them your card, and ask them to bring a few clients by. The beautiful thing here is that personal shoppers have an established list of clients. Typically the personal shopper will charge you about eight percent commission for bringing you a sale.

How to Promote Yourself

When you attend social or business functions with potential clients, you'll want to have plenty of business cards available. Don't hand them your card before you've had a chance to talk to them a bit, or you'll seem like you are just trolling for business. Exchange business cards only after you've established that the potential for a mutually beneficial relationship exists. When you collect business cards from others, write the occasion and date on the back to jog your memory later.

If you meet someone who expresses an interest in or need for some custom clothing design, follow up after the meeting with a glad-I-met-you introductory letter, and send your promotional materials (brochures and postcards) to them. You can give them a call a few days later to see where they are at.

You should practice describing what you do briefly and accurately to people. It should flow easily. Don't forget to ask what they do, too, and then think about whether there is any connection between what you do and what they may need. For example, if they say, "I'm a traveling sales-man," you can tell them about your line of suits that are virtually wrinkle-free and coffee-stain proof.

If you are in a social situation where talking about your business may not be appropriate, listen for opportunities to tactfully bring it up. If you want to introduce your line of work to the conversation, a quick and easy way is to comment nicely on what the person is wearing. They will be even more flattered when they find out the compliment is coming from a de-sign professional.

6.3.5 Host a Private Trunk Show

A trunk show is an exclusive showing and sale of your designs. While most trunk shows are held in a boutique or retail store that sells some of your clothing (see section 6.5.1 on setting up a trunk show), as a private designer you can also host a private trunk show at your home, your showroom or workspace, a friend or colleague's home, or an office.

Note that a trunk show is not a fashion show. To put on a fashion show you have to create all the samples, hire the models, rent the space and invite all the buyers, or pay someone to do it for you. Until you have a proven track record and a large advertising budget, putting on a big fash-ion show could put you out of business fast. Think of a trunk show like a Tupperware party for clothes — the event should be informal and social.

If you have an established client base, you can contact them personally and invite them to your trunk show. You could also invite a large group within your target market, such as students at a local college, or the women in your church group. The host or hostess (if it is not you) should be offered a generous discount on their purchases. Yet another option is

to throw the doors wide open and run an ad for the event in local media (don't forget to send a press release as well). Promote your trunk show as an exclusive opportunity to:

- Personally meet with you (the designer) and get advice on wearing the designs

- Preview next year's designs before they are released to the public

- Pick up last year's models at a discount (also known as a sample sale)

- Win a door prize of free merchandise

Have your designs on hand in the largest assortment of sizes you can muster, and a private area where people can try them on. You can either formally present the designs one by one, or have them out for display in an informal setting. Bring some fabric samples if the samples are available in other fabrics, and be prepared to take custom orders on the spot (see section 5.6.4 for a sample order sheet).

You should offer snacks and/or refreshments, and attempt to speak with every attendee personally, if possible. Designers often have a number of trunk shows in a year, and as your business grows, you might have to consider having a sales rep attend rather than yourself.

TIP: Your door prize draw box will contain addresses of potential clients, so don't throw them away! Specify on the door prize entry that you will be contacting them with future offers, and add them to your client database.

Once you get someone in the door and buying something from you, always suggest ways to increase the amount of the order in the "Would you like fries with your hamburger today?" sort of way.

For example, if they want an evening gown, perhaps you could also get them to order a matching wrap. If your customer is shopping for a wedding gown, maybe you could also whip up something for the rehearsal dinner. Do they need a special suit for an important speech? Well, they're almost certainly going to need a dress for the cocktail party the night before.

You don't have to be obnoxious about it. All you need to do is suggest other things they might have forgotten that you can help them with. It's called "up selling," and for many businesses in many industries, it can add an extra 30 percent to their bottom line.

6.4 Finding Wholesale Buyers

Selling to corporate buyers and retailers is a whole different ball of wax, though you don't have to give up private clients to do the other. Here is a look at who is likely to order your designs, and how to deal with them, as well as creative ways to find and reach new corporate buyers.

6.4.1 Specialty Stores and Boutiques

If your goal is to sell your products wholesale to local specialty stores and boutiques, start by pulling out your phone book and making a list of all such stores in your area. Then, start visiting them one by one if you haven't before. You're looking for stores that sell to your target market that have similar products in your targeted price range.

When you find one that fits your profile, ask who the buyer is and if you might schedule an appointment to show your samples. In many boutiques, the owner handles the buying, and they may have specific days of the week or the month when they consider new merchandise. Pull out your calendar and schedule an appointment. Never drop by unannounced and expect the buyer to stop what they're doing to look at your samples. That's presumptuous and will earn you strikes before you get started.

You can also talk to the owner on the phone and make your pitch, or you can mail your materials to the boutique owner and call back in a few days and ask for an appointment or offer an invitation to your office or showroom.

If you get the appointment, be sure to practice your pitch until you have it down pat. You'll want to show each piece one at a time, pointing out the details. If you have groups within your line (like outfits), show by groups to avoid confusion. Be mindful of the buyer's time by aiming to keep your presentation short, no more than fifteen or twenty minutes. You may even want to practice with a friend so you can get constructive feedback.

Be on time for your appointment and dress appropriately and professionally. Show your samples like you practiced, and answer any of the buyer's questions. If they offer suggestions on changes, listen to them. They know their customers best, so don't assume the worst if they don't snap up your designs. Take their words into consideration. If they place an order, it will probably be a small one, to test both your ability to deliver and the salability of the clothes.

With boutiques, you can negotiate with the owner and set up a billing system. You can either bill them later, or have the order they submit serve as the bill as well (which is usually the case with big retailers). In the fashion business, expecting to get paid within 30 days of delivery is the standard. Experts consulted for this book also said it's not unusual for a boutique owner to only offer partial payment if they had a bad month, so choose your boutique owners carefully.

If everything goes as it should, from delivery to customer sales, the boutique or specialty store will probably buy from you again. Keep in touch with them by either calling them every season or by sending them a postcard to let them know you have a new line to show. Follow up with a phone call to set an appointment if they haven't called you to schedule one themselves.

> **TIP:** Sometimes boutiques have loyal customers who are seeking something they can't find in the shop. If you also service couture clients in addition to your retail accounts, let the retailer know that you do custom orders, and give them an incentive to refer you. This may be a percentage of the special order or a flat fee. This kind of service will keep customers coming back for more, as it's "above and beyond" the call of duty and always leaves a lasting impression.

Consignment Agreements

Consigning clothing means that you are paid a percentage by the shop after it is sold to the customer. For example, you may consign on a 60/40 ratio (depending on the store's policy), meaning 60 percent of the retail price goes to you, while 40 percent goes to the shop to cover all site-related fees.

Some retailers may do this when they are not 100 percent positive about your line (being a new line, new designer). It is a good sign though, that they want to try it in their store, and it is an opportunity to prove yourself and your line without any risk to the retailer.

Some consignment-only shops buy this way exclusively, and some consignment shops have a mix of new and used clothing. It has become a growing segment of the fashion retail market, and can also give you an opportunity to show your product to customers who are looking for brand names.

A fashion designer can either sell by consignment or accept a pre-paid order for a certain amount of goods from the store — the preferred method depends on the designer's market. Generally speaking, those who prefer to sell by order are going to be on the large end of the market, who most likely produce a catalog from which stores can purchase orders in bulk amounts.

Designers on the smaller end of the market might prefer doing business by consignment. Jamie Stratton, a Seattle independent designer, started her Agent X line by selling her hand-crafted garments on consignment at Seattle boutiques until she opened her own retail store. She generally took home 50 percent of the sales, which worked very well for her until she earned enough to rent a space where she could keep 100 percent of the sales. Stratton cautions new designers to be very selective when shopping for a place to sell on consignment. She suggests you match your product to the products in the store, which increases your chance of selling successfully.

Because the owner is not purchasing the line, they are more likely to try out more pieces in it, which gives you opportunity to show the line completely rather than in pieces. (In a retail store they may only select four or five styles and therefore are not really showing the true style or direction of the line.) It is at no financial risk for the consignment shop to take on more styles.

The big disadvantage is that you do not get paid until it is actually sold, and it may not be at a percentage that you intended. For example, if it does not sell after a certain amount of time (like the end of season), the retailers can then mark it down to clear it out of their store, if you have agreed to that when they place their order.

236

Sample Boutique Consignment Agreement

This agreement is made on *[date]* between *[name of the consignment shop]*, herein referred to as "Seller," and *[individual or designer]*.

Whereas *[individual or designer]* wishes to sell *[description of item(s)]* by consigning said item(s) to *[name of consignment shop]* for sale, it is understood:

- That Seller agrees to display item(s) in a prominent place in Seller's establishment.

- That Seller will make every attempt to obtain the best possible price for the consigned merchandise and will accept no less than $_____ as purchase price.

- That for the Seller's efforts Seller is entitled to retain _____% (percent) of the purchase price.

- That should a sale be effectuated, Seller shall forward a check for the amount of the full purchase price less the aforementioned _____% (percent) to Consignee within 10 days of the receipt of same.

- That Seller represents that Seller maintains insurance for theft and damage, and that the consigned merchandise will be covered by said insurance while it is in Seller's possession.

- That Consignee agrees to leave the merchandise with Seller for a minimum of _____ days.

That should the merchandise remain unsold at the end of the consignment period and a decision be made by the Consignee to remove said merchandise, any costs incurred by the delivery of same to Consignee shall be borne by Consignee.

Signed on: _____
 (date)

Consignor: _____

Consignee: _____

6.4.2 Department Stores and Large Retailers

Once you've worked with specialty stores and boutiques, you may find that you want to increase your brand recognition and profits by selling to department stores. This is a natural progression, but it's not one to be taken lightly.

To get a big start fast, it might seem logical to approach department stores right away in your design career; however, it's usually too much for a new designer to handle. If the department store buyer likes your line and orders everything, you have to have a system in place to fulfill a huge order, and the financial stability to wait 30 to 60 days for payment for the goods.

Department stores are notoriously difficult to work with, because they're high volume, very demanding, tend to pay their bills late and frequently eat into your profits with charge backs and returns. Still, they can raise your brand profile and profits because of their ready access to your target market. So, proceed with caution, but go for it.

Making Contact

> *"Once you identify what buyers you want to pitch your line to, it's a matter of call, call, and call some more."*
>
> — Giulietta Graci, Designer

Department stores have buying departments and, depending on the store, may invite emerging designers to come sell to them on specific days of the week or month. Check the store's website (if they have one), or call the store directly to find out who you should speak with and when to come in. If they don't have set times, ask to speak to the buyer and schedule an appointment.

The buyer may ask you a lot of questions about your background and experience before they agree to meet with you, but don't be intimidated. They get calls from people all the time who aren't serious or who don't know what they're doing, so they're just trying to assess whether you warrant their time. Assure them that you do.

You will also have to convince them that your designs are both a fit and a needed addition to their current collection, so have their current prod-

ucts researched and your explanations ready. They are anxious to discover new talent, but they don't want to be made a fool by someone who isn't ready for the "big leagues." Take any suggestions and criticisms into consideration.

Questions to Expect

Before you go, make sure you practice your presentation, have your samples presentable and in order, and have your line sheets and order forms with you. Show your line professionally, and answer any questions the buyer has. They may drill you extensively about your manufacturing situation to make sure that you can deliver as promised. The typical questions a buyer will ask you are:

What Are Your Price Points?

A buyer will not argue price. However, that doesn't mean they're not going to ask how much! There is one thing to bear in mind here though: Make sure your price points are consistent with the current market price of similar lines or garments, or, if your prices are higher, then be prepared to prove to the buying team why your line rates the higher price.

Where Are Your Garments Made?

This is a matter of delivery. If your fashions are manufactured domestically, the buyer will know the shipping time will be shorter compared to being manufactured overseas. Now, just because your line is manufactured overseas doesn't mean your designs won't sell, but it all comes down to how soon they can get the goods.

Who Are Your Existing Clients/What Stores Are You In?

Here, the buyer wants to know who else is buying your designs. Remember while it's true that the buyer buys the goods, ultimately, it's the consumer who decides if a fashion is going to sell.

How Soon Can You Deliver *X* Number of Units?

This is the bottom-line question. Never, **ever** fudge on this answer! Buyers forecast months in advance so they can have their fashions on the sales floor in time for the upcoming season, so a buyer may ask for

delivery up to several months in advance. This is why you need to have your manufacturing in order prior to soliciting sales.

Now, let's say a buyer gives you the thumbs up, wants your goods and wants to know when you can deliver. There's no reason to lie and say you can do something when you can't, or say yes and then run like mad to try to convince your manufacturer to work double-time or find an additional manufacturer.

If a buyer asks for an order that's too large, say, "I'm sorry, but currently my manufacturer can only deliver half that amount in your time frame. I can appreciate that you need X number of units, and I'm willing to do what it takes to deliver them to you. Would you be willing to take half of the requested amount by your deadline while I negotiate with my manufacturer to see how quickly we can come up with the rest of your order?" Your honesty will be appreciated.

Some designers have relationships with more than one manufacturer at a time for situations such as these, and you may want to consider this as well. If the buyer refuses to negotiate, then ask for their card and contact information and permission to contact them in the future or the next season when you're able to handle larger orders. It's more important to build a solid relationship so you have a customer for life. After all, it's the long-term, repeat business that will be the core of your profits.

Getting the Order

After the first meeting, there will be some type of follow up with more questions by the buying team. This is when you'll talk about your line in more specific terms and try to narrow your line down to what pieces would fit in best with the buyer's current offerings.

At this meeting, you may be asked to bring a live model with you so the team can see the look, feel, and texture of your products and how they move and look on the body. You'll also be asked about fit, fabric, and color ranges. Price points will be discussed in more detail here.

Your next meeting will get into the actual purchasing of your products. Here the buying team will decide exactly what garments they want, how many, what style, color, sizes and how many "doors" (number of stores your fashions will appear in) they'll initially sell your line in.

A Sales Success Story

Giulietta Graci sold her line of eveningwear to none other than Neiman Marcus for the fall of 2003 using the techniques discussed above.

Graci said the key to negotiating with buyers is to be mindful of their time. "If you get a buyer on the phone and they even sound busy, be quick and ask them if you can send them [pictures] or call back at a more convenient time."

Once Graci made contact with Neiman, she first met with an assistant buyer and showed her some samples in her office. The assistant liked the samples, then called in another team member to view them as well. After that, the samples and other relevant information went to a buyer in Dallas. The Dallas buyer showed enough interest to visit Graci's showroom in New York on a Thursday. The following Monday, Graci got the call she had been waiting for — Neiman wanted to buy. "This is when they started to ask about price points," Graci said. Once they got the price points, Neiman's bean counters crunched the numbers, decided how many products they wanted, the costs involved and what colors.

With beginners, who are definitely a higher risk then an established designer, they'll want to put your lines into their test markets first to see how they do before committing to a chain-wide introduction of your fashion.

There will also be a delivery date that you and the buyer work out together. All orders are considered tentative until you deliver the goods.

6.4.3 Trade Shows

Fashion industry trade shows are events that bring retail buyers and designers together at specific times to buy specific merchandise. There are thousands of trade shows all over the world every year, selling everything from accessories and outerwear to women's sportswear and winter formalwear. Buyers come looking for specific merchandise, and if you have a good product, you can write thousands of dollars in orders at trade shows.

The number one reason you attend a trade show is to convince buyers to place orders. Notice that's "place orders," not sell. This is because most shows will not allow actual physical sales of goods to take place at the show, although ordering is allowed and encouraged.

Aside from landing customers, attending trade shows can also help you:

- Garner attention for yourself from the industry and the media

- Find wholesalers for goods (such as textiles) you will need to manufacture your line

- Find manufacturers

- See what other designers are producing

- Network with others in your business

- Attend "breakouts," or seminars held pertaining to what's happening in the industry

Decide if You Are Ready

Before you attend a trade show, you must have all your ducks in a row — meaning your business must be up and running, and you must be ready to take orders and manufacture your goods. The easiest way to get shut out in this business is by making a promise on which you can't deliver.

Remember what this means: If you'll be selling to retailers via trade shows, you'll need to have fall/winter samples ready in May to be delivered in September and spring/summer samples ready in November for delivery in February and March.

Before applying to attend your first trade show, you should:

- **Have an existing consumer base.** The judges who will decide whether or not you qualify for the show will want proof that you have a legitimate business up and running, and you're not a fly-by-night operation. Buyers want to work with designers who have a reputation and can deliver, as well as someone who has been around for a few seasons.

- **Have a manufacturer who can produce.** Manufacturers vary greatly in terms of staff volume and therefore vary in terms of the volume of apparel they are able to handle. You need to know how many units that manufacturer can produce and in what time frame. Some designers use or have relationships with more than one manufacturer just in case they get a big order.

- **Have your price points set.** Waffling on price is a tip-off to buyers that you don't know what you are doing. You need to know exactly how much it costs you to make your unit, what your markup is, and what the retail markup is as well.

Finding a Show

Finding a trade show is as easy as turning on your computer — the trick is finding the show that's appropriate to your line of products. Designers often get rejected from shows because their goods do not match the show's theme. In other words, if you design swimwear, and you apply as an exhibitor at a show for menswear, you're probably not going to get accepted.

Here are some excellent sites for finding fashion trade shows all over the world:

- *ApparelNews.net*
 www.apparelnews.net/TradeShows/

- *TradeShowWeek.com*
 http://directory.tradeshowweek.com/directory/index.asp

- *Apparel Search*
 www.apparelsearch.com/trade_show.htm

The Application Process

There is a process to get into a trade show, in which you apply to a jury panel. Since the trade show organizers have the responsibility of getting buyers and sellers together, they will act like a buyer in terms of the questions they'll ask on the application.

Once you target your show, you need to contact the people who run it, either by phone, by mail, or by email and request an "exhibitor's application." Since everything is electronic these days, the best way to go about the application process is to fill one out online. On most trade show websites, you can find a link for "exhibitor information" right on the home page and that will lead you to every place you need to be on the site regarding the application process.

On the application, they will want to know information such as:

- How long you have been in business

- Your target market

- Your price points

- Where your goods are physically manufactured

- Who your competitors are

- The scope of your existing client base (both private and retailers)

Your application will go to a judging panel to decide if you're in or out. Assuming you do get accepted, you'll get a nice fat package in the mail from the show producers filled with information about everything you'll need to do before the show. You'll be required to fill out more paperwork at this point. Your packet will also include things such as prepress items, a listing of who's going to be there and so on.

Once your application to the exhibit has been accepted, you need to think about your display. If you've attended trade shows in the past, think about the elements that made the best booths so popular. Also, think about how big of a space you want and need. A typical booth is 10 feet by 10 feet (100 square feet). Once you fill out and send in the paperwork with your money, you'll be ready to go.

TIP: Some shows will give you as many as 500 postcards with all of the information about the show, and all you have to do is address and send them to the companies you would like to see your wares. Be sure to include your booth number — that's your "location" at the show.

If you get turned down, make sure to apply to the same show the following year, since one reason designers get rejected is because they haven't been in business long enough.

Trade Show Costs

Once you decide to attend a trade show, you'll need to look at your budget. Showing at trade shows does require a bit of an investment, but if your products sell, it will be money well spent.

Booth Rental

Booths at a trade show are often priced by the square foot, with different sizes available. Consider displays you want to set up, and how busy you want your area to be. Typically when you rent a booth, you'll pay a flat fee, at an average of about $1,500, though some shows will charge $5,000 or more just for the booth.

This fee typically gets you the booth, a listing in the show directory, floor covering, walls and curtains (bare basics), table and chairs, racks, and some shelves. Sometimes it includes risers for the display, a sign for the booth, and a cart for transporting samples to and from your booth.

Travel

You have to factor in all elements of attending a trade show, including plane tickets or gas to get there, car rental fees, and hotel and food costs. These will of course vary depending on how close you are to the trade show.

Shipping

You will have to pay to ship your samples, brochures, and anything else you need with you if it won't fit in your luggage or in your car.

Signage

You may also want to have a sign or backdrop manufactured that states the name of your business and is attractive. Signs are usually a few hundred dollars, while a paneled display booth will cost you a few thousand. Some trade shows will provide a generic sign for your booth as part of their fee package.

Lighting and Decorations

Basic lighting may come free with the booth, but additional lighting will draw attention to your displays and make your area stand out. Many trade shows will also offer you the rental of fake plants and the like to make your booth "homey."

Tables

Again, a small table may come standard in the booth, with the option to upgrade to more or nicer ones. Make sure that you get some kind of table covering and chairs with it, or rent these. You can sometimes request table coverings to match your company colors.

Staffing

Remember that your booth needs to be staffed during the entire show. While you may be able to spend a lot of time there, you'll need to eat and powder your nose from time to time. If you can, hire someone to man the booth with you, or get your spouse or a friend to help. You'll be glad you did.

> **TIP:** Some shows offer "booth packages," where for one set price you get many of these items included with your booth rental for considerably less than what you would pay to get each separately.

You can browse around online for ideas at trade show exhibitor sites like the ones below. These websites will give you plenty of ideas to feed your creativity and help you think of booth displays that fit your budget.

- *CamelBack Display*
 www.camelbackdisplays.com

- *ExhibitsToGo*
 www.exhibitstogo.com

- *TradeShow MAX*
 www.tradeshowmax.com

Before the Show

Your pre-show packet will give you all the information you need about what time you can get on the show floor to set up.

While this may sound obvious, you want to make sure you have all of your samples ready to go. You don't have to bring every single garment, but you should bring a good representative sampling of your line or collection. You'll also want to bring different fabric swatches, your portfolio, any marketing materials you have, and lots and lots of business cards.

You can have all of these items set out on your table at your booth, or you can package them up in a press kit, which goes out to the press before the show. Getting some pre-show publicity is essential. You can do this in two ways: You can hire a public relations representative or agency to put it all together for you, or you can do it yourself.

If you send out a press release, it should include the booth number for the show where you exhibit. Make sure you include a full description of your product, along with sizes, colors, and the suggested retail price. You should also make sure that your release doesn't "tell all," but rather whets their appetite and makes the reader want to know more about your design. A publication will typically send only one or two writers to cover an entire show.

If you talk to a reporter at the show, make sure you know what their deadline is and follow up afterwards. If they have questions, they will contact you. Once the story runs, make sure to get a copy for your records and send a polite, quick thank-you note to the writer. Remember: It's all about building relationships! The next time a writer has a story idea and needs to talk to a designer, you want them to talk to you.

At the Show

When you're at a trade show, don't think of yourself so much as a designer but as a businessperson. Anyone with the proper skills can sew a garment. What buyers want are businesspeople who can deliver the goods. If you can't deliver, the buyer who placed their trust in you looks bad as well. For this reason, a buyer may not be willing to do business with you until they've seen you at a few shows or a few seasons. So don't think of a show with only a few sales as a bust.

Also, not all the sales will be made at the show; you want as many people as possible to walk away with your line sheets and other marketing materials. Have all of your line sheets, pictures, business cards, brochures, and other marketing materials handy for their review.

You will want to get away from your booth to take advantage of the rest of the show, too. The best time to do so is on the last day, or the last few days of the show if it is a long one. Typically, if a show is running for a week, a buyer will only be there for a few days at best.

> **TIP:** If you're attending the show by yourself, you'll want to have a sign with you that reads "Back in 10 minutes" for emergencies, so that if someone does take interest in your wares, they will know you'll be back soon. Since you're going to have your contact information at your booth too, they can always pick up a card or a brochure and contact you at a later time.

A lot of attendees leave the last day, so this is a better time for you to browse. It's a good idea to have a cell phone or a walkie-talkie with you, though, so you can return at a moment's notice if a buyer wants to talk to the designer. Here's what you want to check out:

Breakout Sessions

These seminars will keep you up-to-date on the latest in the industry. Just as a side note, the press always attends breakout sessions, so it can be a good time to network.

Other Designers

Visit as many booths as possible, and talk to people. See what's hot, and what's not. Remember, you may or may not get a nice reception here — your name tag will show that you are an exhibitor...you're the competition.

Stylists, Models, Hairdressers, and Photographers

If you plan on holding a runway show, you'll need the services of these people. As with accessories, these folks are often willing to exchange services for show credit, so the more people you can network with the better.

Accessory Vendors

Since an accessory must go with a fashion and a fashion must go with an accessory, visiting the accessory vendors is a great way to make relationships. It's not uncommon for accessory folks to loan their accessories to designers who are producing runway shows in exchange for a show credit. This is a great way to get something in exchange for no money.

Manufacturers

Again, if there are manufacturers at the show, this is a great time to meet them and compare prices. There are literally thousands of clothing manufacturers around the world and finding a good one is key to producing the best possible product at the best possible price. Take the time to meet with them and chat with them.

A Trade Show Success Story

Attending a trade show takes time, money, planning, and a giant leap of faith, since there's no guarantee you'll get a single order. Going on the theme of, "nothing ventured, nothing gained," here's a true story about a contributing designer for this FabJob guide:

Karen was a successful fashion designer in Boston, until her company got bought out and Karen found herself out of work. The School of Fashion Design graduate then went into business for herself, designing her own fashions in the friendly confines of her own apartment.

Karen's boyfriend (and now husband), Warren, encouraged her to attend a New York trade show to promote her designs, but she didn't want to. He attended for her and the result was Warren walking out of that 1989 trade show with $35,000 in orders.

The clothing line – now called **Karen Warren** – that began with an out-of-work woman making designs in her apartment has grown to a well-respected business whose fashions are sold in more than 100 boutiques all over the United States.

After the Show

As mentioned earlier, not every order is going to take place at the trade show. After some well-deserved rest, here are some things you can and should do:

- **Start manufacturing.** If you got orders, immediately get busy and have them made and meet your deadline. This should be your number one priority.

- **Fulfill other commitments.** Did you promise someone to send a sample or a line sheet? If you gave a promise, make it a top priority and get it done. If you can't get it done immediately, then call your contact and let him know you'll have it to him soon.

- **Thank-you cards.** Sending thank-you cards to everyone you talked to or networked with is a great way to keep your name in their minds.

- **Make follow-up appointments.** Your follow ups can be in the form of calls, emails, or regular mail. Did you meet a buyer who gave you a maybe? This is the time you want to approach that person and ask for an appointment.

6.5 Growing Your Business

With your business up and running, you might want to consider using some of these techniques to stay competitive in the industry and grow your business to the level you desire.

6.5.1 Trunk Shows

In most cases, a boutique or retailer will only purchase items from you that they believe will sell the best. But wouldn't it be great to get them to carry your entire collection? Well, that's what happens at a trunk show, if only for a few days, or one exclusive evening.

At a trunk show, the designer brings in all of their merchandise to a particular retailer for a limited time, either in a variety of sizes, or in sample form. The name "trunk show" comes from the past, when designers

would carry around their latest samples in a large trunk. It is often a semi-social event, to which the retailer invites select clients to sip champagne, nibble hors d'oeuvres, and of course, buy your designs.

The trunk show is promoted by the boutique or retailer as a short-term event when customers can come in, meet the designer or the designer's sales representative, and get advice on choosing a garment. The trunk show also offers the customer a chance to see the entire design collection in one place. The client can order custom designs from you or your sales rep.

If you want to start setting up trunk shows, approach your buyer at boutiques or retailers where you have limited designs for sale. Trunk shows benefit the boutique or retailer because they are good publicity, and because they don't have to buy your entire collection to see what customers like. They are also good publicity for the designer, help you build a relationship with retailers, and can sometimes help you unload samples or overruns to eager clients. (For information on holding a true "sample sale," see section 6.5.6.)

If you plan on setting up a lot of trunk shows, you'll have to hire a sales rep to attend them in your place. You can list upcoming trunk show dates and locations on your website.

6.5.2 Getting Into a Fashion Magazine

For a relatively new fashion designer trying to break in, one way to build your reputation and your clientele is to find a fashion magazine that will publish an article on your work. Many of the big-name fashion magazines will likely not take much of an interest in you until you have done a few fashion shows and built a name for yourself, but they are also looking for the next big thing, so it's a fine balance.

When you participate in fashion events, fundraisers or auctions, take the time to meet the media contacts (magazine editors will often attend), and show them samples of your work. Get a business card, and follow up after the event with a phone call. If they are interested, you can set up a meeting, and bring in some samples of your collection. It's not technically bribery if you were to leave a sample or two with an editor in their size, right?

In order to get the ball rolling, you can also cold-contact media outlets on your own. Research the outlets that may be most interested in your work, and submit photos of your designs, as well as copies of any other good press you've gotten locally or in other publications. If you don't have these, write some press releases that highlight your work and submit them with the pictures.

You can target fashion, beauty and shopping magazines, general interest magazines, lifestyle magazines, as well as business and entrepreneurial magazines. Local publications might take a shine to you more quickly, as they try to keep their stories about people in and around the area. You can then use these stories to garner interest from some of the bigger magazines.

Sometimes the media will contact you, especially when you are doing other things to promote your fashions, such as writing or speaking. When Seattle-based fashion designer Jamie Stratton first started, interest in her and her designs was gradual. *Lucky*, a shopping magazine, contacted her for an interview and profiled her in their regional section, a huge break for an independent designer.

6.5.3 Runway Shows

Runway shows are very different from trade shows. When you attend a trade show, your goal is to take orders and make money. At a runway show, your goal is to garner attention from buyers, the press, and other decision makers. It's essentially a really big publicity event for your label.

Your business will need to be established and ready to produce before you participate in a formal runway show, or you are looking at a potential colossal waste of money.

Runway shows are pretty straightforward: You lower the lights, raise the music, and march out your models wearing your line of clothing. The entire process may take all of 15 minutes, and will likely cost you a minimum of $5,000.

Runway shows are held in various cities all over the world, but the two most popular seasons for runway shows (often called "Fashion Week") are fall and spring, traditionally the two most popular selling seasons.

Find and Apply to a Show

As with trade shows, finding a runway show is simple, they have them nearly every month is one city or another. Here are a couple of web links to shows all over the world:

- *FashionWindows.com*
 www.fashionwindows.com/runway_shows/

- *First View*
 www.firstview.com

The very biggest runway shows are by invitation only, but just as many smaller ones aren't. The application process will be very similar to that of applying to a trade show: Identify an appropriate show for your designs, and request and fill out the forms. If you are accepted, pay up and attend!

Getting Ready

Before the show, you're going to need pre-show publicity. You'll want to use the same techniques as with trade shows regarding inviting buyers and the press to your show, and sending press releases to the media.

You are also going to need models to show your clothes. You can find models using modeling agencies. In a professional show, you will need at least one model for every two looks you are going to send out, and preferably one model per look. If you are changing your models, you will need to hire dressers to get them in and out of clothing.

You can expect to pay hundreds or thousands of dollars per model through an agency, though many models will work for clothes in exchange for their services.

You will also need hair and makeup artists and photographers for your runway show. Offer your makeup artists show credit in exchange for their services, or expect to pay them between $25 and $100 an hour. You'll have to pay for your photographer unless you're willing to take your own shots. As the designer, you won't want to go that route if you can help it, so if you have a friend who's a photographer, that's the best way

to go. You can usually hire a professional for about $150 an hour, and since your show will only run 15 minutes or so, this is pretty affordable.

At the Show

You'll want to have all of your marketing materials, pictures, line sheets, and anything else that will help you make a sale with you at the show. The buyers and press will sit front and center, and after the show, the buyers will typically pick up your materials and run off to the next show, so immediate sales won't happen.

If a journalist is taken with you, and you didn't get any pre-show press, this may be the time when you get an interview. But again, don't push it. If they liked what they saw, they'll contact you, or you can contact them after the show.

Just like with a trade show, you'll want to follow up with the press and buyers. Again, what you're after here is recognition, and the press can be your most powerful tool. After word of mouth, being in a fashion magazine is the next best way to garner attention and make sales (see section 6.5.2 on how to approach editors for coverage).

6.5.4 The Traveling Showroom

If you didn't get a spot on the runway but still want to show off your designs during a city's Fashion Week or in a distant location, an alternative is to rent yourself a hotel room and set it up like a mini-showroom. Advantages include:

- **Cheaper cost.** Unless you get a room at the Ritz, the cost will be more reasonable than shelling out $5,000 for a runway show.

- **Convenience.** You give the buyer the opportunity to come see your wares anytime they wish. On your end, you don't have to hire a ton of models and support staff.

- **Better networking.** By renting a room, you can spend more time with buyers, the press, and other decision makers, rather than watching their coattails fly out the door as they rush to the next show.

TIP: Book your space early, especially in the large cities. Some New York hotels accept reservations a year in advance.

To set up your space, pretend that your hotel room is your traveling show-room. If you can bring some type of racks with you to hang your clothes on, that's great. If not, then attempt to make arrangements with the hotel staff to put some racks in your room prior to your visit. Don't worry about making this look fancy. Remember: The buyer will be interested in your clothes, not in the racks you hang them on!

You'll also want to have all of your sales and press information with you, just like at a trade show — line sheets, portfolio and so on. Set up your laptop logged onto your website. Then you can show the buyer your full line right there in the room. You can also consider having a model on hand to show buyers how your clothes look on a person. Don't forget to follow up in a few days, the same as if you were at a trade show.

6.5.5 Hire a Sales Rep

Are you ready for a sales rep? The best time in your career to have a sales rep is when you're new. Experts interviewed for this book said that once you get an established list of clients, you will no longer need the sales rep, since your customer list will be in place.

Sales reps are salespeople who represent specific designers or manu-facturers. They seek out buyers to get them to carry the lines they repre-sent. In return, they get a percentage of every order they write that is shipped and accepted by the retailer, which is usually 10 to 15 percent, depending on the product, the territory and the experience of the sales rep.

Some sales reps set up their own showrooms and have buyers call on them. They represent multiple lines and are known as independent sales representatives. Some conduct their business by packing samples in the car and visiting various boutiques and specialty retailers in a terri-tory. They are called road reps. Road reps are usually responsible for their own expenses, including the cost of maintaining and operating their car.

TIP: You will need to send the sales rep out with appropriate marketing materials, including sample garments, fabric swatches, line sheets and order forms. If you engage more than one sales rep, you will need to have a duplicate set of these for each.

Choosing a Rep

You can find a sales rep by doing any or all of the following:

- Run an ad in a trade paper

- Ask the buyers of your target stores whom they recommend

- Visit your closest regional apparel mart and interview sales reps who are there

- Check the ads or in-house publications at the apparel mart to find reps

- Scout trade shows

Here are two excellent places to start your search for the perfect sales representative:

- *Apparel Search*
 You can fill out a detailed questionnaire, and then the company will contact you to help you find a rep that's right for your needs.
 www.apparelsearch.com/sales_representatives.htm

- *The Apparel Marketing Group*
 www.apparelsalesreps.com

The sales reps you choose should represent your line well and have solid contacts in your target market. You want to make sure, if they do represent multiple lines, that their other lines complement – not compete – with your products.

Make sure that you clarify what you can and cannot handle before you send your reps out to sell. If you have minimum requirements to process an order, let your reps know. Also let them know what would qualify as

too large of an order. You don't want to end up with more than you can handle and risk running into late delivery.

Always check references on the sales reps you're thinking about engaging. Follow up with the stores they sell to and make sure everything checks out. After you hire someone, you may even want to sit in on the first few presentations he or she gives on your line. This should convince you that you've selected the right (or wrong!) person for the job.

Payment

The industry average pay for sales reps is a 10 to 15 percent commission on sales of your clothing. Commissions are not paid on cancelled orders. Since samples are expensive to create, ask that they be returned at season's end so that you can then sell them at sample sales.

It's always a good idea to have a written agreement between both parties before the sales rep starts selling. Getting something in writing protects you. Horror stories abound about the few dishonest reps who lose samples, don't promote the line as agreed, reveal confidential information to competitors or come across as abrasive to those with whom they interact. You'll want to spell out payment terms, territories, markdown conditions, contract duration, etc., so that everyone is clear on what's expected.

6.5.6 Sample Sales

Sample sales are a win-win situation for both designers and consumers. For the designer, it's a chance to unload the one-of-a-kind samples you used to promote this year's line, or items you manufactured too much of for one reason or another. For the consumer, it's a chance to buy your normally expensive designs at 25 to 75 percent off the usual selling price. For this reason, sample sales are usually a very popular event. Many sample sales are cash-only, and all sales are final.

In most cases you will need to have a large established business to organize a solo sample sale. Smaller designers tend to partner up and host group sample sales once or twice a year. You can share the costs of renting space and advertising, and buyers get more selection. You'll have to provide a dressing area, although for many sample sales this is a communal area, not private stalls.

You can open up your sample sale to the public, or agree that it will be by invitation only to preferred clients and media. If you do opt for solo sale, you can have it in your showroom and invite each person on your existing client list and their companion.

> **TIP:** When you promote your sample sales, don't forget to let buyers know what sizes you have available. While stock overruns come in every shape and size, true samples are made to fit model sizes 6, 8 and 10, not the average consumer.

6.5.7 International Sales

Once you've sold successfully in your own country for several years, you may be thinking about the possibilities of selling abroad. Depending on what you sell, it could be lucrative. Luxury brands, in particular, enjoy brisk sales in Europe, the Middle East and Asia. Expanding into foreign countries can be profitable, but it's not without its risks.

Pros

- Increased sales and profits

- Selling to untapped markets

- Selling the same lines for two seasons in different hemispheres

- Exposure to new ideas and competition

- Outselling competitors

- Enhancing brand awareness

Cons

- Export challenges

- Having to translate marketing materials

- Having to engage a new team who knows the culture

- Currency and exchange rate issues

Other issues to consider include adjusting your lines to reflect local preferences for colors, cut, and sizing, the difference in the marketing cycle between Northern and Southern Hemispheres, and hiring a lawyer who specializes in international law and business.

If selling overseas is something you feel is worth doing, you can begin your research by visiting the National Trade Data Bank (**www.stat-usa.com**). This resource has all sorts of information, from market research reports and trade contacts to statistical information and country reports. You'll be able to narrow down the countries or regions most likely to want and buy your goods.

Once you've established your target markets abroad, you'll need to research the customs issues for each. Exporting anything usually involves paperwork, and many companies engage a local rep or transition team in the destination country to help them navigate through all the necessary paperwork.

6.5.8 Professional Organizations

Joining a professional organization lends your company credibility, and gives you an opportunity to network within the industry. Even if you can't make it to a yearly trade show, there are local chapters of groups like Fashion Group International, as well as members-only online discussion boards, and other advantages that will help you run your business more effectively.

Fashion Group International

Website: **www.fgi.org/home.html**

Address: 8 West 40th Street, 7th Floor
 New York, NY 10018

Phone: (212) 302-5511

Email: info@fgi.org

Canadian Apparel Federation

Website: **http://cam.apparel.ca/eng/index.cfm**

Address: 124 O'Connor St., Suite 504
 Ottawa, ON K1P 5M9

Phone: (613) 231-3220

Council of Fashion Designers of America

Website: **www.cfda.com/flash.html**

Address: 1412 Broadway, Suite 2006
 New York, NY 10018

Phone: (212) 302-1821

Email: info@cfda.com

International Association of Clothing Designers (IACD)

Website: **www.iacde.com**

Address: 34 Thornton Ferry Road #1
 Amherst, NH, 03031

Phone: (603) 672-4065

Email: dmschmida@aol.com

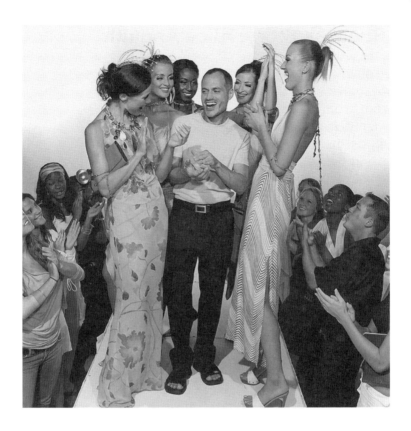

7. The Road to Success

Imagination, intuitiveness and persistence, combined with some technical ability, are all it takes to make your dream of a fashion career a reality. So go grab your sketchbook, and dare to be different. The fashion world is waiting.

You now know what you need to do to get started as a fashion designer, and according to the statistics cited at the beginning of this book, *now* is the time to do it. Jobs in the fashion industry are increasing and new market niches are just waiting to be discovered.

Here are some success stories to inform and motivate you, from designers who trained formally to those who had a good idea, determination, and no formal training at all. Following these stories is a list of resources to help you along your way. Good luck!

7.1 Success Story: Alice Asquith

Alice Asquith has traveled a long way in a few short years. She went from selling her sportswear designs to a loyal following on the Internet and later getting her line in major department stores to gaining the interest of superstars such as Madonna, Gwyneth Paltrow and Victoria Beckham.

Before making her mark in the fashion industry, Asquith worked as a media executive. She used yoga and Pilates to work out the stress that came with her job. Out of these workout experiences came her inspiration to try out fashion design. Unhappy with the choices of sport apparel that she could wear, and tired of her life in the fast lane, Asquith left her media job and began investigating apparel for the yoga and fitness market.

She soon discovered that she wasn't the only one who found the sportswear market lacking. "The most surprising thing in my research was that a similar type of label didn't really exist," she said.

"I knew I had to find a niche market, and I did: yoga/Pilates/lifestyle clothes for a mid-30s and above market. It seemed that somewhere in sportswear, this market had been overlooked. All sports labels, when I first started researching, were just that: sporty, not catering to the millions of women who participate in fitness who didn't want ... a big logo emblazoned across their [shirts]."

She began designing sportswear, which grew into a collection of comfortable, elegant, and flattering clothes for women in her target audience. She designed her collection so women could not only wear the clothes working out but on summer holidays and spa trips.

Her company, simply called Asquith, was launched in March 2002. It began as a mail-order Internet company, and soon the new designer had a busy website business.

One year later, the famous department store Harrods began carrying her collection. Soon Asquith gained several more large retail accounts, was featured in international magazines, and gained celebrity clients.

Asquith is a good example of how to succeed in the highly competitive field of fashion design without a degree. She offers this advice to people without formal training: Find your niche. "Ensure that your label does something that no one else's does. You are building a brand; it has to be a unique product," she said. You must know and understand your USP (unique selling point) and ensure that this is conveyed at all times; through your product, your marketing and advertising.

Research your competitors, Asquith said. "Fully understand every brand in your specific area," she said. "Study how they have put together their collection — stitching, fabric, cut, and colors," she said. "Read as many fashion magazines as possible; look out for styles that you like. Clip them out and keep style files and lookbooks." Attend any and all fashion shows or short courses that you can and talk to as many people as possible about their ranges, Asquith said, and you will gradually start to build a picture of your own.

It is also important to understand what it is that your customer wants, Asquith added. "Always keep that person in mind and design for them," she added. "That will help you enormously in your design process. Or, if you are your target market, design for yourself [but think of] the needs of others. If you're over six feet tall, don't forget that not everyone wants long, slim-fitting trousers."

Identify the areas where you need support, Asquith said, and then enlist the help of experts. "You can't be expected to do everything," she said. "There's too much to do when running a fashion business. If your strength is design, then get assistance with your marketing — a brand very rarely sells itself. Employ an experienced pattern cutter and production unit and work closely with them. Try to learn terminology, cut, and structure of garments from them. And never be afraid to ask if there's something you don't understand."

Another tip from Asquith: "In the beginning, be very modest in your sales projections and go for steady growth with proper prices," she said. "If you under-price your first collection it will be hard to increase the price

point in future seasons. If a garment is beautifully made in quality fabrics, it will usually sell, provided the look and image is right.

"Take the time to understand the cash flow of your business. It is boring but absolutely crucial to having a successful business. If your accounts are all at sea then your business will be. If you really can't get to grips with the accounts, then a good accountant is a must."

7.2 Success Story: Besnik

In a short period of time, Besnik (who goes by this single name) has gone from relative obscurity to having his creations find their way into the closets of the rich and famous. He has made these strides in only five years, living proof that hard work, determination, and a natural gift tunneled into a craft can propel you to stardom. The Albanian-born fashion designer was not formally educated in fashion design. His work comes from his soul or inner being, as he described it.

As a child in a third world country, Besnik learned how to make his own clothes from wool shorn from sheep. "That was my first experience with fashion," he said. "I made my own dolls and I dressed them up."

At the age of 19, Besnik arrived in the United States. He spent his first few years in Texas, then moved to San Francisco. Although he didn't know how to sew, he received a sewing machine for a birthday present. "I never took a class," he said. "I just read and that helped me learn."

Besnik defined his new career in 2001, when he asked all of his friends to give him their old clothes. "I went all over the city and got denim and cotton, non-wrinkle items." He turned these old, worn-out pieces into his first creations. "I made a little picture, a one-page brochure for people to look at," he said. "I went from boutique to boutique."

Using this tactic he sold all of the pieces in his first "collection," a term he doesn't use, he said, because his designs are all handcrafted and one-of-a-kind. "When I make something, it is the only one that will ever be made," he said. "I don't like to conform."

Besnik was successful, albeit on small scale, in his first foray into the business end of fashion design. He made $6,000 selling those first pieces, and reinvested that back into his business. He bought a portable sewing machine and finer fabrics. From there, he was on his way. His star slowly began to rise and today a move to New York, which many consider the fashion capital of the world, is in the works.

Besnik has shown his creations at San Francisco Fashion Week. His shimmering, body-hugging designs have been called flirtatious and avant-garde. Others have noted the rock 'n' roll edge to his work, with slashed T-shirts and micro-mini-dresses. His clients have included superstar actress Angelina Jolie and singer/pop star Dido.

His advice to others new to the field: "Everyone has a voice inside them. Always keep in touch with that voice. Stay true to yourself. Do exactly what you want to do. Follow your passion."

Besnik looks at his work as art. And, like an artist, he said, you may have to sell a piece for less than you think it is worth. "But you have to get your name out there," he said. "And in every single thing you do [in your life], talk about what you do [as a designer], how you love it, show them your workbook. I have sold so many things that way; people have told other people."

For his work portfolio, Besnik took photographs of his clothes on models, hand-cut 4-by-6 sheets of paper, and married the work. "I took it to Kinko's and printed them, punched holes in them and then put string through it," he said. His cover has a simple design in black and white with his name on it, covered in plastic. "Make sure to name each piece," he confided. "It looks professional and amazing."

Besnik has an assistant who, he said, deals with the cerebral end of his business. She helps set up fashion shows as well as small showings for selected clientele.

However, Besnik still does all his own work when it comes to his designs. "I pick the fabric, the thread, and the sewing design," he said. "I do every little detail myself."

7.3 Success Story: Erin Bransford

Erin Bransford is proof that you don't need a degree in fashion design to become a success in the field. A creative flair, know-how, and dedication to her work has helped Bransford make a name for herself in the niche market of accessories.

Bransford has a background in creative arts. She studied art and art history at the University of Georgia; in Italy; at the Atlanta College of Art; and Abernathy Arts Center. She wasn't looking for a career as a fashion designer, but a pottery class in 1998 set the spark for her entry into the field. Very quickly, Bransford's designs – plates, platters, and spoon rests – were popular among family and friends. She began showing her designs at home shows and festivals. Her company, last laugh designs, was formed soon after.

While focusing on pottery, Bransford was also hand-embroidering dish towels and aprons. From there, she made the leap to what she admitted may not seem like a logical next step for some people — handbags. "It was 2002, the hot item in the fall was the tote bag," she said. Since she knew how to sew, Bransford started her newest venture by buying fabric, cutting it by hand and sewing a handbag. Her first creation: a faux fur tote bag.

This inauspicious start soon led to erin bransford designs being formed. The formula she started with is one she still relies on today. She or her mother do all of her sewing and she presents only limited editions, no more than six, of any of her designs. She also custom designs items for customers.

Her initial entry into the field was an eye-opener. "I found out that everyone is making handbags, and it is hard to define yourself in the marketplace," she said. "I started with the tote and then added a couple of handbags. My designs are whimsical and fun. My approach is serious but there is no reason to do it unless it is fun."

From handbags, Bransford branched out to scarves, designing them in a way that makes them look like a feather boa. "They are long, fun, and flowery and they have become incredibly popular," she said.

By adding to her collection things she found both fun and interesting, Bransford said, her business grew. She designs scarf sashes, faux fur wraps, and fabric corsages.

Bransford introduced a baby line in the spring of 2004. The line – chic mommy and baby – began with a bag. "I took my tote and sort of morphed it into a baby bag," she said. From there, she added bibs, burp clothes and onesies. "The impetus for this (design) was the same as for the pottery and handbags," she said. "I had friends who had babies and I was looking for something cute to get them. I couldn't find anything I liked, so I made my own."

Bransford has purposefully kept her business small. Her designs are sold through shows, in boutiques and online. "I am a little unusual," she admitted. "I don't want to be in tons of stores. I sell small, quality, limited editions."

Newcomers to the field have to get out and introduce themselves to boutique owners and attend trunk shows, Bransford said. "It sounds simplistic but that is the best way to do it," she said. "Meet other designers. See what things you want to work on and whether you might want to do a group show."

Other designers, Bransford said, have been her best resource. "Very rarely will you find someone who is looking for 'inspiration' from your work, but you can share ideas, find out who is a good retailer, and where you can get good fabric."

"You have to do a lot of dropping into fabric stores," she said. "Start by buying small yardage and experiment." Getting this resource in place is a must, she said.

Bransford has even been known to approach complete strangers in fabric stores and ask them where they shop for their resources. "Usually I break the ice by admiring their fabric," she said. Another good resource she recommends is **www.fabric.com**.

Design by Erin Bransford

Building relationships with store managers is also important. "Find out what store has a great manager who will call you when something special comes in," she said. The best way to a bond is simply by introducing yourself and shopping there. "Their business is selling," she said. "If they know you are a good customer, they will want you to come by."

Selling your designs to stores or boutiques is an art as well. "Send a sample of your work that is appropriate to the store," she said. Then go and talk to the manager. Find out if they may be willing to introduce your work through a private show or a trunk show with several designers.

7.4 Success Story: Louis de Gama

 Louis de Gama, a women's wear designer, is known for his edgy style and the contradictions in fabrics that jump out at you when you see his dramatic fashions. His style is clearly unique. When one thinks of silk chiffon, leather doesn't immediately come to mind, but for de Gama it does.

His love of contrasts and the partnership of "incompatible" fabrics has helped define his niche in the field of fashion design. In fact, it has become his trademark of sorts, and has propelled de Gama, at 34, to quite a bit of success in his career.

When he was young, de Gama was shy by nature, but says he dressed flamboyantly to give himself confidence. He left Portugal for Paris as a young adult before finally settling in London. It is in the U.K. that he made his mark.

After studying garment technology and fashion design at Newham College and Barnet College, respectively, de Gama went on to further his studies in fashion design at the University of Westminster, London. He graduated with honors in 1999 and got experience in the field while he was still learning his craft. This strategy allowed him to later break into the field very quickly.

He had the opportunity to work at Boudicca with the renowned duo of Zowie Broach and Brian Kirkby. Here he made a notable connection that

helped launch his career. "At college on my last year, I was assisting at Boudicca and Tristan Webber. I met up with a stylist called Victoria Adcock at Boudicca's," de Gama said. "I showed her some garments I was making. Victoria suggested I should have a showcase after London Fashion Week because nobody knew me then."

Through Adcock's contacts, they extended invitations to a group of magazine editors as well as Yeda Yun, a senior buyer for the acclaimed shop Brown Focus. The show got a respectable turnout. "[Yun] loved the collection and bought everything," de Gama said. "I started to stock at Brown Focus and everything just happened from there."

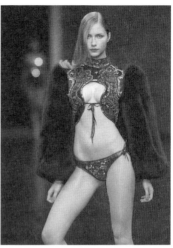

Design by Louis de Gama
Photo by Rui Vasco,
courtesy Moda Lisboa

Since that memorable first show in 1999, de Gama has been on the fast track. He has been showing his collections at London Fashion Week since 2000. His label is sold in selected boutiques in Tokyo, Hong Kong, Lisbon and London. The London-based de Gama also is a lecturer at London College of Fashion.

One of the highlights of his career, de Gama says, was being awarded the "New Generation Designer" award from the British Fashion Council. Another high point was when he was asked to take part as a special guest at the Portugal Fashion Week in Lisbon, where he showed his Autumn/Winter 2002/03 collection.

Looking at de Gama's background, it is not a surprise that he suggests newcomers to the field get experience by working alongside an experienced fashion designer. "You'll definitely learn some crucial skills and get valuable experience," de Gama says.

And how can new fashion designers putting their own label on a collection avoid what de Gama considers common mistakes? "You have to build your production infrastructures well," de Gama stresses. "Make sure you meet your deliver [deadlines] to avoid disappointment. You should start with taking only a few orders, allowing yourself to grow slowly but steadily."

Finding and hiring media consultants to help spread the word about your collection is critical, according to de Gama. "Get a good PR company to do the press," he says, "and a marketing person to liaise with the buyers."

Be very committed to your new vocation. "Don't kid yourself, you've got to put the time and effort," de Gama says. "It is a very competitive industry and you only get one chance. Also, don't try to do everything yourself or you'll end up with nothing done."

Having traveled from unknown status in 1999 to a point today where he is respected for his dramatic style, de Gama's advice is well worth taking.

7.5 Success Story: Linda Lundström

Linda Lundström designs and manufactures her own lines of women's fashions sold in more than 350 retail stores and through three company-owned Lundström stores.

In 1974, with a $10,000 loan from her parents, Linda Lundström formed her company, Linda Lundström Inc., in a small apartment in Toronto.

Lundström experienced some lean years as a newcomer to the field, but all that changed when she took a trip to Japan and saw the return of the ancient kimono to the fashion scene. Lundström wondered what garment held a similar significance to the Canadian culture, and her journey of discovering a source of creativity and success began.

Lundström found her inspiration using a modern interpretation of the traditional Inuit parka. The LAPARKA was the beginning of a highly successful career, which has seen Lundström win some 25 prestigious awards.

Growing up in a small mining town in northwestern Ontario, Lundström witnessed various ways Natives suffered discrimination. Lundström said

she came to the realization while living in Toronto. "I had been carrying around some guilt and shame because I participated in racism through my silence," she says. "I guess that was the birth of my social consciousness." This led Lundström to begin collaborating with Native artists, who supply the intricate artwork for the back of the LAPARKA. "I still work with Native artists and feature their work," Lundström says.

Being from northwestern Ontario, Lundström has also experienced the extremes of Canadian weather. "Up in the north, it can be 95 degrees in the summer and 40 below in the winter," she says. "Having outerwear that will take you through those two temperatures is always a challenge. I thought, 'What if I could make one coat that could be your coat for 12 months of the year?' It has been an absolutely incredible phenomenon. The LAPARKA has been manufactured for 18 years and it is still a very important part of our Fall collections."

Since the birth of LAPARKA, her business has flourished. By 1997, Linda Lundström Inc. saw sales go over $12 million. Two years later, the eroding global economy took a toll on the company forcing Lundström to restructure and reduce staff.

Those difficult days are behind her. Today, Lundström designs four collections a year, plus a new Spa line of robes, wraps, and amenities for the spa and resort industry. Lundström says she draws inspiration for her family of products from "authentic women everywhere — real women with real lives, real bodies, and real beauty."

Lundström says she was brought up with the motto "waste not, want not." Some of her best designs, she says, have come from a desire to not waste fabrics. "I often add something to a style or cut the panel in a particular way to make maximum use of the fabric that ends up creating the design that I wouldn't have thought of if I had sketched it on paper," she says.

Her company gives preference to environmentally kind fabrics, and it has recycling programs at the manufacturing and administrative facilities to reduce waste and reuse materials.

Lundström – who started with very little, grew her empire, saw it downsized, and is now back on top – has a few suggestions for those new to the field. Many people have a misconception about clothing designers, says Lundström, as well as the work they do.

"Being a fashion designer is a creative process and an artistic process but it is also very technical. If you look at the very best designers, you may see the glamour but behind that there is a highly technical exacting, and precise discipline; it is really engineering. That color engineering and use of fabric make up 90 percent of the final product. The original idea is only about 10 percent of the process."

Training is necessary, she says. "You have to get training, whether you get it through a learning institution; but the best training is in the workplace," she says. "I think I learned most through apprenticing."

Lundström, who studied fashion design at Sheridan College in Oakville, Ontario, and spent a year as an apprentice in Europe (a position awarded through a Fashion Canada Scholarship), worked with four companies before opening her own. She says she gleaned some knowledge from each one of them. "I learned how to make things, how to manufacture things."

She suggests that people who are trying to break into the field offer to work for nothing if necessary. "Do anything to get your foot in the door, so you know how to hold a pair of scissors and be part of the environment. That is where you will learn the most," she says. "And if you are any good, chances are the company will end up giving you a job."

Lundström says that the best training grounds are companies that do not have big-name designers. "There is a whole team of very technical and knowledgeable people that someone can go and work for," she says.

"It could be a company that just manufactures golf shirts or evening gowns. The technical knowledge is the same — how to make a pattern, how does manufacturing and production work, and what are some of the machineries that are used. I have people working for me now that started working for nothing as apprentices. That really speaks volumes about their level of commitment."

8. Resources

Trade Publications

Apparel Magazine

Website: **www.bobbin.com**

Phone: (847) 763-9050

Published 12 times a year, *Apparel* is the leading business-to-business publication for the apparel industry. Written for executives and top managers, it addresses key business, technology and operations issues. Subscriptions are $69/year in the U.S. and $85/year in Canada.

California Apparel News

Website: **www.apparelnews.net**

Phone: (866) 207-1448

Published every Friday, the newspaper and website have classifieds and articles on news, fashion, and trade shows. Subscription rates for the print version are $83/year in the U.S. and $125/year in Canada. For the online version the cost is $85/year in the U.S. and Canada. For both versions the cost is $125/year in the U.S. and $175/year in Canada.

Children's Business

Website: **www.childrensbusiness.com**

Phone: (800) 424-8698

Children's Business is a monthly trade magazine covering apparel and footwear for boys and girls, infants through preteens. Subscriptions are $49/year in the U.S. and $85/year in Canada.

DNR

Website: **www.dailynewsrecord.com**

Phone: (800) 360-1700

DNR is the leading news magazine of men's fashion and retail, published every Monday. Subscriptions cost $85/year in the U.S. and $295/year in Canada.

Look Online

Website: **www.lookonline.com**

Phone: (212) 734-9747

Premium features for subscribers of this website include a bi-monthly report covering New York fashion news, issues, and events; professional market reports; a schedule of A-list New York fashion events for the upcoming two-week period; and a directory of fashion public relations firms in New York. Subscriptions are $79/year U.S.

Women's Wear Daily

Website: **www.wwd.com**

Phone: (800) 289-0273

WWD is considered the leading source for women's fashion news. It covers the entire gamut of fashion: business issues, fashion trends, retailing developments, and market overviews. You can subscribe to the daily newspaper or the website. Print subscriptions cost $99/year in the U.S. and $295/year in Canada. Website subscriptions cost $99/year in the U.S.

Worth Global Style Network

Website: **www.wgsn.com**

This website is a research, trend analysis and news service for the fashion and style industries. To subscribe, you can fill out a form on their website and a representative will contact you.

The Apparel Strategist

Website: **www.apparelstrategist.com**

Phone: (866) 944-5995

The Apparel Strategist is a monthly print and email newsletter for the apparel and textile industry. The newsletter reports and predicts the business cycles in the industry and the reasons behind them. Subscription rates for the print OR email newsletter are $395/year U.S. and $425/year all others. For the print AND email letter the cost is $495/year U.S. and $595/year all others.

Consumer Magazines

- *Elle*
 www.elle.com

- *Flare (Canada)*
 www.flare.com

- *Harper's Bazaar*
 www.harpersbazaar.com

- *Style.com (W and Vogue)*
 www.style.com

- *Vogue U.K.*
 www.vogue.co.uk

Websites

- *Fashion.net*
 www.fashion.net

- *FashionInformation.com*
 www.fashioninformation.com

- *FashionLines.com*
 www.fashionlines.com

- *Fashion Planet*
 www.fashion-planet.com

- *Fashion UK*
 www.widemedia.com/fashionuk

- *Fashion Wire Daily*
 www.fashionwiredaily.com/headlines.weml

- *Hint Magazine*
 www.hintmag.com

- *The New York Times: Fashion & Style*
 www.nytimes.com/pages/fashion

Industry Organizations and Associations

- *Fashion Group International*
 www.fgi.org/home.html

- *Association of Image Consultants International*
 www.aici.org

- *National Retail Federation*
 www.nrf.com

- *AAMA (American Apparel Manufacturer Association)*
 www.amalabs.com

- *AACA (American Apparel Contractors Association)*
 www.usawear.org/Content/ContentCT.asp?P=19

- *Atlantic Apparel Contractors Association Apparel Manufacturer's Sourcing Web*
 http://atlanticapparel.com

- *Cotton Inc.*
 www.cottoninc.com

- *The Professional Association of Custom Clothiers*
 http://paccprofessionals.org

- *San Francisco Fashion Industries*
 www.sffi.org

- *Sporting Goods Manufacturing Association*
 www.sgma.com/index.html

Online Directories and Networks

- *Alpaca Net*
 www.alpacanet.com

- *FabricLink*
 www.fabriclink.com/home.html

- *First View*
 www.firstview.com

- *MAGIC Online*
 www.magiconline.com

- *New York Web*
 http://models.com/night

- *PSR/Pennsylvania Sewing Research Corporation*
 www.acpsr.com

- *Textile Exchange*
 www.teonline.com

- *Textile Technology*
 www.tc2.com

- *Tech Exchange*
 www.techexchange.com

Business Resources

- *Nolo.com*
 www.nolo.com

- *Quicken.com*
 www.quicken.com/small_business/start

- *Canadian Small Business Centres:
 Online Small Business Workshop*
 www.cbsc.org/osbw

- *SCORE*
 www.score.org

- *Small Business Administration (SBA)*
 www.sbaonline.sba.gov

- *Seven Steps to Starting Your Own Business*
 www.startupbiz.com/7Steps/Seven.html

Does Someone You Love Deserve a Fab Job?

Giving a FabJob® guide is a fabulous way to show someone you believe in them and support their dreams. Help them break into the career of their dreams with the ...

- FabJob Guide to **Become an Actor**
- FabJob Guide to **Become a Boutique Owner**
- FabJob Guide to **Become a Business Consultant**
- FabJob Guide to **Become a Caterer**
- FabJob Guide to **Become a Celebrity Personal Assistant**
- FabJob Guide to **Become a Children's Book Author**
- FabJob Guide to **Become an Etiquette Consultant**
- FabJob Guide to **Become an Event Planner**
- FabJob Guide to **Become a Florist**
- FabJob Guide to **Become an Interior Decorator**
- FabJob Guide to **Become a Makeup Artist**
- FabJob Guide to **Become a Model**
- FabJob Guide to **Become a Motivational Speaker**
- FabJob Guide to **Become an Personal Shopper**
- FabJob Guide to **Become a Public Relations Consultant**
- FabJob Guide to **Become a Spa Owner**
- FabJob Guide to **Become a Super Salesperson**
- FabJob Guide to **Become a Wedding Planner**
- **And dozens more fabulous careers!**

Visit FabJob.com for details and special offers

More Fabulous Books

Find out how to break into the "fab" job of your dreams with FabJob career guides. Each 2-in-1 set includes a print book and CD-ROM.

Get Paid to Help People Look Fabulous

Imagine having an exciting high paying job showing people and companies how to make a fabulous impression. **FabJob Guide to Become an Image Consultant** shows you how to:

- Do image consultations and advise people about: total image makeovers, communication skills, wardrobe, and corporate image
- Start an image consulting business, price your services, and find clients
- Select strategic partners such as makeup artists, hair stylists, and cosmetic surgeons
- Have the polished look and personal style of a professional image consultant

Get Paid to Shop

Imagine having a creative high-paying job shopping for fashions, housewares, gifts, or almost anything else you love to shop for. In the **FabJob Guide to Become a Personal Shopper** you will discover:

- Step-by-step instructions for personal shopping from identifying what people want to finding the best products and retailers
- How to get discounts on merchandise
- How to prevent purchasing mistakes
- How to get a job as a personal shopper for a boutique, department store or shopping center
- How to start a personal shopping business, price your services, and find clients

Visit www.FabJob.com to order guides today!

Get Paid to Plan Events

Imagine having an exciting job using your creativity to organize fun and important events such as fashion shows. **FabJob Guide to Become an Event Planner** shows you how to:

- Teach yourself event planning (includes step-by-step advice for planning an event)
- Make your event a success and avoid disasters
- Get a job as an event planner with a corporation, convention center, country club, tourist attraction, resort or other event industry employer
- Start your own event planning business, price your services, and find clients
- Be certified as a professional event planner

Visit www.FabJob.com to order guides today!